UNOFFICIAL
THE LEGO®
BUILDER'S GUIDE

2nd Edition

by Allan Bedford

no starch press

San Francisco

THE UNOFFICIAL LEGO® BUILDER'S GUIDE, 2ND EDITION. Copyright © 2013 by Allan Bedford.

Printed in Korea

First printing

16 15 14 13 12 1 2 3 4 5 6 7 8 9

ISBN-10: 1-59327-441-6
ISBN-13: 978-1-59327-441-2

Publisher: William Pollock
Production Editor: Serena Yang
Interior Design: Octopod Studios
Photographs and sketches: Allan Bedford
Illustrations: Eric "Blakbird" Albrecht
Developmental Editor: William Pollock
Copyeditor: Alison Law
Compositor: Serena Yang
Proofreader: Ward Webber

For information on book distributors or translations, please contact No Starch Press, Inc. directly:

No Starch Press, Inc.
38 Ringold Street, San Francisco, CA 94103
phone: 415.863.9900; fax: 415.863.9950; info@nostarch.com; www.nostarch.com

The Library of Congress has catalogued the first edition as follows:

Bedford, Allan.
 The unofficial LEGO builder's guide / Allan Bedford.
 p. cm.
 Includes index.
 ISBN 1-59327-054-2
1. LEGO toys. I. Title.
 TS2301.T7B44 2005
 688.7'25--dc22

 2005013747

To my mother and father, and my sister.
Thank you for your brilliant and unwavering love and support.
This book would not be without you.

BRIEF CONTENTS

CONTENTS IN DETAIL

3
MINIFIG SCALE: OH, WHAT A WONDERFUL MINIFIG WORLD IT IS! 35

4
MINILAND SCALE: THE WHOLE WORLD IN MINIATURE 57

5
JUMBO ELEMENTS: BUILDING BIGGER BRICKS 73

10
BEYOND JUST BRICKS: OTHER WAYS TO ENJOY
THE LEGO HOBBY
149

A
BRICKOPEDIA
159

B
DESIGN GRIDS: BUILDING BETTER BY PLANNING AHEAD
205

INDEX
216

ACKNOWLEDGMENTS

Great credit must first go to all the readers and fans of the first edition of *The Unofficial LEGO Builder's Guide (ULBG)*. I know from stories I've heard and emails I've received just how close to your hearts many of you held this book. And from there, you helped spread the word by telling friends and relatives, inquiring at local bookstores, and by giving the book as gifts. You're all ULBG gurus, and this book could not have been as successful without you. Thank you.

Next, I want to thank the crew at No Starch Press for the continued support they've offered to me and this book over the years. Thank you, Serena Yang, for all your incredible hard work managing this rewrite and bringing the color version of ULBG to fruition. Thanks also for not letting me lose sight of anything on my To Do list! Riley Hoffman and Alison Law, thank you for contributing to the new look and layout and for helping handle the hundreds of little changes that were made. Thanks go to Bill Pollock for encouraging me to undertake this colorful makeover of ULBG and for many suggestions and advice along the way. Thanks go to Karol Jurado as well for her many hours of hard work on the first edition.

And Leigh Poehler, thank you for all the many emailed questions you've responded to over the years. I appreciate your always being there with a reassuring answer.

Although they're already mentioned in the dedication, these acknowledgements wouldn't be complete without once again mentioning my parents. There are no two bigger ULBG fans in the world. And, because of their tireless efforts, telling friends and acquaintances far and wide, there are now many more fans of my book out there. Thanks, Mom and Dad.

A note of thanks goes to Patricia Witkin for the many ways she found to put the first edition of the book in front of tech and geek bloggers who wrote such terrific reviews. You helped create even more ULBG gurus.

Thanks go to Joe Meno for the continued support from both himself and *BrickJournal*. Further thanks go to Joe and also to John Fiala and Frédéric Siva for the time and energy they spent reading and reviewing the first edition of the book. I appreciate all the honest and insightful feedback they provided.

By now you'll have no doubt noticed that *The Unofficial LEGO Builder's Guide* is now in full color. A very special thanks to Eric Albrecht, who worked with me for several months to re-render the hundreds of images needed to re-create all the figures in the book. Great work, Eric—thank you!

And thanks go to all of the software and parts authors in the "virtual" LEGO community as well. Many of the images in this book were produced with their tools, and without them the book would not be nearly as interesting. Be sure to visit *http://ldraw.org/* to get started building your own virtual LEGO models.

To the gang at Hipstamatic, thank you for all your love and support!

What can I say to jacki? Thank you for always being jacki! I'm deeply grateful for the friendship that we share. Thank you for your trust and your photographic inspiration.

Megan, thank you for your artistic ear, your strong shoulder, and your check-ins along the way.

A note of thanks goes to Dana, for patience, guidance, and companionship through unprecedented change.

Lisa, I'm so glad that we've found an incredible renewed friendship as older, more real versions of ourselves.

INTRODUCTION

LEGO bricks have been engaging builders young and old for decades. There are a number of ways to connect LEGO bricks, and millions of different things can be created with them. For many builders, the possibilities can be overwhelming. The question is often the same: "How do I get started?"

I hope to answer that question with this book. *The Unofficial LEGO Builder's Guide* starts at the very beginning, assuming no prior knowledge on your part.

In **Chapter 1**, you'll learn what a single LEGO brick is, how pieces are categorized, and what keeps elements from falling apart when you snap them together.

Chapter 2 builds on these basics with core building techniques for every builder. Fundamental principles (like how to secure a column of bricks) are explained and illustrated, setting the stage for the examples to follow.

In **Chapter 3**, you'll learn about scale and how to build a train station to minifig scale.

Chapter 4 explores the slightly larger world of miniland-scale building—the same scale used in miniland exhibits in LEGOLAND theme parks around the world.

Chapter 5 looks at scaling up by teaching you the principles behind building "jumbo" versions of LEGO elements.

In **Chapter 6**, we shrink things down by learning to build at microscale, creating models that need a minimum of parts.

Have you ever wondered how to build a LEGO sphere? **Chapter 7** looks at sculptures and gives you step-by-step instructions for a complete sphere, using just 220 basic pieces!

Chapter 8 moves on to mosaics, explaining how to create beautiful patterns and even how to re-create your favorite photos using common LEGO elements.

By **Chapter 9**, you'll be ready to become a model designer! I take you through the entire process, from finding a subject to constructing a complete prototype. Full instructions for a space shuttle are included.

Chapter 10 shows you how to create and share instructions for the LEGO models you create. This chapter also includes a section on making and playing games using LEGO bricks to create the playing surface and pieces.

The Brickopedia (**Appendix A**) is a graphical reference that presents the most common and most versatile LEGO elements. You won't find an entry for every piece ever produced, but you will find a good-sized collection of the LEGO bricks, plates, slopes, and other elements that best define the LEGO building system.

Appendix B will teach you all about the design grids. They're a type of graph paper that can be used to plan your LEGO models.

I hope that this book will help LEGO builders who wish to move beyond the instructions in the official sets and would like to create their own original models. Whether you're a novice builder just getting your feet wet or a more experienced builder looking to remember long-forgotten techniques or wanting to develop new ones, this book is for you.

So sit down with a bunch of LEGO bricks and get ready to build!

Please feel free to email me at *ULBG@apotome.com* with any questions you may have about the information found in this book. I also look forward to hearing about (and seeing pictures of) any creations you've built that were inspired by the techniques contained herein.

1

THE LEGO SYSTEM:
ENDLESS POSSIBILITIES

For millions of people around the world LEGO bricks
have a common meaning: creativity. Regardless of
age, we all recognize the sound those bricks make as
we rummage through a bucket full of them or a pile
on the floor.

Whenever you look at a pile of LEGO pieces, you're looking at some-
thing remarkable and yet at the same time remarkably simple. You're look-
ing at the different parts of a *system*. The LEGO system is a collection of bits
and pieces, and they connect with each other to become a larger object or
series of objects.

In this chapter, you'll learn about the LEGO system and what makes it
so amazing. I'll show you a number of the pieces that make up the system
and how they relate to each other, and I'll look at how geometry and color
come into play as you're building with LEGO pieces.

The LEGO system is made up of an enormous number of different
pieces, or *elements*. Every piece is an element. Every element (with a few
exceptions) can connect to any other element in an almost infinite number

of ways. A handful of pieces can be combined to form a wall. Add a few more to create a roof, a complete house, and maybe a car and a driveway to park it in. Tomorrow you can take those elements apart and recombine them to create a deep space cruiser, a sculpture of a calico cat, or even a fortress with medieval knights. The LEGO system is really remarkable, isn't it?

A Brick Vocabulary

Take another look at that pile of LEGO pieces, and you'll notice that they're not all brick shaped. Some have sloping sides, some are cylindrical or cone shaped, and some are thinner than others. Without a way to identify different features of bricks you'll have a tough time learning how to build with them. This section describes the key attributes of LEGO bricks and puts them into categories.

As you read about the different types of LEGO pieces, you'll undoubtedly find many that are familiar to you and that are already in your collection, but you'll probably meet some new ones, too. That's part of playing with the LEGO system. As you buy new sets or find used pieces at yard sales or thrift shops, you'll discover new parts that open up new building options.

Sizing Up the Elements

Throughout this book, I'll refer to the size and shape of various LEGO pieces. Let's begin with the basic 1×1 brick, as shown in Figure 1-1.

The 1×1 (pronounced "one by one") brick is the standard upon which I'll base all other measurements. If you put two 1×1 bricks next to each other, you'll see that they're the same size as the next largest standard-sized brick: a 1×2, as shown in Figure 1-2. If a piece is the same height as a 1×1, it's "one brick high." A brick that's the same height as a 1×1 brick but twice as long is a 1×2 brick.

Figure 1-1: A 1×1 brick shown much larger than its actual size

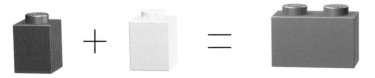

Figure 1-2: Two 1×1 bricks added together equal a 1×2 brick.

Usually, we put the brick's shorter dimension (the width) ahead of its longer one (the length). In other words, the element in Figure 1-3 is a 2×4

brick (the equivalent of two 1×1s wide and four 1×1s long). The LEGO building community uses these measurement standards, and I will, too, throughout this book.

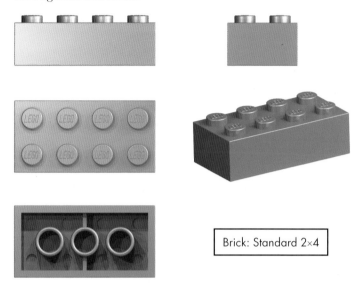

Figure 1-3: Anatomy of a 2×4 brick. When you look at this brick from all sides you get a sense of its general size and shape.

Another important standard is the use of the capital letter N as a substitute for a brick's length. For example, when I talk about a bunch of 1×N (pronounced "one by en") bricks that I used to make the outer wall of a building, the N represents a number of possible brick lengths, such as 1×2, 1×4, 1×8, and so on. Rather than list all of the sizes, it can be easier to replace the last number with an N and allow the description to apply to a range of brick sizes.

The Stud

The *stud* (shown circled in Figure 1-4) is part of almost every LEGO piece, and we use it to measure the length or width of the piece. The stud helps define the look of a LEGO element and is integral to how the entire system functions.

The 1×1 brick shown in Figure 1-4 has one stud and is one stud wide by one stud long. The element shown in Figure 1-3 is a 2×4 brick: two studs wide by four studs long.

Figure 1-4: The stud gives an element half of what it needs to connect to almost any other element.

The Tube

The *tube* in the brick helps bricks stick together. Tubes capture the studs so that you can join LEGO elements. You can see the tubes by looking underneath most LEGO pieces, like the ones shown in Figure 1-5.

Figure 1-5 uses a simple upside-down assembly of pieces to demonstrate the way in which the tubes work with the studs. Different elements vary the tube design. For example, in Figure 1-5, the thinnest piece (at the top) has shortened tubes, while the 2×4 bricks beneath it have longer tubes. The 1×4 brick (at the bottom of the sculpture) has thin posts rather than hollow tubes. Despite these differences, all tubes serve the same purpose: They press against the studs of the piece attached to them with just the right amount of force to hold the bricks together.

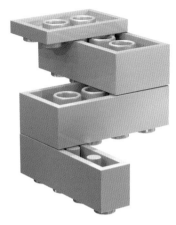

Figure 1-5: The underside of LEGO elements reveals the other half of the secret that locks bricks together.

The Brick

Although it's tempting to refer to all LEGO pieces as bricks, the term "brick" really applies only to certain elements. In general, a *brick* is a LEGO part that is the same height as a standard 1×1 element, like the ones in Figure 1-6. A brick has straight sides and a rectangular shape when you view it from the side.

Figure 1-6: An assortment of standard bricks

LEGO bricks are like the real bricks that you might use to build the walls of a real house, and they can be used to create the walls of buildings. But you can also use them to create vehicles, cities, moats, airplanes, and many other things you can't make with real bricks.

Using Various Brick Sizes

You will use 1×1 bricks in many ways. You'll see how to use them in mini-land style figures (Chapter 4), mosaics (Chapter 8), small-scale animals, or just about any model where small detail work is required. In some ways, the 1×1 is an extremely flexible brick that is sometimes overlooked. The 1×2 and 1×3 bricks are handy for creating columns for either true structural support or just for ornamental purposes, as you'll see in Chapter 2. The longer bricks in the 1×N category are the backbone of the detail-building portion of the LEGO system. They have an enormous number of uses, one of which is as the standard walls for virtually any small building. They provide a reasonable to-scale rendition of the thickness that you would find in real-world walls.

When it comes to wider pieces, one stands out from the rest. For many builders, the 2×4 represents a standard image of a LEGO brick. This piece finds its way into models of every size and theme you can imagine. For many projects, they represent the core material onto which other elements can be added. They are the true "bricks" of the LEGO system.

The Plate

At first glance, the common *plate* (shown in Figure 1-7) may not seem as useful as its big brother, the brick. After all, it takes three plates stacked on top of each other to equal the height of any regular-sized brick. But that's exactly what makes the plate such an effective building tool: Because it's only one-third as tall as a full-sized brick, you can use it to add subtle detailing, internal bracing, or realistic scaling to your models.

Figure 1-7: An assortment of standard plates

The plate is often the little piece that could. Plates are found in many of the same length and width combinations as bricks—1×1, 1×4, 2×2, 2×4, and so on.

Using Various Plate Sizes

The 1×1 plate can find its way into any model, from the smallest automobile to artistic mosaics (Chapter 8) to the largest of sculptures (like those in

Chapter 7). You can also find 1×2 and 1×3 plates in a range of applications and in just as many colors.

You can use longer 1×N plates in all sorts of projects ranging from building helicopter blades for small-sized rescue machines to creating long colorful stripes on the sides of a locomotive. They're also great for helping tie together several columns of bricks or other plates stacked vertically to create an interesting pattern (as you'll see in Chapter 2). If the 2×N bricks are the foundation of the brick class, the 2×2, 2×3, and 2×4 plates are the working class elements that allow you to accomplish a lot with a little.

The Slope

When you dig through your LEGO collection, you'll probably find pieces that look like ramps for tiny cars. These are called *slopes* because one or more of their sides are on a slant (Figure 1-8). Slopes come in a variety of angles from 18 to 75 degrees, but 33- and 45-degree angles are the most common.

Figure 1-8: Slopes come in a variety of angles and shapes.

Slopes are sometimes called *roof bricks*, but they can do a lot more than simply cap off LEGO houses. They can add character to a model by helping to soften harsh square edges, give beveled wings to an airplane, create a reasonable facsimile of an evergreen tree, or put the roof on just about any building. Slopes also come in an inverted variety with the slant found under the brick, like what you would see if you put a regular slope on a mirrored surface (see Figure 1-9). (You can put your LEGO elements on a mirror, but don't expect them to realize how gorgeous they are.)

Figure 1-9: These two slopes are nearly mirror images of each other. Many slopes come in both a standard and an inverted variety.

Specialized Elements

Certain elements in the LEGO system defy easy classification, like the ones shown in Figure 1-10. These pieces are either unique or just different enough from other elements that they require their own category. Many of these pieces have a unique shape or an unusual stud orientation. The pieces in this category usually offer some type of extra functionality, and they're useful in many ordinary and special situations.

Some classification systems (typically those used to catalog, track, or sell elements) may sort specialized pieces into existing standardized categories even if they don't fit, which can make it hard to find some of these pieces. For example, the offset plate (shown on the left in Figure 1-10) is often described as a plate with a single stud in the center, but you'll sometimes find it labeled as a *modified* plate or a *jumper* plate. You could just as easily call it a tile with a stud in the center, because its surface is more tile-like than plate-like. Without a specialized category, it is not the easiest part to classify.

Figure 1-10: Specialized elements can take on a variety of shapes and sizes.

Arch Pieces

The *arch pieces* (like the ones in Figure 1-11) may seem too specialized to be of much use other than for architectural detailing, but they can add character and shape to all kinds of models.

Figure 1-11: Among the most graceful of LEGO elements are the arches. They come in several sizes and styles.

Using an arch as an arch is a no-brainer, but using arches of varying sizes and shapes is a little more difficult. It's usually best to draw your inspiration directly from the building you are attempting to copy or from

a similar structure if you're building something new. Picking out the many ways arches are used on buildings can be like working on one of those brainteasers where you have to figure out how many triangles are created by the dozens of intersecting lines on the page.

Tiles and Panels

Standard *tiles* are easy to spot (see Figure 1-12) because they're like plates without studs. Cylinder tiles look like tiny, smooth manhole covers.

Figure 1-12: Tiles have a tiny groove at their base that allows you to remove them more easily.

Panels, on the other hand, come in more shapes and sizes (see Figure 1-13). Panels are kind of like tiles with other tiles attached at right angles to form a thin vertical wall or two. Panels may or may not have studs.

Figure 1-13: Panels come in a variety of shapes and sizes.

Cylinders and Cones

Cylinder elements have a cylindrical shape, like a coffee can or a drum (see Figure 1-14). *Cones*, on the other hand, are sort of like upside-down ice cream cones. Although only a few elements fall into the standard cylinder or cone categories, what they lack in number they make up for in usefulness.

Figure 1-14: The standard vertical-walled elements are cylinders, and the sloped versions are cones.

From tree trunks to light posts to the nozzles on the ends of water cannons, you'll find lots of uses for cylinders and cones.

Cylinder Plates

Cylinder plates are just shorter versions of their full brick-height cousins. The tiny 1×1 cylinder plate (sometimes called a *pip*), the 2×2 cylinder plate, and the 4×4 cylinder plate (all shown in Figure 1-15) are the only elements in this tiny subcategory.

Figure 1-15: A pip sits next to the only other two elements like it in the entire system: the 2x2 and 4x4 cylinder plates.

Baseplates

It's easy to confuse large standard plates with small baseplates, so where do large plates end and baseplates begin? For our purposes, assume a *baseplate* is an element that's one full brick in height and larger than 8×16 studs in size or has a waffled underside to which no other bricks can be attached. The latter type of baseplate is thinner than even a standard plate, as shown in Figure 1-16. They may be plain (with only regular studs on top), or they may have designs (like roadways) printed on them.

Baseplates can be used as the foundation for a model, whether it's a building, a machine, or a sculpture. They're useful for anything that requires a platform to steady, transport, or display it.

Figure 1-16: A 1×1 plate is used to show the difference in thickness between a plate and a waffled baseplate.

Decorative Elements

When it's time to add a bit of character to your creations, *decorative elements* can be used to add realistic-looking windows, doors, trees, and so on. These elements often provide a one-element solution to a building need, and as you can see in Figure 1-17, they take many forms.

Figure 1-17: Fences, windows, trees, and flags are just a few examples of decorative elements.

Precision, Geometry, and Color

Now that you have a handle on basic LEGO-related terminology and some sense of how parts are categorized, let's look at the importance of precision, geometry, and color in the LEGO system.

Why Precision Manufacturing Matters

It doesn't take long to realize something really important about LEGO pieces: Every element is manufactured to a very high degree of precision, not unlike the accuracy seen in the manufacture of aircraft parts. This may not be so important to you if all you're doing is snapping a few bricks together and they're off by a hair. But what if you want to stack up more and more bricks? How long will it be before even a small difference in quality control begins to show itself?

Take Figure 1-18 for example. Imagine you're making a doorway. On the right, you use properly made bricks, each exactly the height it's supposed to be. On the left, you use a handful of bricks that don't meet that same standard. Maybe they're just a tiny bit too short, say the thickness of a pencil mark. As you can see, only a few layers of imperfect bricks would begin to play havoc with your construction. How would you join these two mismatched walls to create a stable model?

Height is just one of three dimensions that have to match in every element. Differences in length or width would also quickly become apparent because you'd find that a brick wouldn't press down securely onto the pieces beneath it. Studs would be out of alignment and finishing even a modest-sized model would become nearly impossible.

Figure 1-18: Imagine the difference a tiny error makes when multiplied by a number of bricks.

The LEGO Group applies the same attention to detail to things like the height and width of the studs themselves, the height and thickness of inner tubes, the diameter of the walls of bricks and plates, and so on. The care that goes into the manufacture of LEGO elements is a testament to the company that's been making them for so many decades.

Fun with LEGO Geometry

Look at the base measurement piece (the 1×1 brick) and you'll see that it's a vertically oriented rectangle with a ratio of 5:6 (width:height) as shown in Figure 1-19.

This ratio means that five 1×1 bricks stacked on top of each other are exactly the same length as a standard 1×6 brick, as shown in Figure 1-20.

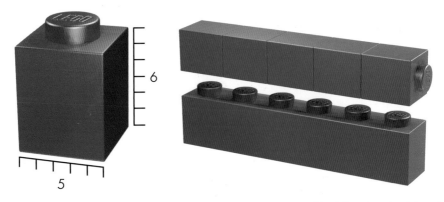

Figure 1-19: The 5:6 ratio of width to height applies to all standard LEGO bricks.

Figure 1-20: The 5:6 ratio of brick height to brick length

Why? Because the five 1×1 bricks are each six units high and 5 times 6 equals 30. Similarly, each stud of the 1×6 brick represents five units of width, and 6 studs times 5 equals 30 again. (We consider only the dimensions of a brick's walls, not the height of the exposed studs.) We'll see this geometry at play a bit more in Chapter 8 when we look at mosaics.

There are other interesting geometries in the system. For example, the tubes under a standard brick or plate are the same distance apart as regular studs, and the inner diameter of the tube is the same diameter as the stud itself. This feature allows you to place a brick or plate on top of exposed studs where the number of studs is equal to or less than the number of tubes available, as shown in Figure 1-21.

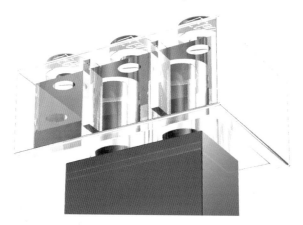

Figure 1-21: Studs inserted into tubes, not alongside them

This represents one of the few times, other than when you are using offset plates, that you can offset elements from one another by a value of one-half of a stud rather than a full stud.

Consider, too, the relationship between the height of a standard plate and a standard brick, as shown in Figure 1-22.

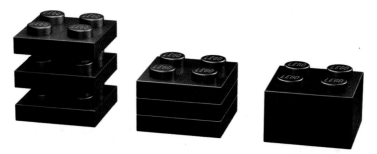

Figure 1-22: Three plates stacked together will always equal the height of one standard brick.

Notice that three plates equal one brick. This means that in a pinch three plates stacked together can be used as a substitute for the same sized standard brick. You can also use plates to create visual illusions within walls or other structures. For example, the white stripe in the fire truck in Figure 1-23 shows how you can stagger plates through several layers of other plates and bricks to create the illusion of an angle.

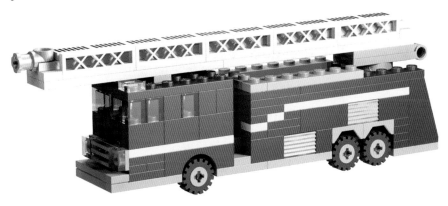

Figure 1-23: A fire truck with stripes made from plates

The Colors

For many years, LEGO bricks came mostly in red, yellow, and blue. In fact, in 1958, when the original patent was issued for the basic design, there were only seven colors: white, black, red, blue, yellow, green, and clear. Of course, today's sets have many colors, like mossy green, maroon, pale blue, dark grey, bright orange, and pink!

Given the original color limitations, builders improvised to create new colors from the existing ones. Their trick was to place one or more colors next to each other to create a kind of blending. For example, a white brick takes on a subtle grey tone when placed next to a black element, as shown in Figure 1-24. A yellow piece would shift slightly toward orange when placed next to a red brick, as shown in Figure 1-25.

Figure 1-24: White bricks next to dark grey or black may take on a slightly grey appearance. You can use the same technique to tone down bright colors.

Figure 1-25: You can create a hint of orange in a model by placing yellow bricks next to red ones.

The colors you choose to use in your models can add realism, character, or even a sense of humor. For example, a fire engine you model in red or bright yellow will probably look more like the real thing than if you build it with blue or grey bricks. A snowman sculpture will look more accurate if it uses a traditional white scheme. (You could add red horns to his head to create something playful or mischievous.) A fairground ride will look more exciting and fun if it uses a variety of colors in playful patterns of reds, blues, and yellows. Color plays an important part in almost everything you build.

For the Color Challenged

One problem that new or younger builders often have is that they don't have enough bricks in any one color to give a model a consistent look. This can be frustrating, but don't let it stop your plans to build sophisticated models.

There are two ways to make the most of your bricks, no matter their colors, without spending a fortune building up your stash.

- Match your models to the bricks you have. Build small models that let you stay within a single color or two.

- Use multiple colors as a design element to maximize your collection. Many vehicles, buildings, animals, and other subjects are naturally multicolored or can be modeled in other colors.

Even official LEGO sets use limited color schemes to great effect. Some contain only a few colors and can be a great way to learn how to use limited colors effectively, or to add healthy quantities of two or three colors to your collection. Do you have sets with a lot of red and white elements? Aside from the models shown in the instructions, why not build a candy cane in time for the holidays, like the one shown in Figure 1-26? Or use a similar color scheme to build a small lighthouse like the one shown in Figure 1-27.

NOTE *When building your LEGO collection, it may make sense to buy more than one of the same set to build up your collection of a certain color, especially if you can find the set on sale.*

Figure 1-26: Having limited colors means using what you have to the best of your ability.

Figure 1-27: The stripe on the lighthouse is achieved by carefully placing just two different colors of bricks. Try building this model using red and white elements with brown or dark grey for the base.

Review: The LEGO System

You didn't learn much about actually building with LEGO pieces in this chapter, but there's lots to come. You learned about the basic framework and terminology of the LEGO system, and you'll use that knowledge to work through the construction techniques and ideas in later chapters. Your ability to tell a brick from a plate will make all the difference as you learn how to create a minifig-scale train station, a three-dimensional sphere, or even a mini space shuttle.

2

BACK TO BASICS:
TIPS AND TECHNIQUES

No matter how old you are, when you sit down with a pile of LEGO bricks, one thing never changes: You want to connect a few. LEGO bricks, like grains of sand on a beach, are meant to be together.

But what are the best ways to join bricks? That depends, of course, on what you're building. Official LEGO literature describes the many possible ways to connect bricks. For example, they say that six 2×4 bricks can be arranged in 102,981,500 different patterns. (Someone at the LEGO Group has a very good understanding of geometry and mathematics or just way too much time on his hands.) Figure 2-1 demonstrates just three of the millions of possible combinations. I'd need an enormous number of pages to show pictures of every pattern.

Figure 2-1: You can combine six 2×4 bricks in many ways.

Decisions, Decisions: The Best Ways to Connect Bricks

Perhaps more important than the *number* of ways in which you can fasten bricks together are the principles behind *how* to connect them.

For example, you can connect any two 2×4 bricks in three basic ways, as shown in Figures 2-2 through 2-4. You can stack them, overlap them, or stagger them.

Figure 2-2: Stacked Figure 2-3: Overlapped Figure 2-4: Staggered

Each illustration represents a different type of *bond*, or way of joining LEGO bricks. *Bond patterns* are the ways in which bricks are arranged or connected. Let's look at each pattern individually to get a sense of its strength.

Stacking

Although not the most common or sturdiest way to build, *stacking* bricks one on top of the other can be necessary. For instance, a small shop in your LEGO town might have vertical stripes of color that you wish to appear painted on the sides of the building. Or perhaps an airplane needs to have a colorful pattern of lines on its tail section.

Typically your decision whether or not to use vertically stacked bricks will be driven by aesthetic rather than structural needs. The reason is simple: As you can see in Figure 2-5, stacks of bricks, unsupported by surrounding pieces or layers, are generally not very stable.

When you need to stack bricks, make sure that you secure the stacks—both above and below—with longer bricks or plates. For example, in Figure 2-6, stacked 1×1 bricks create the vertical stripes on the tail section of a plane. The vertical part of the tail sits on several offset plates, but below that, the stripes are held together by a 2×8 plate. Near the top, the stacked bricks are locked together by the 1×4 plate just above the highest slope piece.

Figure 2-5: Crash! With nothing to support it, the center column of bricks may fall over when you least expect it.

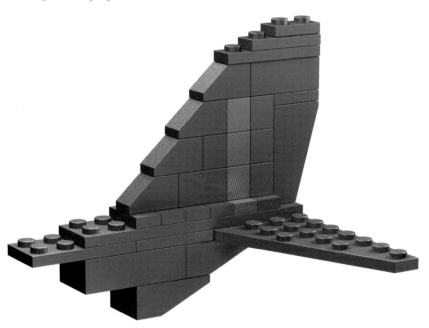

Figure 2-6: When you need to stack bricks, make sure you lock them in place to avoid the Humpty Dumpty effect.

Overlapping

No building technique will add as much strength to your models as *overlapping*. As with real brick walls, LEGO bricks work best together when they sit on top of each other in overlapping patterns, like the ones shown in Figure 2-7. These overlapping connections strengthen the structure of your models and prevent them from falling apart.

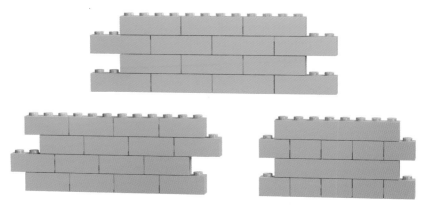

Figure 2-7: Bricks can overlap in a variety of patterns.

Overlapping bricks strengthens your models and allows you to make full use of one of the primary features of the LEGO system: the interlocking feature of elements. Models containing standard bricks and plates almost always use one or more overlapping patterns. (Later in this chapter, I'll show you how to build walls and connect them using overlapping bricks.)

Other elements need to be overlapped as well. Doors and windows should be secured using this technique to make sure they won't fall out of your wall, as shown in Figure 2-8.

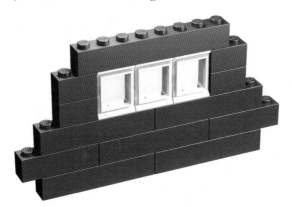

Figure 2-8: A well-placed brick can keep a wall from collapsing.

Notice in Figure 2-8 that the 1×8 brick at the top of the wall overlaps both the windows and the bricks to either side of them, locking them all together. This helps create a solid structure.

The best way to achieve good overlapping is to avoid stacking too many bricks on top of one another, which creates vertical seams like the ones in Figure 2-9.

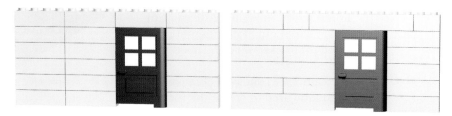

Figure 2-9: A poorly designed wall (on the left) is shown with a properly designed wall (on the right).

The wall on the left in Figure 2-9 uses stacking. You can see how unstable the door would be if you tried to open it, because the 1×4 brick on top isn't attached to anything else. On the right, the 1×8 brick over the door is also attached to bricks on either side, like the brick above the windows in Figure 2-8. This helps anchor the door to the wall and ensures that the two won't come apart when you least expect it.

Staggering

When you *stagger* bricks, you set one layer of bricks back from the front edge of an adjoining layer to produce a stair-step pattern, like the one shown in Figure 2-10.

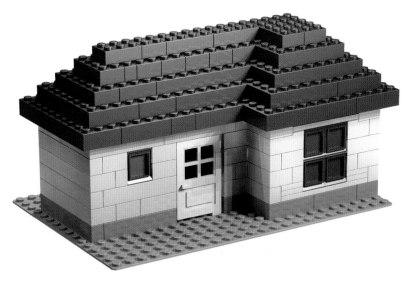

Figure 2-10: You can apply this simple staggered roof technique to a multitude of models.

Staggering is particularly important when building sculptures (covered in Chapter 7) because it allows typically square or rectangular bricks to produce more organic shapes when used in the right combinations.

By staggering the bricks in the house shown in Figure 2-10, you can create a roof out of nothing more than standard bricks; you don't need to use slopes.

Figure 2-11 shows the stagger technique used to create the roof in Figure 2-10. I've alternated the colors of the layers to show you how to stagger. (Obviously 2×N-sized bricks work best for this technique.) Notice that even though I stagger the bricks to create the slope, I still overlap them from layer to layer to create an even sturdier model.

Figure 2-11: Don't forget to overlap bricks as you stagger the layers.

Building Walls

When building with LEGO bricks we always seem to be making walls. Walls of a fire station, a hospital, a police department, a medieval castle, or even an alien base on some far-off planet. In "Overlapping" on page 20, you learned how to build a strong wall that stands by itself. Now let's connect two or more walls together.

Connecting Walls

In Figures 2-7 through 2-9 you learned how to build simple walls with the overlap technique. But, a lone wall isn't much good if you intend to create a realistic-looking building (unless you're building a ruin, of course!). The inhabitants of your LEGO world will enjoy their buildings a whole lot more if you give them rooms, doorways, and walls that won't fall down.

But don't expect to connect two already-built walls to each other to make a strong pair; build the walls at the same time and have them draw on each other's strength. Walls should be joined to each other from the very first layer, or *course*, of bricks, as shown in Figure 2-12.

The next course of bricks begins to lock the first layer in place by overlapping, as shown in Figure 2-13. The orange 1×4 brick ties one blue wall to another, locking the 1×6 to the 1×8.

This particular overlapping technique is key to building solid models. As you can see in Figure 2-14, as you add the remainder of the second course, the other bricks (in this example) aren't quite as important as the orange one in Figure 2-13. They are part of the walls, but not part of what is holding the two walls together.

In Figure 2-15, notice that the overlapping technique is still used to connect the two walls to each other, but it is also used within each individual wall. For example, the blue 1×4s in the third layer cover the gaps in the orange bricks below them, just as the orange layer connected the gaps between the blue bricks below them. When layers of bricks are overlapped with each other in this way, you get the strongest possible model in the end.

Figure 2-12: The first course of bricks when building a wall connected to another wall

Figure 2-13: The orange 1×4 brick is the cornerstone of the overlap. It connects the two blue walls beginning with the second course.

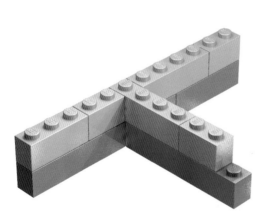

Figure 2-14: The remainder of the second layer is added.

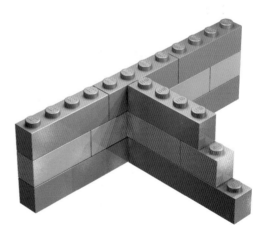

Figure 2-15: The completed example

After just a few layers, you should find that your two walls are firmly supporting each other. Try pushing on either wall, and you should find it hard to move. The overlap pattern creates strong walls, made even stronger by using the same overlap technique to connect the walls to each other.

Straight Bricks Can Make Round Walls

Of course, you won't always want perfectly straight and perfectly interlocked walls. Sometimes you'll want to create a model that's a little more organic or, at the very least, less than square.

How can you use straight bricks to form a curved wall? One fun technique is to dig up as many 1×3 bricks as you can find and link them together, as shown in Figure 2-16.

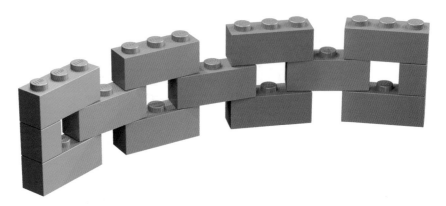

Figure 2-16: 1×3 bricks joined in this fashion make it possible to create curved or even completely circular walls.

This method allows you to curve a wall, even to the point of creating a complete circle. You may find yourself using this technique to make a pen for barnyard animals, the body of a rocket, a fence around a house, and so on.

To create a different look, try adding 1×1 cylinders to the openings between the 1×3 bricks. As you can see in Figure 2-17, this makes the wall appear more solid. You won't be able to curve it as much as the example in Figure 2-16, but it's still a great way to add new shapes to your models.

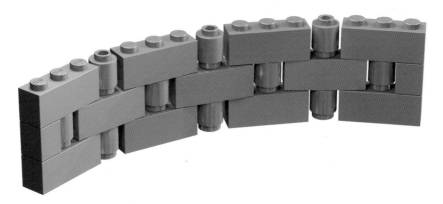

Figure 2-17: A few small pieces can make a big difference in how your wall looks.

By playing around with the length of your wall and the curve of the bricks, you may find that you can even link the ends of the wall into existing square structures (as shown in Figure 2-18). For example, you might take two castle walls and create a rounded corner that connects them. Or, create a guard tower using this technique and set it on a castle made from regular walls that meet at 90 degrees. By placing 1×1 round plates at various points under the 1×3s, you'll find combinations that allow you to connect your round wall to the other parts of your model.

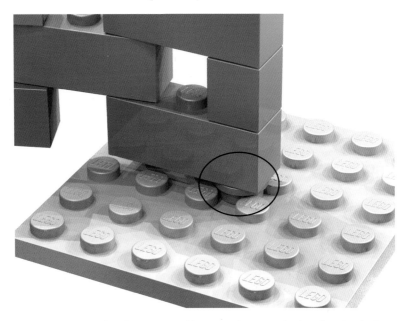

Figure 2-18: Round and square worlds meet. The 1×1 cylinder plate (circled) is used to anchor the curved wall to a flat surface.

Bracing: Unseen but Not Forgotten

Bracing is the art of reinforcing your models, typically on the inside, to make them stronger and more stable. The bracing itself can be as simple as adding a few long bricks to strengthen an otherwise unsteady structure, or as involved as building columns and beams within a larger model to allow it to be handled or transported or to simply stand up without falling down.

Bracing = Beams + Columns

Figure 2-19 shows some simple walls, which could be the walls of an office building, the sides of a grandfather clock, or even the beginnings of a tall but slender air traffic control tower. The bricks marked A and B seem to connect the other walls. This reinforcement or bracing, made up of a central column and two horizontal beams, strengthens the model.

The amount of bracing required varies from model to model—from none for smaller models to lots for large buildings and towers. Bracing your model properly can give it a very solid structure that will come in particularly handy when transporting it, whether to a public display or a friend's house, or even when you're just playing with it.

Why not just fill in the area inside the building completely and make it solid? Although this might work for some smaller models, doing so makes larger ones heavier than they need to be and uses more bricks than necessary. Why hide your bricks needlessly? Use what you need for support and no more. Use the bricks you save to build other parts or other models.

Bracing is meant to be functional, and it doesn't have to look pretty. The great thing about it is that you can brace with just about any brick to beef up a model from behind or underneath. After all, no one will see the bricks, so you can use whatever colors you have handy.

In Figure 2-19, the column (A) stands away from the walls of the building. The beam (B) extends from the column to the outside wall (D). The dark red square (C) is really the end of beam B. It's built into the wall to create a strong link between A and D.

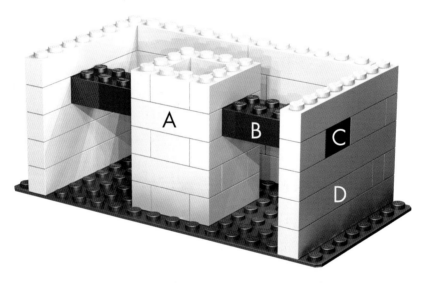

Figure 2-19: A peek behind the scenes shows how columns and beams come together to form bracing for this representative building.

To better understand bracing, you need to learn a bit more about columns and beams.

Beams

You saw one form of columns (the stacked 2×2s) in Figure 2-5. Normally, though, you wouldn't expect to see columns lined up next to each other like that. Instead, you'd find them as the corners of buildings, the structures on either side of doorways, or as supports for wide floors or ceilings.

One reason that the columns in Figure 2-5 tumbled was that nothing held them together. That's where beams come in. *Beams* are the horizontal equivalents of columns, and they work with columns to form strong structures.

A beam can be as simple as a single brick (like the one shown in Figure 2-20) connecting two parts of a structure that would not otherwise touch. Or, a beam can be a much larger and much more complicated submodel; a *submodel* is a portion of a model that you build separately then join to the main model (like the composite beam shown in Figure 2-21 or the ladder on a fire truck). Submodels are also known as substructures.

Figure 2-20: A beam can be as simple as a single 2×8 brick.

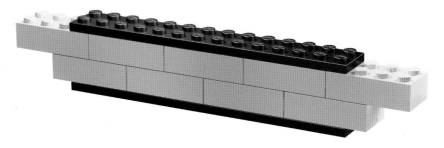

Figure 2-21: A composite beam, made from bricks and plates

You can make composite beams (see Figure 2-21) from a mixture of bricks and plates or several layers of bricks. You can build them very long, and they'll still remain strong.

Notice in Figure 2-21 that the black plates overlap the gaps between the yellow bricks, just as they would if you were building with bricks alone. The overlap technique can be used when snapping any type of element onto any other: Look for the gaps in each layer and close them with pieces you place above them in the next layer.

How Not to Build a Beam

Set up a few bricks as in Figure 2-22. To conduct this experiment, push down with your finger on the brick. With little effort, the bricks you set up between the two columns will quickly break apart and fall down. The structure fails, something you want to avoid in most models.

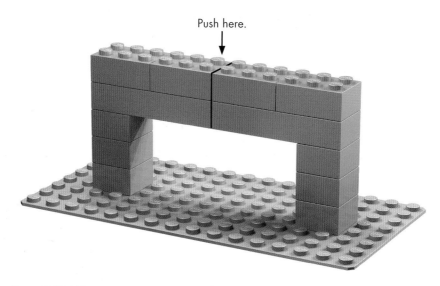

Figure 2-22: When you set up your example, pay attention to the bond patterns I used.

The Right Way to Build a Beam

Now try setting up a similar set of bricks in a slightly different pattern, as shown in Figure 2-23. Carefully note the positions of the bricks and where they overlap. Now when you push down, it should be nearly impossible to make the beam fail. See why it's so important to overlap bricks?

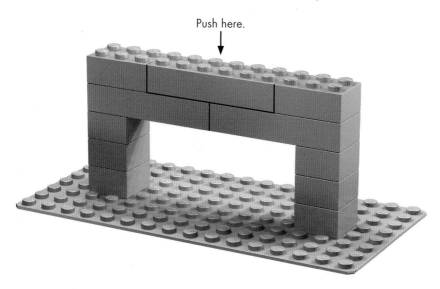

Figure 2-23: This example uses a simple overlap pattern to ensure the beam won't buckle under pressure.

You could use the beam in Figure 2-23 to connect the outer walls of a large building, or you could place it over top of the large opening at the front of a LEGO aircraft hangar.

Columns

Columns can be used with beams to provide side-to-side stability. They can also be used to create open space, between the floors of an office building, for example, or between the decks of a space station diorama to give the walls the height you want without blocking the space in between layers. Columns can take many different forms, as shown in Figures 2-24 through 2-27.

Figure 2-24: The simple post

Figure 2-25: The compound post

Figure 2-26: The chimney pattern

Figure 2-27: The keyhole pattern

The Simple Post

Figure 2-24 shows 2×2 bricks stacked on top of each other. A simple column like this might suit some of your projects, but if you make the post too high you'll end up with a weaker column than the ones I'll introduce next.

In addition to the 2×2 bricks in Figure 2-24, you could also make a simple post from 2×3s, 2×4s, or just about any other size of brick.

The Compound Post

Figure 2-25 shows a compound post, a sturdier column that also uses more bricks. Unlike the 2×2 version, this 2×4 column can withstand a certain amount of pressure from any side without crumbling. It's also very simple to build, which makes it an excellent way to create several columns quickly (even as temporary supports).

The Chimney Pattern

The chimney column in Figure 2-26 is about as strong as the compound post, but it offers some weight and brick savings. Because its core is hollow, you get much of the horizontal stability of the 2×4 version at only 75 percent of its weight, which may be important if you are building a large model that you want to transport.

One drawback to the chimney pattern is that you must check it regularly to make sure that its core stays square. To do so, make a 2×2 column of six or more pieces and, as you build, insert it into the core from time to time.

The Keyhole Pattern

What do you do with all those leftover 1×2s? Make them into a keyhole-patterned column! The keyhole column shown in Figure 2-27 can be varied in both size and shape. The arrangement shown here is just one possible pattern based on creating composite walls out of mostly smaller (1×3 or less) bricks. You can change the pattern slightly and grow the column to suit your needs.

Like the chimney pattern, use a square of bricks that fits the shape of the core to make sure that it stays aligned. Because it uses many components, the keyhole column tends to warp and twist as it rises. But, if you can keep it reasonably straight, you'll find it both functional and attractive.

The Hybrid Column

You'll create an interesting new pattern when you mix the compound post column with the chimney pattern, as you can see in Figure 2-28.

By using this hybrid column, you immediately resolve one of the major problems with the hollow-core chimney: By adding a layer or two of 2×4 bricks (as shown in Figure 2-29) every few layers, you help keep the 1×2 and 1×4 bricks aligned.

Figure 2-28: The hybrid column is both lightweight and self-straightening.

Figure 2-29: An "exploded" view of the hybrid column design shows the orientation of the different layers.

Given the bricks that most builders have in their inventory, this hybrid version may be more realistic for you to build. You probably won't build a large-scale model entirely of 2×4, 1×2, or 1×4 bricks. Usually you'll mix and match bricks of different sizes as you need them. When it comes to having bricks left over for your columns, you'll probably have a good mix of the three sizes.

If you're like most builders, not all of your models will need internal bracing. Still, the construction techniques you've learned here will be useful in many other ways. In Chapter 3, you'll see just how useful a simple post–style column can be for creating a small building. You'll also learn how you can use beams to support the floors in a building or to create a solid structure for a roof. Keeping these basic construction techniques in mind gives you the tools you need to be a successful LEGO builder.

How to Separate Pieces

We're still learning techniques for putting bricks together, but sooner or later you'll want to take one of your LEGO creations apart. Whether it's an official set that you built out of the box and put on a shelf for a few months, or a robot that you built last weekend, you're eventually going to want to reuse its pieces. The first step is to pull off large sections of bricks. Then, break those down into smaller chunks, and finally separate individual bricks from one another.

At some point, you'll likely come across two or more pieces that are stuck together so tightly that you can't pry them apart or even get a fingernail between them. Often these will be two small plates (proving just how well the stud and tube mechanism works). Despite their best efforts to stay together, you know they need to come apart.

In some official LEGO sets and assorted tubs of bricks, you'll find a rather odd-looking piece of plastic (Figure 2-30). This isn't quite a brick, but it does have some studs on it. It's a *brick separator*.

Figure 2-30: The brick separator—a tool for builders of all skill levels

If you haven't got a brick separator, consider buying a couple since they're often used in pairs. If you haven't found one in a LEGO set, you should be able to purchase them directly from the LEGO Group's Shop at Home service, *http://shop.lego.com/*, item #630. They sell for about three dollars each and will save you much more than that in dental fees by helping you separate bricks and plates without resorting to yanking them apart with your teeth.

Take, for example, two 2×2 plates stuck neatly together. Start by taking one of your brick separators in one hand, and then place the 2×2 stacked plates studs down on top of it. Next, bring the second separator down from above; this creates something that looks like the handles of a pair of pliers (see Figure 2-31). Squeeze the separators together gently, and you'll find the two plates begin to disconnect.

Figure 2-31: Two brick separators working to take apart two 2×2 plates. Gently squeezing the two handles is usually enough to quickly separate even the most stubborn pieces.

Or say you need to remove a small part from a larger one, like the 1×2 plate stuck in the middle of a 4×6 plate, as shown in Figure 2-32. You can use a single brick separator here to free the little piece. Figure 2-33 shows the separator working its magic.

Figure 2-32: Sooner or later you'll find yourself trying to remove a 1×2, like the one shown here, from the middle of a much larger piece.

Figure 2-33: The brick separator's unique design allows it to get close to the 1×2 plate and then lever it away from the larger plate beneath it.

Figure 2-34 shows a trick for removing pieces when you don't have a brick separator. Here we have two 1×2 plates stuck together. Instead of scratching away with your fingernails at the joint between them, try placing a 1×2 brick on the top and bottom of the plate combination. The bricks give you enough leverage to cause a small separation between the plates. The gap that forms should allow you to separate the plates completely.

You could also use a brick to separate pieces like the ones shown in Figure 2-32. Put the brick on top of the 1×2 plate (Figure 2-35) and gently press down as you tilt the brick toward the surface of the larger plate. If you do this without lifting up on the brick, you should find that the 1×2 plate loosens from the studs of the 4×6 plate.

Figure 2-34: This easy solution uses pieces you already have.

Figure 2-35: Here a standard 1×2 brick is being substituted for a brick separator.

Review: Basic Building Principles

Now that you know some of the best ways to connect bricks to make your models strong, it's important to understand how to plan your constructions. When building, it's always a good idea to try to minimize problems so that you'll enjoy your building sessions to the fullest. Here are a couple of basic principles to help you do that.

1. Build big but think small.

No matter how big you think your model might end up, consider breaking the work into smaller sections that will be easier to work on. Doing so will make the project seem less daunting and will make it easier to figure out how to build very high sections or ones built at different angles from the rest of the model. For example, if you're building a skyscraper, think about building sections of a few floors each and then attaching these sections to each other.

If you're making a model of a real-life object, like a building or a vehicle, examine the object and try to find natural separations, like where the object's size or shape changes dramatically or where one color ends and another begins.

Existing separations can help you determine how to build your model in sections. For example, if you're building a pickup truck, try building the cab separately from the box section.

2. Pick the right bond pattern.

Your choice of bond patterns (Figures 2-2 through 2-4) will vary from model to model and even within the same model. You won't always want to use overlapping, despite its obvious strengths. Sometimes you'll want to stack bricks and other times stagger them. Throughout this book, I'll point out which pattern I'm using and why so that when you design and build your own models, you'll have a better sense of the pattern to use at any given time.

3

MINIFIG SCALE:
OH, WHAT A WONDERFUL
MINIFIG WORLD IT IS!

The LEGO system is always adding new elements, colors, and modern set designs. But perhaps one of the more significant additions came in 1978 with the miniature figure, better known as the *minifig* (Figure 3-1).

The years have brought us many different minifigs, from astronauts and cowboys to helicopter pilots and robots, wizards and witches, and everything in between.

Figure 3-1: Who is this guy, and why is he smiling?

Scale: It's All Relative

When you build to a particular *scale* you make buildings and other constructions that would fit in a world of a particular size. When you build at *minifig scale* you're building a world that the minifig would live in.

As you can see in Figure 3-2, in real life the basic minifig is just barely 1.5 inches tall. But from his point of view, he's 6 feet tall! So now we can come up with minifig scale.

Figure 3-2: How does a minifig measure up? In our world he's only 1.5 inches. In his world he's 6 feet tall.

To convert to minifig scale, do the following:

1. Convert 6 feet (the minifig's height in his world) into inches:

 6 feet × 12 inches per foot = 72 inches

2. Divide the minifig's height in his world by his height in our world:

 72 inches ÷ 1.5 inches = 48 inches

3. Create your scale. Your minifig is 1:48 scale (pronounced "one-forty-eighth" or "one to forty-eight").

Scale is shown as two numbers separated by a colon. The number on the left (1) represents size in the real world. The number on the right (48) tells us how many actual minifigs it would take (stacked on top of one another) to equal a minifig's real-world height. In other words, if we stacked 48 actual minifigs, the stack would be about 6 feet high.

Once you have your scale, you can use it to determine how big a real-life object should be in your minifig world. For example, say you want to give the minifig a house that's 24 feet tall in real life. The formula for calculating the height based on your scale is as follows:

Real height ÷ Scale value = Size of scale model

So to figure out how high the house should be in minifig scale, you divide its actual height (24 feet) by your scale value (48). Here's how to do it:

1. Convert 24 feet to inches by multiplying by 12.

 24 feet × 12 inches per foot = 288 inches

2. Divide the result by the scale value (48) to determine the object's size in minifig scale.

 288 inches ÷ 48 = 6 inches

Your minifig-scale house should be 6 inches tall.

Creating a Minifig-Scale Building

The rest of this chapter will focus on building a railway station to minifig scale. I'll show you the parts that will go into the model and how to use the building techniques you've learned so far to build other buildings in your LEGO town.

As you read, remember that this building doesn't have to be a train station. You can adapt it to be an ice cream parlor, hamburger stand, or even a ticket booth for a theme park or a zoo. You never have to color inside the lines when building with LEGO bricks.

Building Two Versions of the Train Station

We'll tackle the building in two ways. First, we'll build it as if it were an official LEGO set using a nearly unlimited range of parts. You can use specialty pieces to add details. Next, I'll remake certain parts of the building using more common pieces, like those you might find in your own collection.

The station design is based on one you might find in many small towns across North America. A typical station constructed sometime in the late 1800s or early 1900s might look something like Figure 3-3. Often, these buildings shared common features like sloped roofs, arched entryways, and windows dressed in contrasting colors.

Before building the roof or other details, we need to make the basic building. I'll use a simple overlap technique for the outside walls before incorporating some slopes to complete the roof design.

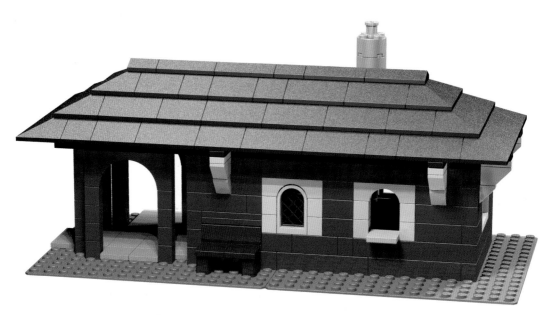

Figure 3-3: Use the design ideas from this building to create all kinds of structures for your LEGO town.

Bill of Materials: The Parts You'll Need to Make This Model

Figure 3-4 shows you the *Bill of Materials* (*BOM*; a list of parts with pictures of each) you'll need in order to build this model. Even if you don't have every piece listed, you can still build the model; just substitute! If you're short on 1×8 bricks, replace each of them with two 1×4 bricks. If you're missing one 2×2 brick in a certain color, stack up three 2×2 plates to do the same job. Use your imagination to substitute one or more elements when necessary.

Step by Step: Train Station Construction Details

Here are the steps for building your train station.

Step 1

Notice the 1×1 bricks to the left side of the building in Figure 3-5. I'm going to use stacking to create very slender columns based on the simple post technique discussed in Chapter 2 (Figure 2-24 on page 29). When I'm done, I'll have created six columns to support part of the roof. On their own, these columns are very weak, but when you use them together, and support them with arches, you'll see they're strong, and they look good too!

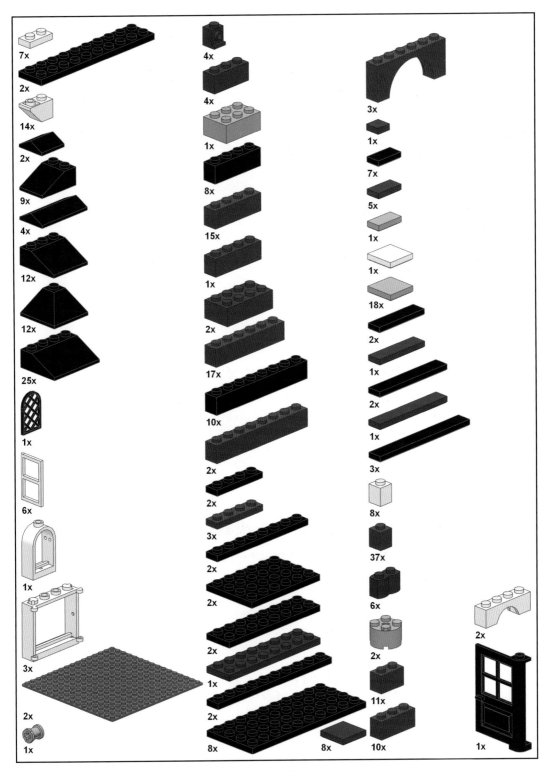

Figure 3-4: The Bill of Materials for the train station model

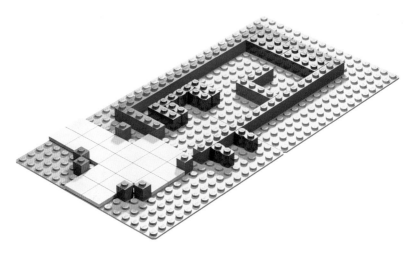

Figure 3-5: Every structure needs a good plan. The layout of your foundation will affect the look of your finished building.

Step 2

Figure 3-6 shows the model after I added the second course of bricks. I'm using overlapping for the main walls and stacking for the columns.

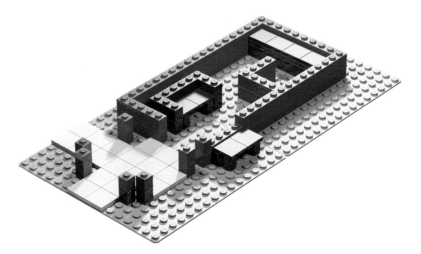

Figure 3-6: Overlapping and stacking techniques used within the same model

I'm using overlapping to create the counter in the station—the L-shaped interior wall near the top right of the model. This wall connects to the outside wall with a 1×4 brick, which keeps the wall from going anywhere when the train rumbles by.

There are three benches. The first is outside the station on two brown 1×2 log bricks. The second, inside the station, has armrests. The third, at the very top, is a long bench seat that minifig children can sit on to watch the trains go by.

It's usually best to add furniture and inner walls early on in the building process so you won't have to take apart the walls or roof to add them later.

Step 3

As the walls and columns rose, I installed the large windows, as shown in Figure 3-7. Plan ahead and decide early on where walls will meet, where windows should be, and which wall gets the door.

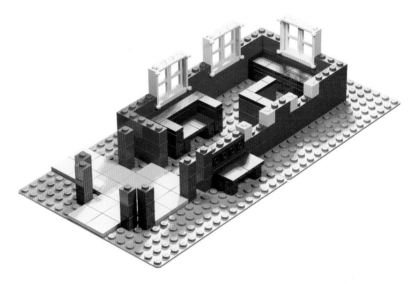

Figure 3-7: The model begins to come to life as the windows are added.

Don't panic if you don't have windows like these. I'll show you how to create simple replacements later in the chapter.

Near the center of Figure 3-7 are four brown studs facing outward, behind the bench. These are four headlight bricks lined up in a row (one of the specialized elements found in Table A-5 on page 183). Each of these 1×1 bricks has a traditional stud on top and one on one side. We'll use them in the next step.

Step 4

Things are shaping up. The door is in place and ready to let minifigs into the station to wait for their trains. I've added a small, arched window with a crisscross latticework screen to the right of the outside bench. The opening to its right is where the ticket agent can serve minifig customers. The 2×2 tile sticking out from this opening is the ticket window counter.

Figure 3-8 shows the completed outside bench. I've covered the fronts of the headlight bricks (where the studs face out) with a brown 1×4 tile, which will be the backrest for the bench.

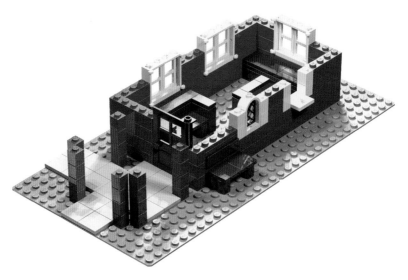

Figure 3-8: Windows and doors add life and realism to your buildings.

Step 5

Figure 3-9 shows how I added 1×6×2 arches to join pairs of columns. Pairs of columns like these can be used to support a roof structure.

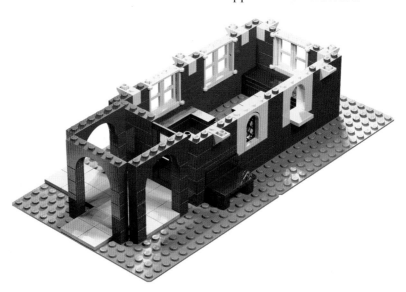

Figure 3-9: The purpose of the 1×1 columns becomes apparent as you add the arches.

With the outside walls almost complete, notice that the two windows at the front now have 1×4 arch bricks above them. These arched windows

give the building a classic look. I'm using stacking on either side of the two arched windows to make it look like there are white frames around the windows. (See the result in Figure 3-3.)

Step 6

Next I added the second set of inverted 1×2 slopes to help create the effect of arched supports for the roof, as shown in Figure 3-10.

NOTE *Although the LEGO system has an inverted half arch (see Table A-6 on page 191), I didn't use it because it would have stuck out past the edge of the roof by one stud.*

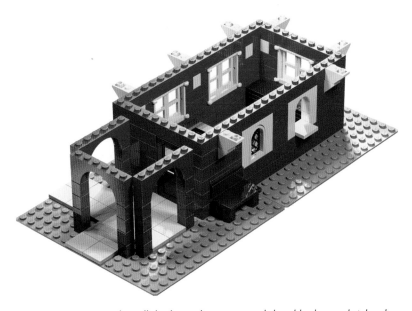

Figure 3-10: Be sure that all the lower layers are stabilized by longer bricks along the top course.

Notice how carefully I've selected the bricks for the top course in Figure 3-10. When possible, try to connect the lower courses of your building by overlapping the top layer across as many seams as possible. For example, look at the red 1×6 brick above and between the two arched windows. This brick is critical to making sure the 1×2s between the windows don't fall out. (Remember, it's okay to stack bricks as long as you add elements to hold them together.)

Another good example of overlap can be seen in the 1×6 that sits over the door to the building. We'll use this brick to hinge the door, but it also connects the walls on either side of the door to each other. That's an important 1×6 brick!

Step 7

A roof at last! Well, at least some of the roof. The black plates on top of the 1×6 arches will become the base of the roof for that part of the station. To prepare for the rest of the roof, I've placed a series of tiles around the top of the main walls, as you can see in Figure 3-11. The reason I used those will be explained in the next step.

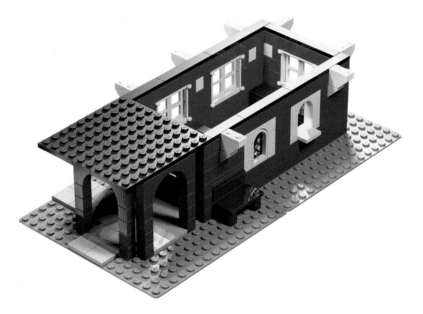

Figure 3-11: The reason for building only part of the roof will become obvious in the next step.

Step 8

More black plates get added above the entryway (Figure 3-12). Those will raise the fixed part of the roof to perfectly align with the removable portion that I'll show you how to build in "Submodel: The Train Station Roof" on page 48. The tiles around the rest of the walls are where the roof submodel will sit, without actually attaching to the station. That's the reason why that section of the roof can easily come off!

Step 9

Slopes make such good elements for building roofs that they are sometimes called *roof bricks*. Here, I've used 33-degree slopes to give the roof a gentle angle. I began the first layer of roof by adding slopes to the plates I added in the previous step. The 1×8 bricks running between the slopes will support the next layer of roof bricks, as you can see in Figure 3-13.

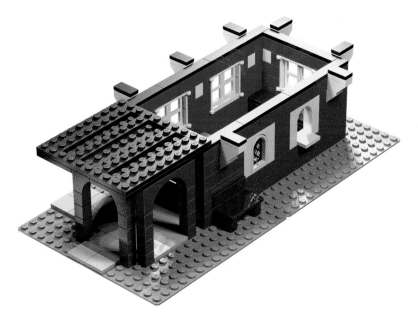

Figure 3-12: Part of the roof and lots of tiles

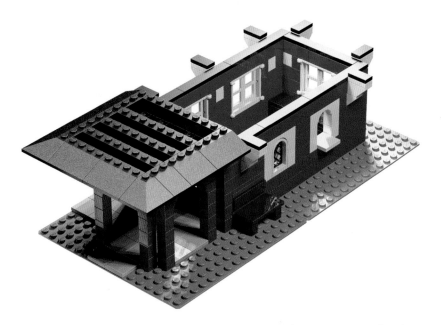

Figure 3-13: The rest of the roof is yet to come. For now, focus on the area directly above the entranceway.

Wait a minute, why only half a roof? I'm creating a nicely sloped and very functional roof but only for part of the station, because I want this project to be something that you can use as a static display or a play set. The tiles along the top of the main walls help create this dual functionality.

Notice in Figure 3-13 that the lowest layer of slopes extends from the sides of the building out as far as the half arches. When I reach the end of the model and reveal the rest of the roof construction, you'll see that although they aren't really attached, the inverted 1×2 slopes *appear* to support the roof.

Step 10

As I added the next layer (see Figure 3-14), I overlapped the slopes, as with the 1×*N* bricks I used for the walls.

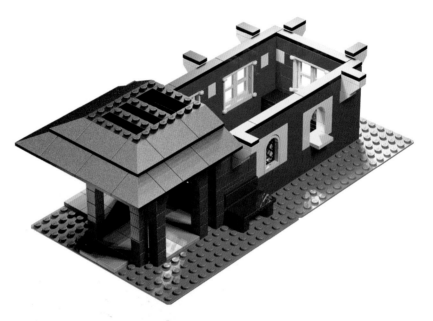

Figure 3-14: The second course of 33-degree slopes

Like the 1×8 bricks in Figure 3-13, the three 1×4 bricks in Figure 3-14 will provide support for the layer of slopes above them.

Step 11

Remember that color isn't everything. Although my building has a black roof, as you can see in Figure 3-15, yours doesn't have to be black. Red or blue slopes will work just as well, and you can change the colors of the walls to match, or not. Experiment with different combinations of colors based on what you have in your collection, or even just on your mood.

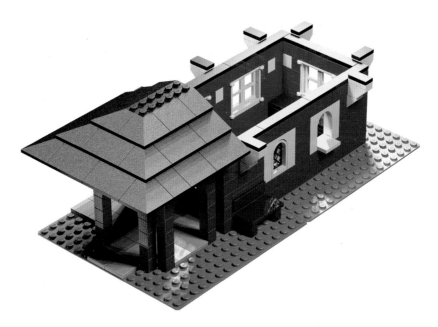

Figure 3-15: Nearly there. The graceful pagoda-style roof takes shape—at least some of it!

Figure 3-16 shows the completed main model. Next we'll build the sub-model that will help complete the main building.

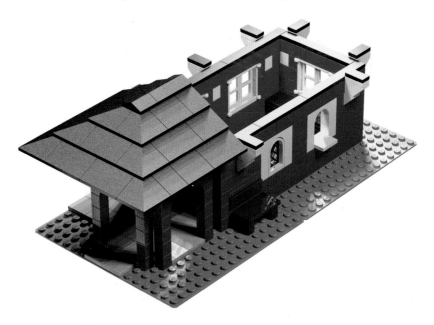

Figure 3-16: Peak elements cap this section of the roof.

A *submodel* is a group of pieces assembled separately from the main model. For example, the wings of an airplane might be a submodel of the airplane body, or the engine might be a submodel of a car. Once you complete the car's body, you add the submodel (the engine). In the case of the train station, I'll build the larger section of the roof as a removable submodel; one that will allow you to access the inside of the building by pulling off part of the roof.

Submodel: The Train Station Roof

Sometimes you'll build submodels to simplify the construction of more complicated models, like a car engine. It's easier to construct all of the little pieces for an engine outside the car, as submodels, and then place them into the main model. Other times, as in the roof, it can help to build separate, self-contained submodels to allow you access to your finished model or to make it easier to take it apart for transport.

Step 1

The roof submodel is as wide as the portion of the roof we built earlier. It's as long and as wide as the opening we left above the main part of the station, as you'll remember from Figure 3-16. The roof submodel will match up perfectly with the main model, covering over the rest of the station to form a complete roof. At the same time, the roof submodel can easily be pulled off, letting you interact with the interior of the station.

As you can see in Figure 3-17, I started with some plates facing studs down.

Figure 3-17: No, your book isn't upside down; the plates are turned studs down.

Step 2

In Figure 3-18, you can see the placement of the next course of plates. (If I had put these plates down first, it would have been trickier to show how to position the next layer.)

Figure 3-18: By starting out with the plates studs down, it's easier to place the first course of plates.

Step 3

Once the first two steps are complete, it's time to turn the plates right side up. In Figure 3-19, you can see that I began adding the slopes to form the angled part of the roof.

Figure 3-19: Flip the plates over, and then add slopes around the edges. The 1×8 bricks in the middle set the stage for the next layer.

Notice that I'm planning ahead here: I'm thinking of the next layer of slopes and how they will overlap the bottom layer of slopes and connect to the 1×8 bricks running through the middle to add strength to the model. These 1×8s provide another form of bracing.

Make the inner five 1×8 bricks any color you want because you won't see them once you're finished. Another example of bracing in action!

Step 4

In Figure 3-20, I added a second layer of roof bricks. I'm using the 1×4 standard bricks in the middle as the 1×8s below them are used: as a support system for the layer to come above them.

Figure 3-20: 1×4 bricks play the same role as the 1×8s below them.

Step 5

In successful LEGO models every layer or substructure works together to produce the final result. For example, in Figure 3-21, you see a 2×3 brick that seems to stick out from the slope bricks in the layer. This isn't a mistake; it sets the stage for pieces I'll add next.

Step 6

Figure 3-22 shows why I added that 2×3 brick in the previous step: It's become a solid platform for the remainder of the chimney. The peak elements added here cover up part of the 2×3 brick and make it look like it's rising from inside the building, just like a real chimney would.

Now you're ready to put this roof section onto the rest of the model. Gravity alone will hold it on; just place it gently on top of the open section of the train station. The result should look like Figure 3-3.

Figure 3-21: Prepare a place for the chimney.

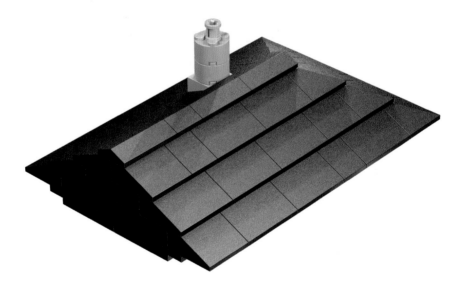

Figure 3-22: The submodel is now complete.

Substitution: When Other Parts Will Do

What if you want to build a railway station like mine, but you don't have all of the pieces? No problem! You can replace certain pieces with more common ones, a design technique known as *substitution*.

Substitution has nothing to do with replacing French fries with mashed potatoes, but it has everything to do with making the best use of your existing LEGO pieces. I'll show you a few examples of substitution in the following sections.

Substitute Walls

Even if your collection comes mostly from assorted buckets, you should have enough basic bricks to make the walls in the original station model design. You may not have exactly the right number of pieces in the same colors, so don't be afraid to swap colors. Grey, brown, or even white would all be good color choices.

Substitute Arches

It's often possible to build an arch from inverted slopes. To do this, you first need to determine the slope, or curvature, you're trying to imitate. To get the right slope, you use a combination of the rise and the span.

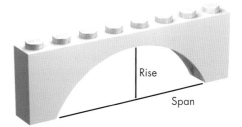

Figure 3-23: The span and rise of an arch

The *span* is the length of a line that runs inside the arch, from edge to edge, as shown in Figure 3-23. The *rise* (also shown) is the distance from this line to the inside center of the arch itself.

When you increase the span of your arch, you widen it, while at the same time dropping its relative height. By the same token, if you increase the rise of the arch, you'll shrink its relative width, unless you increase its span. High, narrow arches are commonly found in doorways or as part of building facades.

Notice in Figure 3-24 that by carefully mixing different slopes, you can make some handsome arches without using a single arch brick. You could also insert standard bricks or plates between the layers of the slopes to increase the rise of the arch without affecting its span.

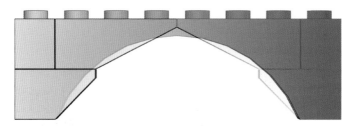

Figure 3-24: A standard 1×8×2 arch is shown superimposed over a composite arch made up of 1×2 and 1×3 inverted slopes. The resulting shape is nearly the same.

Substitute Windows

Sometimes you just don't have enough of the right windows. Fortunately, some simple tricks can give your station its own characteristic windows. For example, in Figure 3-25 you can see that by simulating a small arch (replacing a 1×4 arch element), I've created a look similar to the original train station model in Figure 3-3.

To replace the windows on the sides of the station, try the trick shown in Figure 3-26. It's not perfect, but it's better than no windows at all.

Figure 3-25: You can replace the 1×4 arches used in the original design with inverted 1×2 slopes.

Figure 3-26: Substitutions usually won't look exactly like the pieces they're replacing, but searching for combinations that work is half the fun.

In Figure 3-26, I've put the thickness of a standard plate to good use: I've used three 1×3 plates separated by two 1×1 cylinders. The result is a window that is three bricks high and fits perfectly.

Substitute Roofs

What if you need another way to create a roof? You know that color shouldn't be an issue (if you don't have any black sloped roof bricks, just use red or blue ones), but what if you don't have enough slope bricks? You can use common 2×N bricks to create the illusion of a sloped (if somewhat jagged) roof, as shown in Figures 3-27 through 3-32.

To create a substitute roof, begin by setting down a layer of bricks about the same length and width of the sloped roof. Next, add the second layer, overlapping any point where two lower-level bricks connect, as shown in Figure 3-30. By moving each layer inward by two studs, you can closely simulate the slope we created with the 33-degree roof bricks. Yet another effective use of both overlapping and staggering techniques.

You can use this technique to replace the steps shown in Figures 3-11 through 3-16.

Figure 3-27: These are the same plates you see in Step 7 of the main model (Figure 3-11). Begin building your substitute roof from that point forward.

Figure 3-28: Instead of slopes, use standard bricks.

Figure 3-29: The three 2×4 bricks in the middle will help support the next layer.

Figure 3-30: The second layer is staggered from the first to imitate the slope of the roof.

Figure 3-31: The 2×6 bricks on top hold everything together.

Figure 3-32: The plates overlap and help connect the 2×6 bricks.

You can also create the roof submodel (as detailed in Figures 3-17 through 3-22) using this same technique.

Review: Building Techniques and Alternatives

Our train station model has helped demonstrate some very basic building techniques at minifig scale. You've learned how to apply the overlap technique (Chapter 2), one that you'll use often when you build. Although stacking and staggering are important, overlap generally creates the strongest bonds between LEGO elements.

You've also learned about substitution. Although the substitute roofs, windows, and arches don't look quite as realistic as the "official" version, knowing how to substitute will offer you a lot of building flexibility. While a proper arch brick can only be a certain size and shape, your slope-derived versions can grow or shrink to suit your needs. So although the improvised version of the train station might not win awards for its looks, you can still use it to add character to a LEGO town with just the bricks you have at hand.

Remember that substitution isn't a single technique. It's a way of looking at a model and finding alternative ways to build it using the parts you have available. The LEGO system is remarkably flexible, and as long as you apply your creative abilities, you'll never be stuck with just one way of doing things or just one particular element that you need to use.

4

MINILAND SCALE: THE WHOLE WORLD IN MINIATURE

In 1968, something spectacular happened in Denmark: The LEGO Group opened a unique theme park, called LEGOLAND, not far from its headquarters.

Along with rides and snack shops, LEGOLAND contained an incredible group of LEGO structures in a part of the park that became known as *Miniland*. In the early days, Miniland creations reproduced many famous Danish landmarks and buildings, but as new theme parks opened around the world, all sorts of Miniland structures were built. In Figure 4-1 you can see an interesting scene captured at LEGOLAND in Winter Haven, Florida.

Although miniland scale is used extensively in LEGO parks, you probably won't find any official LEGO sets that contain miniland-scale characters. (Unlike minifigs, which are made up of specialized pieces, miniland people are usually built from common LEGO elements.)

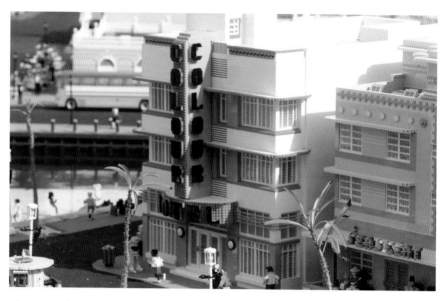

Figure 4-1: The colorful facade and sign of the Colour Hotel help add to the Art Deco feel of this Miami-inspired street scene. The models are part of the Miniland exhibit at LEGOLAND in Florida. (Photo by Michael Huffman)

Miniland Scale: Bigger but Still Small

In Chapter 3 you learned how scale relates to minifig models, which are built at a scale of about 1:48. Most of the miniland-sized models at LEGOLAND are built to a 1:20 scale, meaning that an average character (like the fireman shown in Figure 4-2) is about 3.5 inches tall.

Notice that as the scale value (the number on the right) shrinks, the model size increases. The 1:48 minifig characters are about 1.5 inches high, but the 1:20 miniland figures are more than twice as tall.

When building with minifigs, you can mix and match their torsos with various legs or give them different hairpieces and accessories. But in the end, most minifigs end up looking somewhat similar. When you build your own miniland figures, though, the range of characters you can create is virtually unlimited.

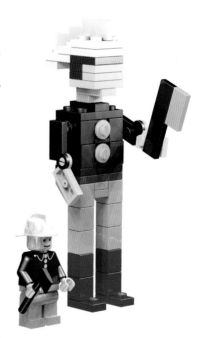

Figure 4-2: A minifig fireman and a miniland version of a similar character. The miniland man is two and one-half times as tall as his smiling minifig counterpart.

Creating a Basic Miniland Figure

You can build miniland figures with an almost endless variety of poses and outfits, but let's start with a no-frills figure (Figure 4-3) to give you a sense of how these little folks are constructed.

The head is square and a bit boring, but we'll add details later to remove some of that blocky feeling. The torso is essentially 2×3 studs, and it's made up of several small pieces. The arms are just 2×2 hinge plates (there aren't really any hands). And the legs are nothing more than standard 1×1 bricks with inverted 1×2 45-degree slopes for the hips.

The Best Bits: Useful Pieces for Miniland Figures

Figures 4-4 through 4-6 show the parts I used to create the basic miniland figure. You may not use each piece in every figure you build, but this should give you a good start.

Small plates, like those in Figure 4-4, are key to creating the details of the head and neck.

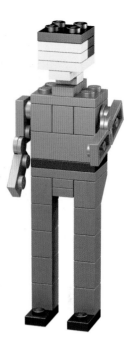

Figure 4-3: Like a department store mannequin, this figure is just waiting to be attired in any number of outfits.

Figure 4-4: Small plates for making miniland-sized heads (from left to right): 1×1 plates, 1×2 plates, offset plates, and 2×2 plates

Technic bricks, like the ones in Figure 4-5, can be used to attach the arms so they can rotate. (The clip plates—used as hands—are optional.)

NOTE *Technic refers to both a series of specialized LEGO parts and complete models. Typical Technic kits are modeled after sports cars, construction equipment, aircraft, and so on. Parts like the 1×2 Technic brick offer a twist on the regular LEGO parts we've been using so far.*

By changing the slopes and bricks you use for the legs, you can create different costumes for your characters. The examples in Figure 4-6 are good choices.

Figure 4-5: Assorted pieces for making miniland-sized torsos (from left to right): 2×3 plates, 2×3 bricks, 1×2 Technic bricks, 1×1 cylinder plates, 1×2 hinge plates, and 1×1 clip plates

Figure 4-6: Various pieces for making miniland-sized legs (from left to right): 1×1 cylinder plates, 1×1 cylinders, 1×1 bricks, 1×2 plates, 1×2 inverted slopes (45 degrees), 2×1×3 standard slopes (75 degrees), and 2×1×3 inverted slopes (75 degrees)

A Basic Miniland Figure

Now it's time to start building your own characters. In Figure 4-7, I show you six easy steps you can use to make a basic figure, and then we'll explore variations on hair, outfits, and poses.

You won't find a BOM for this model, but the elements shown in Figures 4-4 through 4-6 and the images themselves should help you to figure out which pieces you need.

NOTE *In Figure 4-7 I'm adding more than one layer of parts per step. Because this is such a small model, it should be easy to understand these condensed instructions.*

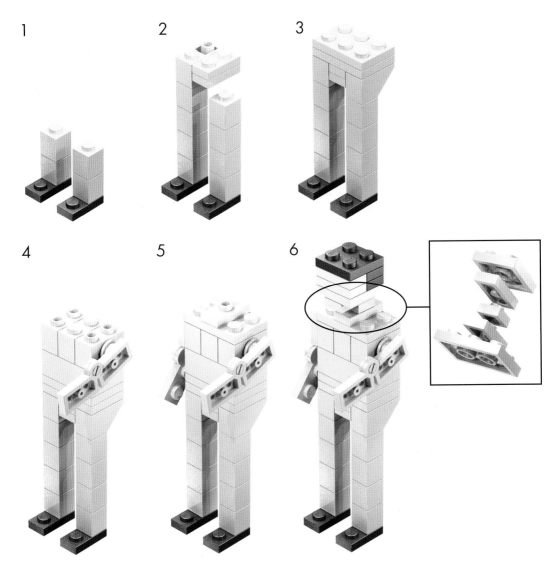

Figure 4-7: Creating a basic miniland character

One cool aspect of the basic miniland figure is that you can pose the arms. The hinge elements shown in Figure 4-7 stick into a 1×1 cylinder plate that's inserted into a 1×2 Technic brick. There is just enough friction between the stud (on the hinge element) and the cylinder plate to hold the arm in position—even straight up in the air!

The head is centered on the torso thanks to a single offset plate.

Creating Characters with Personality

Now it's time to make our character come alive by adding details to the head, arms, and legs, as well as clothing and accessories.

Once you get the hang of building these parts, you can use them in different combinations to create your own world of miniland-sized people, each with a unique personality. Think of these examples as submodels.

Heads and Hats

The faces of miniland people are kind of abstract; they don't really have eyes or a nose. In fact, they're really just a representation of a person, without the hands, movable legs, and detailed faces that you see in the minifig world.

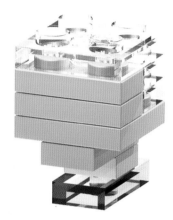

That's why creating a "face" for your miniland person is just a matter of trying to suggest where the skin is located and where things like hair and hats begin. In Figure 4-8, you can see the elements you would use to create the impression of a face and neck. (Use whatever color plates you like to make each character unique.)

Experiment with combinations of plates, cylinder plates, and other parts, like the 1×1 clip plate with studs, to create items like hats and hair for your miniland people. For example, in Figure 4-9, the head in the middle looks like it's wearing a blue baseball cap, while the one on the far right looks like it belongs to someone who's good with a curling iron.

Figure 4-8: The solid yellow elements represent the character's face; the clear elements represent his hair or hat, and perhaps neck. Use different colors of plates to create realistic skin tones for your miniland folk.

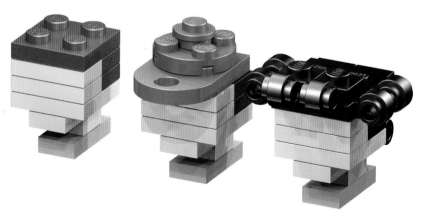

Figure 4-9: A redhead on the left, a capped head, and a head full of curls

Shirts and Skirts

You can give the impression of a miniland person's career or hobby by combining the parts you use for their clothing with the colors you select for them. For example, Figure 4-10 shows three very different outfits that you could use to help populate your miniland world: a soccer referee's uniform, a classy fuchsia cocktail dress, and a plain grey suit suggesting a businessman.

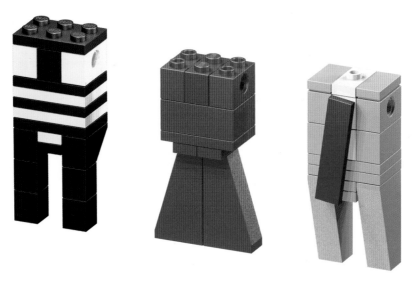

Figure 4-10: Clothes do make the miniland person. Remember that little details and careful color choices can add a great deal of realism and charm.

How do you know that that's a soccer referee's outfit? The striped shirt and black pants are pretty good clues. You might finish this particular character off by adding a cap, like the one in Figure 4-9, and maybe a whistle or flag in the character's hands.

The cocktail dress shows how you can use elements like the 2×1×3 75-degree slopes to create a very feminine look. The slopes are centered under two offset plates, which help give this character a more slender waist. The 1×2 brick at the top can be replaced with a brick that matches the figure's skin color to give the illusion that the dress has an open neckline.

As for the grey suit, don't be afraid to use little tricks like making his red tie off center in order to let the white of his shirt show a bit and to give the impression that he has just rushed off a busy subway car. Little details like these will add *character* to your characters.

Lots of Legs

Figure 4-11 shows some simple variations on the basic leg/shoe design from Figure 4-3.

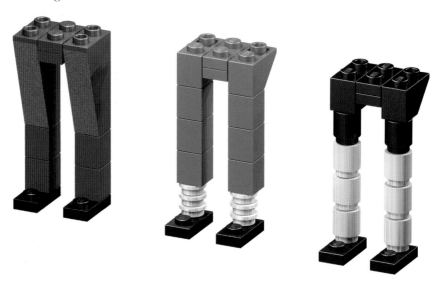

Figure 4-11: Most leg designs eventually create the 2×3-stud base upon which you build the torso.

You can use the design on the left for just about any character who wears long pants. To add a little fun, and make the character a little nerdy, maybe make the pants too short (like the ones in the middle). The legs on the right suggest the legs and cycling shorts of an athletic character who just got off a mountain bike. (Be sure to match the lower 1×1 cylinders with the flesh color you choose for the face and arms.)

Arms and Accessories

By using some simple part substitutions and setting your character's arms at different angles, you can create a wide variety of actions or gestures. Figure 4-12 shows how you might add some life to your characters by adding flair to their arms and hands.

Notice that the figures on the left and the middle both have hands made from 1×1 plates with clips on the side. The character on the right has no hands at all. Instead, I've used offset plates to extend the arms so they hold the binoculars. As you can see, it's more important to achieve the look and feel of the thing you're trying to create rather than to fret over how to model every last detail. The basic miniland character from Figure 4-3 has no hands either, but he looks like a person nonetheless. Keep that in mind as you build.

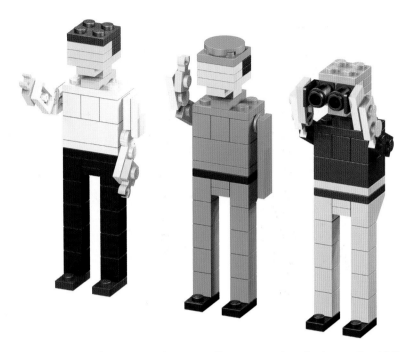

Figure 4-12: Hailing a taxi, saluting an officer, or watching birds—miniland folk can do just about anything you can dream up for them.

On the Run: Making Miniland Figures Come to Life

Now that you know how to model miniland figures and even how to dress them, it's time to learn how to give them the appearance of motion or action. Unlike minifigs, miniland figures have no hinges on their legs, which makes it tricky to make them look like they're moving or doing something. The solution is a matter of selecting elements to give the *appearance* of something that isn't really there.

As you can see in the following examples, the action being undertaken is implied by the position in which you, the builder, pose the figure.

The woman in Figure 4-13, with her arms swinging out from her body, looks like she's walking. (The 75-degree outer corner slopes create the illusion that her long teal dress is moving with her legs.)

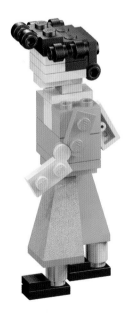

Figure 4-13: You can make a character appear to be walking by simply building the arms and legs slightly ahead of and behind the body.

The character on the left in Figure 4-14 is crouching, perhaps calling a pet or watching his bowling ball roll down the lane. But, if you look closely, he's really not that different from the character in Figure 4-3, shown again on the right of Figure 4-14. To make him crouch, I just changed the black pieces.

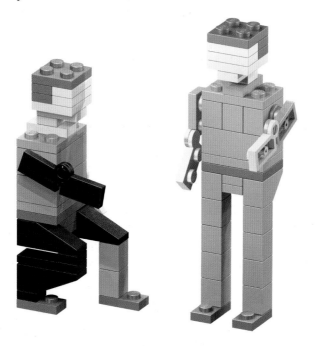

Figure 4-14: The black pieces on the character on the left are the only ones that differ from the pieces I used to build the figure on the right. Changing just a few elements can change a character's entire appearance and make him look like he's doing something completely different.

Miniland Buildings

Perhaps the only drawback to miniland-style creations is that their buildings need to be a lot larger than the ones for minifigs. Large structures use a lot of bricks, and building them can tax even some larger collections, but that doesn't mean that you shouldn't try.

Building Facades

A *facade* is the detailed front of a building that might have plain sides or even no walls or back at all. Movie studios use facades all the time to re-create things like urban street scenes or the main street of an Old West town, and

the only thing behind them is an empty set. Working at miniland scale is a good time to practice creating facades of small buildings rather than building an entire structure.

You can use facades to create a small scene by combining your miniland figures with the facade of a building or two. Focus on just what can be seen from the front; the sides and backs of the buildings are *not* intended to be part of the scene.

Facades work well in miniland scale because they allow you to create taller and wider models with fewer elements than a complete structure would require. In other words, you can create a whole scene without creating a whole building.

Street Life: A Simple Downtown Scene in Miniland Scale

Figure 4-15 shows a simple street scene in front of a small café or shop on a busy downtown corner. You can see a man using the bank machine on the right and a woman about to mail a letter.

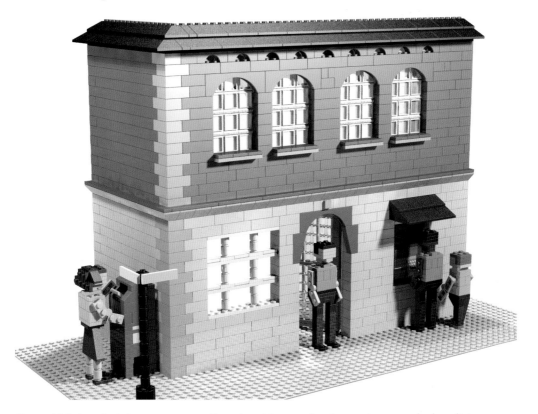

Figure 4-15: A typical downtown scene. Everyday objects and actions make scenes look realistic.

The People in Your Neighborhood

Let's look at the individual pieces that make up this scene, starting with the characters on our street. In the close-up shown in Figure 4-16, notice the child. To create a small figure like a child, just shrink each of the main features of the larger figures (head, body, arms, and legs) proportionately. If you build a child and her legs look too long, they probably are. Just shorten them until they look right.

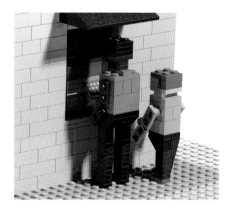

Figure 4-16: Characters doing realistic things add life to your dioramas.

The bank machine is built into the wall of the building. Although it may look out of place on an older building, it represents the kinds of changes that are sometimes made to decades-old buildings as their uses change.

The woman in Figure 4-17 has a letter in her hand that she's about to drop in the mailbox. (Notice that she's wearing a variation on the dress from Figure 4-10.)

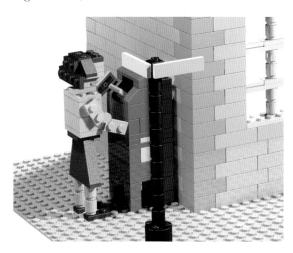

Figure 4-17: Mailing a letter is another everyday activity that you'd see on a real street.

NOTE *Your characters will stand up best when anchored to a baseplate, as shown in Figures 4-16 and 4-17. They might wobble if you just place them on a tabletop or other flat surface.*

Building the Buildings

Now to the building's architecture. Since you'll want your buildings to look as realistic as possible, draw your inspiration from real shops, banks, and schools near where you live. Look at the way stone and brick are used to create walls. Study the windows of buildings, looking at how many there are, where they're placed, and how far apart from each other they are. Larger buildings often have more than one entrance, so don't forget to include enough doors in your scaled-down version. Look for any details you can easily duplicate to add realism, and remember that buildings evolve over time as they're renovated or restored. Don't be afraid to incorporate modern items in a building that looks like it was built in the last century.

Sometimes using a single piece over and over can add interest to your models. For example, the area above the large second-story windows could have been built with plain bricks, but as you can see in Figure 4-18, by using several 1×4 arches side by side, I've created a more attractive pattern.

Figure 4-18: The arches above the large windows could easily be created with inverted slopes if you don't have the actual arch pieces you need. (See Figure 3-25 on page 53.)

The larger 1×8×2 arches above the windows are a dramatic feature that adds flair to the model. As you can see, they are positioned just in front of the many 1×2×2 windows, but they also hide a portion of them.

Behind the Scenes

Remember when I mentioned that facades are only pretty from the front? Figure 4-19 shows our street scene from behind.

In this view, you can see clearly that the building is a facade, pretty much just two walls and a support column. There is no roof or second floor, and the walls are far from complete. See? A facade allows you to concentrate only on how things look from the front and not worry about interior details or even walls.

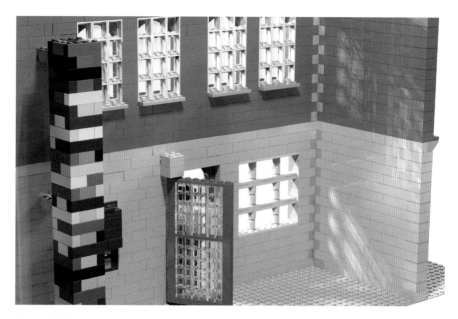

Figure 4-19: A behind-the-scenes peek at the storefront facade

Propping Up the Facade

Now let's look at the building's structure. I've used a column to support the end of the wall that contains the bank machine (see Figure 4-15 for a front view). This sturdy column, linked to the end of the wall, makes an excellent substitute for the side and rear walls that I've left out. Using a single column, instead of an entire wall, can save bricks.

Notice the crazy multicolored construction of the column. Internal bracing or any parts of the model eventually hidden by other parts can be made out of whatever color bricks you have left over—just remember to place these pieces behind a solid part of the facade, rather than behind a window where they will be seen.

In the close-up in Figure 4-20, you can see that the column is *tied* to the wall with a simple beam; it's built into the wall. In fact, that's the only piece connected to the column where color does matter. That beam should be the same color as the outside wall. In this example it's light green. Connecting (or tying) the two structures is just a matter of using a 2×8 or 2×10 brick or even a composite beam like the one from Figure 2-21 on page 27. The beam is built into the column and extended out until it too becomes part of the wall.

The right of Figure 4-20 shows part of both the wall and the column with a few bricks removed from each to show how the 2×10 brick joins the two structures.

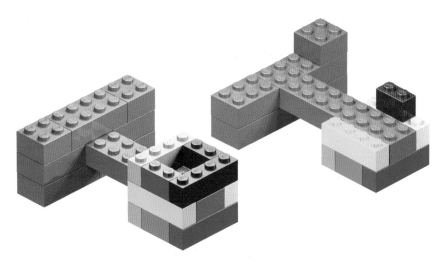

Figure 4-20: A close-up of the column and part of the main wall (left). On the right, the same two structures are shown with bricks removed to reveal how the light green 2×10 brick connects them.

Review: Miniland Scale, Big Possibilities

In this chapter you've seen how unique miniland-scale figures can be created from mostly basic bricks, plates, and slopes. We built a facade of a building at miniland scale and used it to create a street scene with characters going about their business.

In the next chapter we'll look at scale again, but in a completely different way. You'll learn how to make some monster-sized LEGO pieces that look like they've been blasted with an enlarging ray!

5

JUMBO ELEMENTS:
BUILDING BIGGER BRICKS

In Chapter 3, you learned about scale as you created a small-scale train station for a small-scale LEGO town. In this chapter, we'll do the opposite: build a model that's larger than life.

One way to illustrate this technique is to use LEGO bricks to make *jumbo bricks* that look just like the regular LEGO bricks but are many times larger, as you can see in Figure 5-1.

To build a jumbo brick we *scale up* by multiplying the dimensions of the real-life object by a scale factor (as discussed in Chapter 3). For example, in Chapter 3 we said that minifig scale should be around 1:48. That is, models or vehicles in a minifig world are 48 times *smaller* than the same object in the real world. In this chapter, you'll explore *macroscale*, where models might be 10 times larger than real life, like the macroscale brick in Figure 5-1. This macroscale brick is built to a scale of 10:1 or *ten times scale* or 10X.

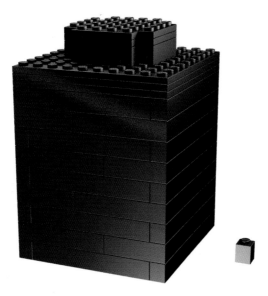

Figure 5-1: This jumbo model of a 1×1 brick dwarfs the
real 1×1 that served as inspiration. It is ten times larger
and stands nearly 4.5 inches tall.

When building to macroscale we multiply each dimension (width, depth, and height) by the scale factor. So in Figure 5-1, the 1×1 brick is 10 studs wide by 10 studs deep by 10 bricks (or courses) high.

Figure 5-2 shows a 1×1 brick scaled up to a factor of 4 (4:1 scale) to make it a little easier to see the relationship between the two numbers that make up the scale. As you can see, it would take four of the 1×1 bricks shown on the left to equal the height of the macro model on the right.

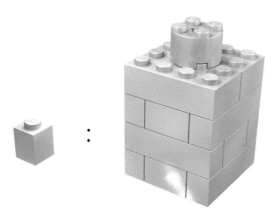

Figure 5-2: Demonstrating 4:1 scale

There isn't much to building a 4X jumbo 1×1 brick like the one on the right of Figure 5-3. In Step 1, build two courses of bricks. Next, in Step 2, add a third layer of 1×2s and 1×4s and then cap the model off with two 2×4 bricks. (To make jumbo bricks look even more like giant LEGO bricks, build them using the same color, like all red or all yellow.) In Step 3, a 2×2 cylinder finishes our model. Sure, we could have covered the studs with tiles, but then we'd have to use more pieces—and by leaving exposed studs on the top of each jumbo brick, we can build with them just like we would with real bricks.

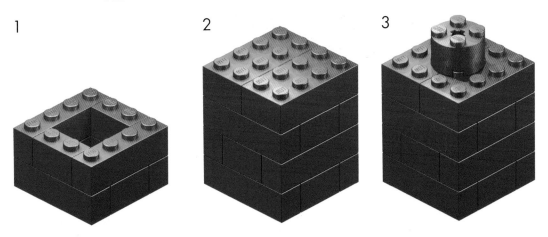

Figure 5-3: Building a 4X jumbo 1×1 brick in three easy steps

How to Scale Up

Now you're ready to build a jumbo brick. We'll build a 2×4 brick to 4X scale by multiplying each of the brick's original dimensions by a factor of 4, as shown in Table 5-1.

Table 5-1: Dimensions for Building a 2×4 Brick to 4X Scale

	Real Brick	Jumbo Brick Model
Width	2 studs	8 studs
Length	4 studs	16 studs
Height	1 brick	4 bricks

This tells us that our model will be 8 studs wide, 16 studs long, and 4 bricks high.

To begin building, lay a foundation layer of 8×16 studs, as shown in the first step of Figure 5-4. (I'm using 1×8 and 1×6 bricks, but you can use whatever pieces you have as long as the result is the same.) Next, build a course on top of the foundation, as shown in Step 2. (Don't forget to overlap as much as possible!) Then build a third layer, as shown in Step 3.

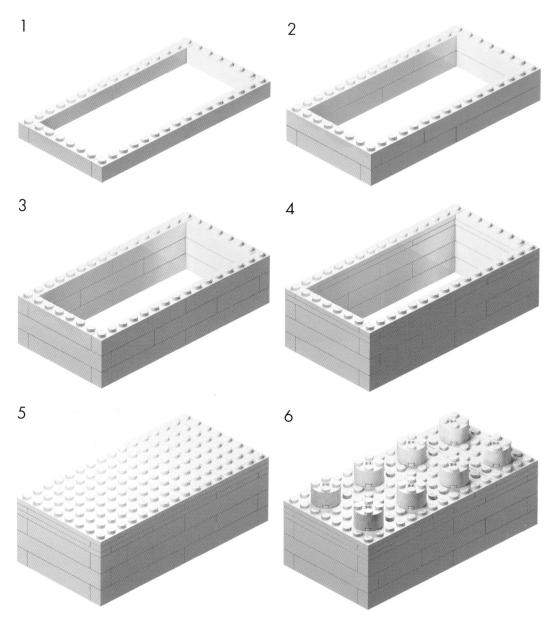

Figure 5-4: Building a 4X jumbo 2×4 brick

For the fourth and final layer, we cover the top of the jumbo brick completely. You can do this either by using two layers of 1×N plates around the top of the model (Step 4) and then topping things off with some 2×8 and 4×8 plates (as I've done in Step 5), or by using just 2×8 bricks and no plates. Finally, you need eight studs on top of this jumbo brick. But where?

Look at an actual 2×4 brick. Notice that the studs are evenly spaced and that they are closer to the edge of the brick than to each other. In fact, as you can see in Figure 5-5, the distance from the edge of a stud to the edge of the brick (A) is only about half the distance between studs (B).

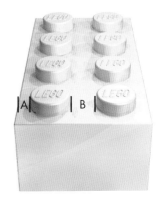

With the dimensions of the studs on a real brick in mind, look at the top of the finished jumbo brick. To make this look more like a real brick, the 2×2 cylinders that we've used for the studs should be one stud away from the edge of the brick and two studs away from the nearest 2×2 cylinder, as shown in the last step of Figure 5-4. In other words, the cylinders, representing the studs, should be twice as far from each other as from the edge of the brick, just like the real studs on the actual 2×4 brick.

Figure 5-5: By studying actual elements, you can learn how to make your jumbo models more realistic.

Our finished jumbo version of the 2×4 brick isn't a perfect copy by any means, but it has the right look and feel, and that's what you're aiming for with macroscale.

Building the Walls of the Jumbo Brick

When we scaled up a 2×4 brick by a factor of 4, we used 1×*N* bricks for its side walls, just like we did with the 1×1 brick in Figure 5-3. Why? Even though the scaled-up 2×4 is bigger than the 1×1, the thickness of the sides of the pieces is the same on each in real life (about 1/16 of an inch), as you can see in Figure 5-6.

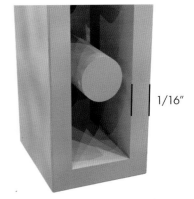

Multiplying 1/16 of an inch by a factor of 4 gives us 4/16, or 1/4 inch. Because real 1×*N* bricks are just about 1/4 inch wide, they're just the thing to make the outer wall of a jumbo brick built to 4X scale.

Figure 5-6: Standard LEGO bricks have walls that are approximately 1/16 of an inch thick.

For the 10X example in Figure 5-1, we used 2×*N* bricks for the walls, but 2×*N* bricks would look really clunky in the 4X version. Figure 5-7 shows 1×4 and 1×2 bricks used in the jumbo brick on the left; the brick on the right uses 2×*N* bricks and, as you can see, the walls are much too thick. In fact, there's no opening at all for a stud, so this is obviously a bad choice!

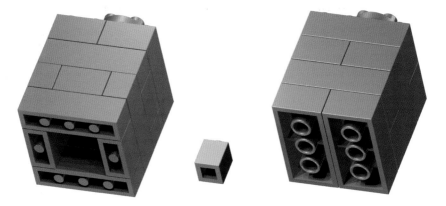

Figure 5-7: One of these things is not like the others, and it might not be the one you think! The version on the right was built with the wrong bricks. It lacks the open core of the jumbo version (left) and the real 1×1 (center).

As you build, you'll constantly be faced with these sorts of decisions. Sometimes it makes sense to do a test build to see if a particular solution will work. By tinkering and experimenting during a test build, you can save yourself a lot of frustration later on.

Other Parts, Same Technique: More Ways to Make Jumbo Bricks

You might be wondering, "Are there parts besides standard bricks that make good jumbos?" The answer is "yes." You can scale up many other LEGO elements. Standard slopes and plates are relatively easy since their geometry is simple, as you can see in Figure 5-8.

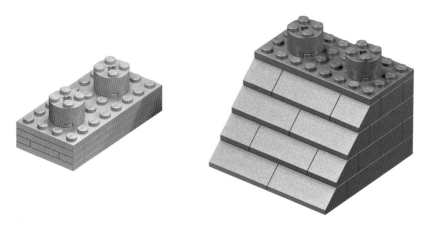

Figure 5-8: A 1×2 plate and a 2×2 45-degree slope

Here's how to make your own plates or slopes as jumbo models.

1×2 Plate: Building Instructions for the Jumbo Version

If you're looking for a small but interesting element to get started with jumbo building, try a 1×2 plate. Then, once you've finished building the large-scale version, hold it in one hand while you hold a real 1×2 plate in the other. The sense of scale becomes obvious when you realize that a tiny piece that you can normally pinch between two fingers is now big enough to nearly cover your palm!

Figure 5-9 shows you how to build a plate in 4X scale.

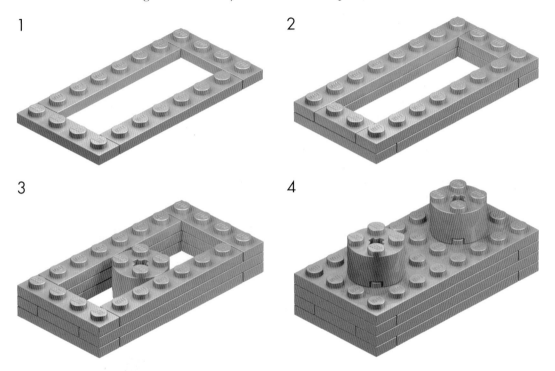

Figure 5-9: Building a 4X jumbo 1×2 plate

The studs on the final jumbo plate model may seem large, but they're built from a fairly common 2×2 cylinder. (If you have 2×2 cylinder plates, you can substitute two of them for each of the 2×2 cylinders to make the size appear more accurate.)

2×2 45-Degree Slope: Building Instructions for the Jumbo Version

When choosing which elements to scale up, keep in mind that you may need large quantities of certain pieces. For example, the 2×2 45-degree slope uses several 45-degree slopes to create the angled side of the jumbo brick, as you can see in the building steps that follow (Figure 5-10). This model requires four 2×2 slopes and six 2×4 slopes. And, as you can imagine, building the same element to a larger scale (10X or 12X) requires many more actual 45-degree elements.

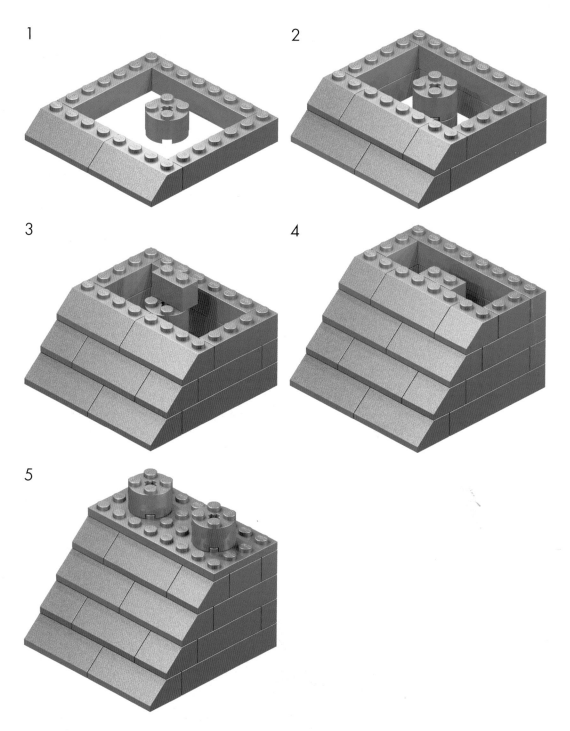

Figure 5-10: Building a 4X jumbo 2×2 slope (45 degrees)

Notice in this example how easy it is to use a 2×2 cylinder to represent the tubes in a brick. The tube isn't hollow, as in a real brick, but the size is perfect.

Building with Jumbo Bricks

You'll find that the jumbo 1×2 plate and the 2×2 slope shown in the preceding pages can connect in almost the same way as their regularly sized versions. The only real difference is the way in which they grip in order to stick together. Normal-sized bricks use the friction between the studs on top and the tubes inside other pieces to lock together, but jumbo elements lock together differently.

Remember when I mentioned earlier that you were leaving the small-sized studs exposed on the top of each of your jumbo elements? That was because it's the normal-sized exposed studs that work to hold the jumbo bricks together, not the studs you built (the scaled-up versions).

This is not unlike the idea of submodels that I talked about in Chapter 3. In the case of building an entire LEGO model out of jumbo elements, you could consider each of the jumbos to be a submodel, so the building process is twofold. First, re-create each individual piece in a jumbo size. Then assemble the set exactly as you would the normal-sized version.

When you put them all together, you end up building a complete LEGO model to jumbo scale, such as the one shown in Figure 5-11. The little plane in the lower right is made from regular LEGO pieces. The larger model is made of jumbo-sized elements (in this case 4X versions) that match each of the pieces in the little version.

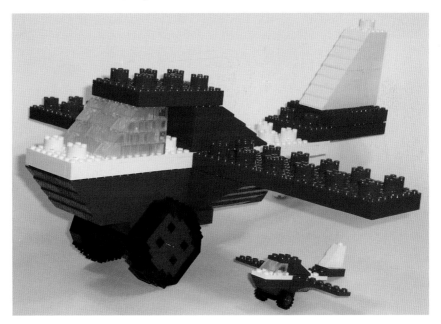

Figure 5-11: The inspiration for this jumbo plane is small enough to fit under its wing.

The Best Solutions from the Simplest Plans

As you work through your LEGO projects, you'll often question the useful-
ness of a particular part in a certain situation. You'll have to choose between
various techniques and decide on scale for building. But no matter what
you build, keep this one principle in mind:

Make things only as complicated as they need to be and no more.

For example, when we used the 2×2 cylinder to represent the stud on
a 4X model (Figure 5-3), we chose to use the minimum number of pieces
required to complete the task and no more.

Other Scales: Which Ones Work and Why

In theory, you can build a jumbo brick to just about any scale you like. In
practice, some scales work better than others.

The smallest scale that works well is 4X, which is why I've used it several
times in this chapter. In fact, most even-numbered scales work well because
it's much easier to center the studs on the tops of elements built to even-
numbered scales. It's more complicated to put studs on top of a brick that
has odd lengths for sides.

Scales such as 4X, 6X, 10X, and 12X (shown in Figure 5-12) all offer
easy solutions for making jumbo LEGO elements. The math is easy to
figure out: For example, at 10X, the jumbo model of a standard brick is
ten real bricks high. A jumbo plate, regardless of which scale you choose,
will always be one-third the height of a jumbo brick at the same scale.
Therefore, a 10X scale plate is three real bricks and one real plate high.
Similarly, at 12X, the jumbo model of a standard brick is 12 real bricks
high, and a 12X scale plate is four real bricks high.

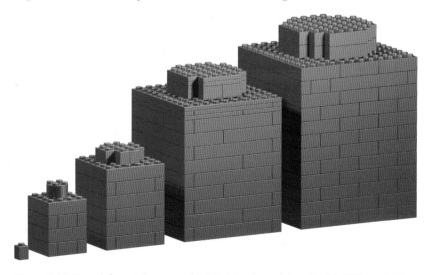

*Figure 5-12: From left to right: a standard 1×1 brick, and the 4X, 6X, 10X, and 12X
jumbo versions*

The other tricky thing about building jumbo-sized studs has to do with finishing off your jumbo-sized elements. You'll need to figure out how to make studs for different scales, since the same solution won't work across the board. For example, at 4X scale you can easily use 2×2 cylinders as studs. But at 6X scale, the 4×4 cylinder is the right shape but not quite tall enough.

For 10X and 12X scales, you will almost certainly find yourself creating studs out of square bricks rather than cylindrical ones. How? By approximating, which you'll learn about next.

Approximation

When building, you'll often find that in order to make your models as realistic as possible, you need to *approximate* certain features to get the look of the original. Sometimes just coming close is enough.

Take jumbo bricks. It's hard to build the studs on each element.

I'll use a 10X-scale stud to demonstrate. But first, turn to Appendix B and follow the directions for printing out a model design grid. Print Design Grid #1, and you'll see that it looks like traditional graph paper. The design grids can be used to create a preliminary sketch of an entire model, or in this case, of part of a model. They're an optional tool, but one that you may find useful at times, especially if you're thinking about buying some extra bricks for a model. Sketching out a design first can let you know if you're ordering the right parts and enough of each.

On your design grid, draw a square to represent the top of a brick, and then draw a circle with the correct diameter to represent the stud. Imagine you're looking down at the top of a 10X jumbo 1×1 brick, like the one shown in Figure 5-1.

Now start shading in squares until you almost fill the circle without really going outside of it. Your drawing should look like Figure 5-13, with the shaded squares not quite filling the circle. This exercise tells us that this example of a jumbo stud will be just a bit smaller than if you could make it perfectly cylindrical.

Now shade in additional squares until your drawing looks like Figure 5-14. This version of the stud is slightly larger than if you could make it exactly cylindrical. Of course, neither technique produces a perfect jumbo copy of the original; we're approximating.

Figures 5-15 and 5-16 show how the two different studs look when we actually build them. As you can see, both techniques will work, so just choose one. Approximation is more about what you *feel* looks best for your particular model than what is technically correct.

Figure 5-13: The small shaded circles inside the larger circle represent the tops of bricks that we'll use to re-create the jumbo stud.

Figure 5-14: In the second example, more real bricks are added. This makes the jumbo stud appear larger than in Figure 5-13. You can use either version.

Figure 5-15: The stud in this example is a bit smaller than the relative diameter of a real stud, but it will work just fine.

Figure 5-16: The stud in this example is slightly larger than the correct diameter, but it will also suffice as a jumbo stud.

Review: Jumbo Bricks Are Just the Beginning

You've built a few jumbo bricks, and you understand the concept of macro building. When it comes to building using the jumbo technique, only one rule really applies and it has to do with choosing the subject of your macro models:

Start small and don't build too big.

First, try re-creating *other* elements you have in your collection. For example, you might build a 1×1 headlight brick or see if you can build the texture on the face of a 1×2 grille brick. (See Appendix A for illustrations of these and many other pieces.) Pick pieces that you find interesting and that you know you'll enjoy seeing in large scale. And remember to try smaller elements first. Don't try building a 1×16 Technic brick right away; try a 1×1 first to see if you can figure out how to make the hole appear round.

Regardless of the scale or subject matter you choose, you'll find that jumbo bricks are eye-catching and fun to build.

6

MICROSCALE BUILDING: MORE THAN MEETS THE EYE

In Chapter 5, I showed you some *macroscale* building techniques that you can use to make models much larger than real life. In this chapter you'll learn how to build things that are smaller than real life using a technique called *microscale* building.

If you've got a limited supply of LEGO bricks, or if you build in a confined space, microscale might work well for you. You'll still be able to create interesting models, but they'll use fewer pieces than larger versions and take up less space—sometimes a lot less space. Just 7 inches long, the microscale cargo ship in Figure 6-1 captures many of the details of the real thing, including shipping containers, the bridge, and a smokestack.

In order to standardize the scale for microscale building, some LEGO builders have decided to use a 1×1 cylinder to represent the size of a person within the microscale world. In other words, one brick in model height equals roughly 6 feet in the real world.

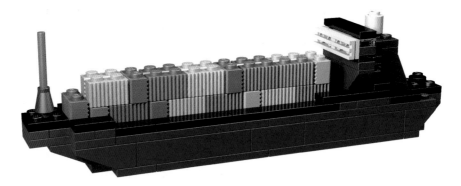

Figure 6-1: Microscale works well when the real-life inspiration is huge.

In fact, the actual scale of microscale building can vary from model to model, but the principle is always the same: Microscale models are extremely small versions of very large things.

Getting Started: Ignore the Details

In Chapter 5, we discussed *approximation*: the building method that gives things the look and feel of real life without necessarily duplicating every detail. That same principle can apply to microscale models. Just look at the thing you are modeling and try to see only the characteristics that stand out the most.

But how do you do that? Let's use the Empire State Building as an example. If you tried to create a minifig-scale version of the Empire State Building, it would have to be more than 26 feet tall! (Minifig scale is about 1:48. Because the real building is 1,250 feet tall, you would divide that number by 48 and end up with 26.04 feet as the height of your model.)

Most people don't have enough LEGO bricks to tackle a project that big, but just about everyone has enough bricks to build a microscale version, which requires far fewer bricks. You'll just need to leave out details like windowsills, decorative statues, and signs because you won't find bricks small enough to create those details.

One reason that the Empire State Building is relatively easy to build in microscale is that it has a recognizable shape. Bringing it to life in microscale involves re-creating that shape with as few elements as possible. Remember, you're trying to achieve the *feeling* of the real thing, not building an exact replica.

To begin building a microscale model of the Empire State Building, I first sketched the shape of the building on graph paper, as you can see in Figure 6-2. I based my drawing on some images of the actual building that I found on the Internet.

For this next example, I've used one of the model design grids (see Appendix B). This is graph paper with lines drawn to the same size and shape as real LEGO elements. Notice that I've drawn only the outline of the building in this first sketch. The silhouette is the most important part of this model, so I've essentially left out all the details.

How did I know how big to draw my sketch? I didn't. I just guessed, though I knew that I wanted to make it fit on one page or less.

If you find that your first few drawings are too large or too small or that they don't capture the profile you want, don't give up. Make a second or third sketch, and your plan will likely improve each time.

Next, I began adding the major details, as you can see in Figure 6-3.

Figure 6-2: A rough outline of the building

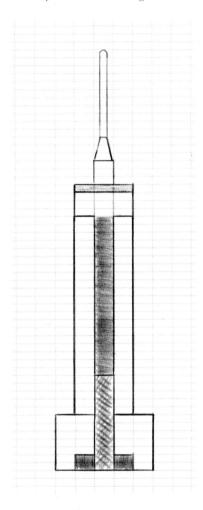

Figure 6-3: I've sketched in the main features of the building.

Here, I've drawn in the main entrance, shaded an indent near the top of the tower, and added the shape of the channel that runs vertically up the center of the building.

Notice that I've used different shades of pencil to represent different parts of the building. In some cases, this is to remind me that even though this is a two-dimensional drawing, it's the plan for a three-dimensional model. I shaded certain areas darker to remind me that they will be closer to the back of the model, like the center channel that runs up most of the building. (I'm not too careful about how my lines meet or how each area is colored in. This is just a sketch; it isn't meant to be perfect.) Finally, as you can see in Figure 6-4, I added some boxes to suggest windows.

Interestingly, this model really does look good in light and dark grey. The simple two-tone effect is just what I'm looking for.

Translating Ideas into Bricks

Now that we have a drawn plan, how do we make this a LEGO model? As you look at the drawing, remember that the main idea of microscale building is to make something as small as possible but still recognizable. Remember, too, that each of the boxes (or cells) on the

Figure 6-4: The blueprint for my micro marvel

design grid is the same height as a standard 1×1 plate. Therefore, three boxes are the height of a standard 1×1 brick (see Figure 6-5).

To me, the bottom left and right corners of my sketch (Figure 6-5) look a lot like 1×1 LEGO bricks. Using this relative measure, I can quickly figure out which bricks and plates to use to construct the rest of the building. As you can see in Figure 6-6, I've put some light and dark grey plates on my sketch to try out the elements I'll use to build the real model. Although these may not be the exact pieces I'll use, they give me a sense of which *types* of elements I'll need.

Figure 6-5: A portion of the blueprint showing how a 1×1 brick compares to the design I've laid out

Figure 6-6: A comparison between actual elements and the partial plan for the model

Notice in Figure 6-6 that I have represented only some of the windows, and even then I've used only dark grey plates to give the feel of windows. As I continue to match the sketch with appropriately sized elements (based on the 1×1s I started with), it doesn't take long for a little building like this to come together as the finished model shown in Figure 6-7.

Notice that this model is constructed almost entirely of plates. You won't build every micro model out of plates, but in general, the smaller size of plates offers you greater creative control at microscale.

Of course, you may not have the right number of light and dark grey plates to make this replica of the Empire State Building, but don't let that stop you. Try building one from bricks alone to see if you can match the shape. Or try using other colors to come up with your own version.

NOTE *You can find complete instructions for both the cargo ship in Figure 6-1 and the Empire State Building in Figure 6-7 at* http://nostarch.com/legobuilder2/.

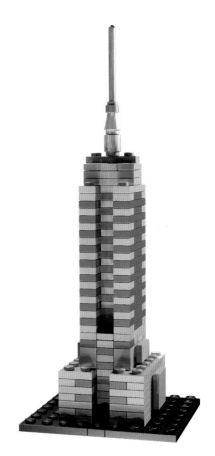

Figure 6-7: Real life brought down to size—micro size!

Reviewing the Technique

When building microscale models you'll follow three simple steps:

1. **Sketch out the object's edges.** Identify the outline of the object you're building and ignore the details to get the basic shape.
2. **Identify the features.** Look for major features, especially interesting shapes or patterns that help give the object its characteristic look.
3. **Discover the details.** Choose some of the object's finer details to model. Be careful to select only things that are critical to its overall feel.

You don't really need to use paper and pencil to work out the design of your model. Sometimes you'll find it more fun to just dig through your LEGO bricks and work through the steps with the real elements in your hands. When you make mistakes, take things apart and rebuild. And look for those mistakes that actually end up being better solutions than the ones you originally had in mind. Whether you decide to plan your model with paper and pencil or choose to jump in and start building, the benefit is that you are thinking in three dimensions and solving problems as you go.

Replacing Full-Size Parts with Microscale Stand-Ins

Now for a couple more microscale techniques. In this section we'll look at two different classes of parts (wheels and windows) and learn how to simulate them at microscale.

Microscale Wheels

Most LEGO wheels are the appropriate size for minifig or miniland scale, but they are much too large for microscale. As an alternative, try using 1×1 cylinder plates turned so that they are sitting on edge, as shown in Figure 6-8.

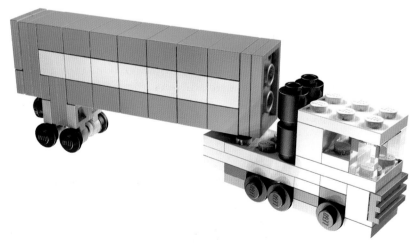

Figure 6-8: A simple microscale truck with 1×1 cylinder plates for wheels

The transport truck shown in Figure 6-8 shows not only how to create microscale wheels but also how to turn bricks on their sides to create certain shapes or patterns. See how I've created a white stripe down the length of the trailer?

The trailer portion of the truck is created by stacking 1×2 bricks on top of each other. Those stacks are then sandwiched between 2×3 plates. The entire trailer section is then turned so that the studs are facing the back of the vehicle.

Microscale Windows

Like the wheels, many LEGO window elements just won't look right as windows at microscale. You saw that I used plates as windows in the Empire State Building earlier in this chapter. For models based on smaller buildings, you can use something like the 1×1 headlight brick with its side stud facing inward to create a window. Several of them placed together create the impression of a picture window in the house shown in Figure 6-9.

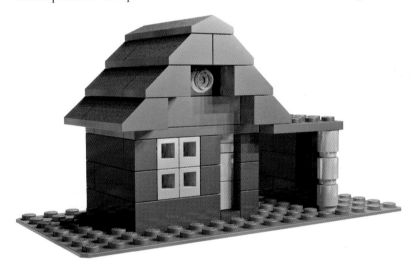

Figure 6-9: This house is much too small for minifigs but just right for a microscale suburbia.

Notice that the door to the house is merely suggested by the white area to the right of the windows. This is really just another example of the technique I used to suggest the windows for the Empire State Building. Sometimes a change in brick color or depth is all it takes to give the illusion that a particular feature exists when it really doesn't.

Instructions for Building a Microscale House

The little house shown in Figure 6-9 is a simple model you can probably build from pieces in your collection. Figure 6-10 shows the Bill of Materials for this micro-mansion. This is followed by a series of figures (Figures 6-11 through 6-16) that show the building steps.

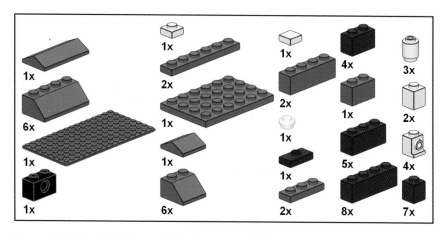

Figure 6-10: The Bill of Materials for the microscale house

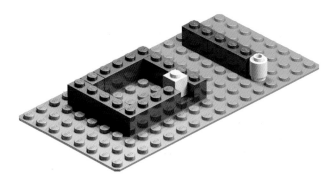

Figure 6-11: Step 1. The white 1×1 brick sits on an offset plate, in what will become the doorway.

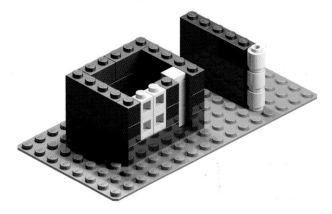

Figure 6-12: Step 2. Install the front windows, which are 1×1 headlight bricks facing backward.

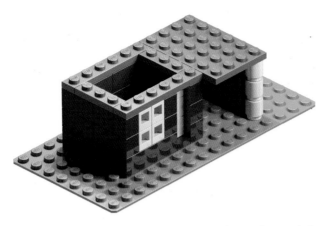

Figure 6-13: Step 3. Place a 1×6 plate near the top front to help hold the windows in place.

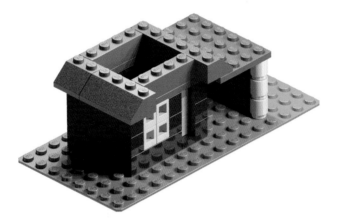

Figure 6-14: Step 4. Start the roof. The slopes on the left should hang over the edge of the wall.

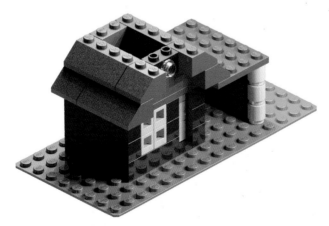

Figure 6-15: Step 5. Place the 1×2 Technic brick in the top center and attach a transparent 1×1 cylinder plate.

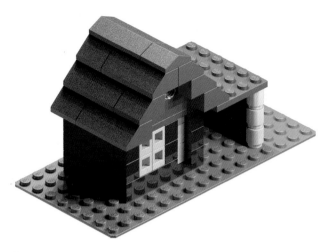

Figure 6-16: Step 6. Complete the roof with a couple of handy peak elements.

Review: Things to Build in Microscale

When building in microscale, you may find it best to pick objects that are naturally very large for your models, like a car, a skyscraper, or even an aircraft carrier. Here's a short list of things that might make good subjects for microscale building:

Automobiles

Trucks

Buses

Locomotives

Train cars

Spaceships from movies

Stores or a mall

Construction equipment

Hotels

Castles

Monuments

Houses

Apartment buildings

Dinosaurs

Zoo animals

Amusement park rides

Skyscrapers

Pyramids

Ships

Aircraft carriers

Bridges

Of course, these are just suggestions, and like everything else in the LEGO system, there are no limits to how you apply your own imagination and creativity. Microscale building is an excellent technique to explore when your collection of LEGO elements is limited in size. As you've seen, this restriction doesn't have to limit the scope of your microsized LEGO world.

7

SCULPTURES: THE SHAPE OF THINGS TO BUILD

How can you make a bunch of square bricks look round or oval? And how do you make them look like a dinosaur or the face of your favorite uncle? The trick lies in the way that you combine them, and that's the idea behind sculpting with LEGO bricks.

LEGO sculpting is different from other forms of building in that your primary goal is to re-create a specific shape or shapes, like a globe, the head of a large-scale minifig, an animal, or even part of a building or vehicle, as realistically as possible.

In this chapter you'll learn how to sculpt a basic sphere (a ball-shaped object) like the one shown in Figure 7-1. Once you've mastered that technique, I'll show you how you might use these "curved" shapes when sculpting other natural shapes.

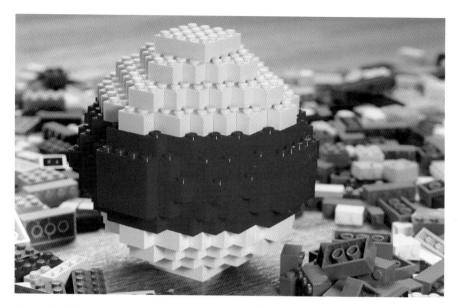

Figure 7-1: This sphere is modeled in three colors. The following instructions illustrate a slightly different color scheme. You can use any combination you like, be it just one color for the whole sphere or different colors for each layer.

Spheres: Round and Round They Go

Let's build a very basic sphere using only standard bricks—no plates, slopes, or other special elements—like the one shown in Figure 7-2. *The method for producing a sphere is the same whether you're building one the size of a softball or one as big as a basketball.*

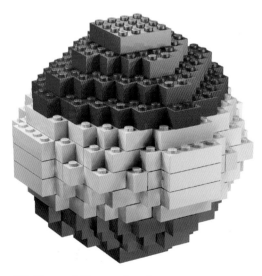

Figure 7-2: The goal: This simple sphere contains only 220 bricks, but you can use the same basic technique to make much larger ones.

The roundness of a LEGO globe or ball depends mostly on how big you build it and how many small plates you add to the mixture of parts. The larger your model, the more rounded it's likely to appear, and you can use plates to fill in some of the square corners to add to its roundness. The sphere we'll build isn't very big (or very smooth), but it's made from only 220 basic bricks. No matter how big or small your LEGO collection, you probably already have the pieces you need to build it right now!

The sphere in Figure 7-2 uses only full-height bricks, which, as you can see, produces a somewhat blocky-looking sphere. But no matter—our goal isn't to create a perfectly smooth ball but rather to demonstrate the technique. The Bill of Materials for this project is shown in Figure 7-3.

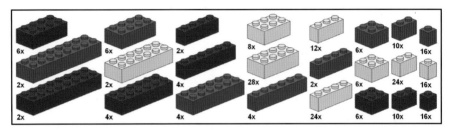

Figure 7-3: Bill of Materials for a basic sphere. This design uses common bricks and not even a whole lot of them!

Dividing the Building Process in Two

One of the most common ways to build a sphere is to divide the build into two parts: the top and bottom halves of the model. You start at the middle, work up to the top, and then go back to the middle and build down to the bottom. Figure 7-4 shows what I mean about starting your build in the middle.

Start building at the center of the sphere, laying down a jagged ring of bricks at the widest point of the model. Then begin the second layer using the stagger technique we learned in Chapter 2, setting one layer of bricks back from the front edge of the previous layer to produce a stair-step pattern.

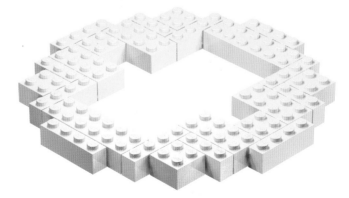

Figure 7-4: Step 1. The first layer of bricks is really the middle of the sphere.

I've added just one more layer in Figure 7-5 and, as you can see, the sphere begins to evolve very slowly at first. It doesn't look like much right now; in fact, the second layer isn't that different from the first. But if you look carefully at the bottom of the figure you can see that *some* studs from the first layer aren't covered by the second layer. By staggering the build you've begun the sculpting process.

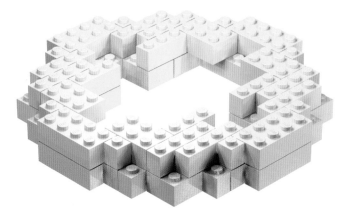

Figure 7-5: Step 2. The second layer is staggered, leaving some studs of the first layer exposed.

In Step 3 (Figure 7-6), you add a third layer, again exposing studs from the previous layer.

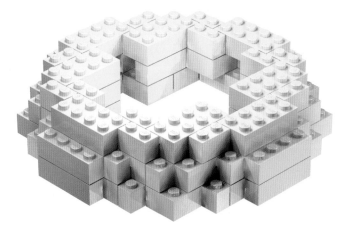

Figure 7-6: Step 3. Each layer requires fewer bricks and continues to recede from the layer beneath it.

The model still doesn't look much like a sphere at this stage, but keep staggering the layers as you build to create the appearance of a rounded shape, as you'll see in the next three steps (Figures 7-7 through 7-9).

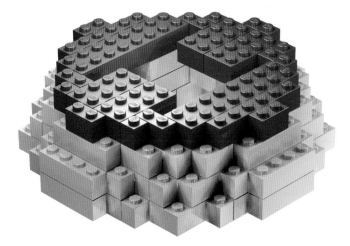

Figure 7-7: Step 4. Here we're beginning to close in the top of the sphere.

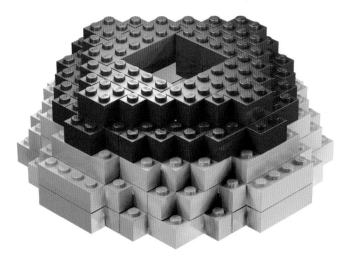

Figure 7-8: Step 5. Although the sphere is made up entirely of standard rectangular bricks, it is beginning to look a bit more rounded.

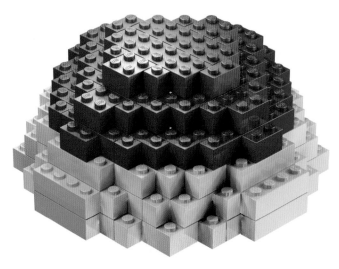

Figure 7-9: Step 6. The sphere is now closed but you're not quite to the top yet.

When you reach the last layer of the top half of the sphere, cap it off with just two 2×4 bricks, as shown in Figure 7-10.

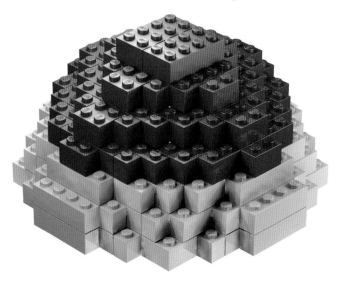

Figure 7-10: Step 7. Two 2×4 bricks cap off the top of the sphere.

In Step 8 you simply rotate the top half of the sphere 180 degrees until it looks like Figure 7-11. This is called a *rotation step*. You're now looking at the bottom of the first layer that you built in Step 1.

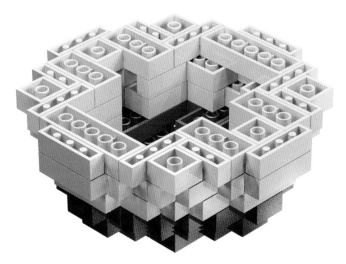

Figure 7-11: Step 8. Before you start the second half of the model, turn the top half over so that the tubes are facing up.

Build the bottom half of the sphere on top of this flipped top half. That works well for a small sphere, like this one, but if you're building a larger sphere, like a globe of Earth or a life-sized soccer ball, you might try building the top and bottom halves separately from each other. Once each half is complete, you can set the upper half on the lower half and carefully press the two together.

In the next five steps (Figures 7-12 through 7-16), we basically repeat the earlier steps, just upside down.

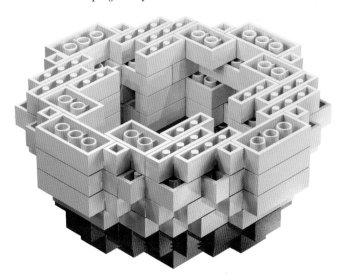

Figure 7-12: Step 9. You're still staggering bricks, just upside down.

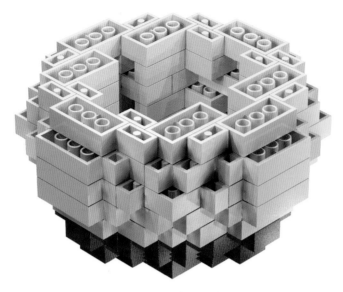

Figure 7-13: Step 10. Staggering also involves a bit of overlapping.

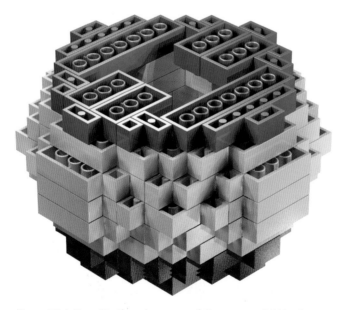

Figure 7-14: Step 11. Place layers carefully on a model like this. Your staggering gives the sphere its shape.

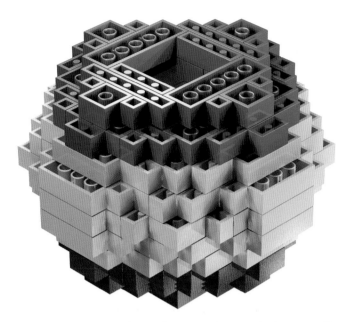

Figure 7-15: Step 12. The small opening that remains is square. Time to fix that.

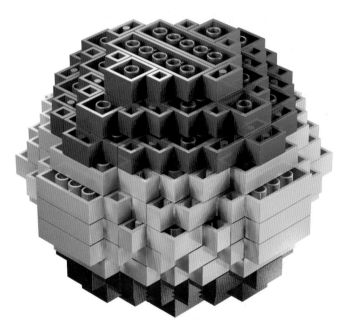

Figure 7-16: Step 13. Close in the bottom with the same combination of pieces you used in Step 6.

Add the final two pieces in Step 14 (Figure 7-17).

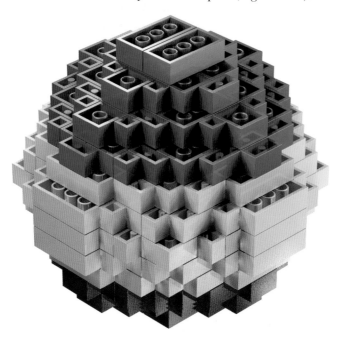

Figure 7-17: Step 14. Once again, 2×4 bricks give the finishing touch.

Now here's something interesting: Compare the two 2×4s on the top of the sphere (Figure 7-10) with the two on the bottom (Figure 7-17). Exactly the same, right? Now compare them with the flat areas on the "sides" of the sphere, as shown in Figure 7-18.

Figure 7-18: Comparing the size of the top layer with the smallest areas on the sides of the sphere will help you get a sense of just how "round" you've made your sculpture.

Two 2×4s are *almost* the same size as those flat areas along the sphere's middle, which confirms that your sphere is the right size and shape. Their equivalent size helps to give the sphere its rounded appearance even though it's built entirely of blocky bricks.

Sculpting Other Subjects: The Sphinx

You've learned how to sculpt a simple sphere using the stagger technique, but what if you want to sculpt an animal, a statue, a cartoon character, or even an extraterrestrial born in your imagination? How about sculpting the famous Great Sphinx of Giza, like the model in Figure 7-19?

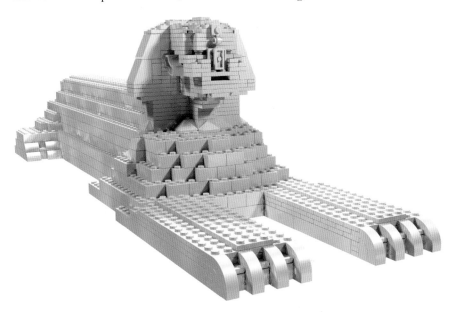

Figure 7-19: The Sphinx combines the head of a pharaoh with the body of a lion.

As with the Empire State Building example in Chapter 6, the first thing I did in preparation for building the Sphinx was search the Internet for pictures of the real-life Sphinx. I didn't use design grids to plan its construction; instead, I began to build and modified my work as things progressed. (You could use grids to help plot your design, if you like.) Besides the fact that it's famous, I selected the Sphinx because it's relatively simple to build with LEGO pieces and it's just one color (tan), so I could concentrate on the shape as I built rather than on color selection. In contrast, a sculpture of a knight riding a horse would have been much harder to build, due to the larger number of shapes, curves, and angles.

Choosing an Identifying Characteristic

Remember that when building from real life it helps to identify a unique feature of the object you're using for inspiration. In the case of the Sphinx, most people recognize its humanlike head with a pharaoh's headdress. I chose this as my starting point, built the head until it looked correct, and then created a body to match. You might choose another identifying characteristic, like its body (a form based on a lion at rest), and work upward from there.

Building the Head

When building the head, I first looked at the angles that make up the headdress because the headdress is such a strong feature.

The sides of the headdress slope at about 55 degrees, which is close enough to the 65-degree standard LEGO slope. After selecting my pieces, including slopes, I began to build.

Figure 7-20 shows the Sphinx's head starting to take shape. As the sides of the head began to rise, I built outward to capture the entire face. I couldn't build a flat face because sculptures need to look right when viewed from all sides.

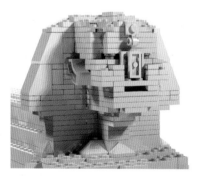

Figure 7-20: The head and headdress of the ancient statue

Figure 7-21 shows the head rotated 90 degrees to show the face coming to life. The face isn't perfect, but this is a relatively small model, and trying to duplicate every detail is very difficult.

Techniques for Building Special Features

The real-life Sphinx has several unique features, each of which presents its own building challenges. Here's how I chose to tackle these challenges.

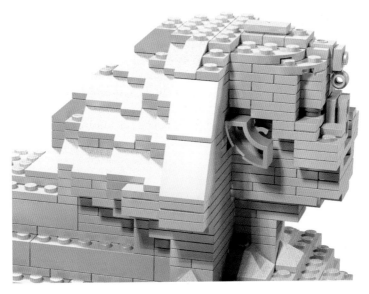

Figure 7-21: Sculptures of faces challenge you to think in three dimensions.

The Nose

The nose is missing on the real-life Sphinx, and I wanted to capture this interesting quirk. Figure 7-22 shows how I accomplished this: I used plates with their undersides facing outward to give the impression of uneven stone where the nose was once attached to the statue.

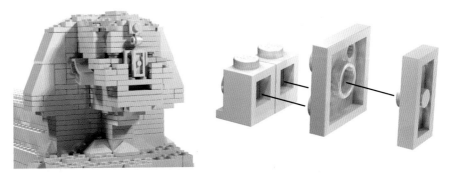

Figure 7-22: Note the unique ways each piece connects to the others. The three pieces on the right join together to become the nose, as shown at left.

This design takes advantage of the unique geometry of LEGO studs and tubes. The offset plate (at the far right in Figure 7-22) fits perfectly into the tube of the 2×2 plate next to it. The plate, in turn, fits snugly into the open sides of the headlight bricks.

The Ears

The ears are another example of how you can build with rotated LEGO elements. For example, Figure 7-23 shows a 2×2 macaroni brick with its underside facing away from the side of the head. The curved shape of this element helps add character to the face of my Sphinx model.

Figure 7-23: A close-up view of the ear shows how the pieces attach to the side of the head.

The Paws

The Sphinx's large paws are mostly rectangular but do have some curved toes at the end. To create these curves, I tucked a 1×2 half arch under a 1×3×2 half arch (Figure 7-24) to represent each toe. As you can see, the smaller of the two parts nests perfectly under the larger half arch, creating a less blocky appearance.

Figure 7-24: Curved pieces like these half arches are pleasing to the eye and add character to this otherwise rectangular section of the model.

The Headdress

Figure 7-25 shows the way the headdress blends into the body. I didn't get the look I wanted on my first attempt, and you may not either when you work on your own sculptures. Don't be afraid to take parts off a model, move them, or swap in new parts until you have sculpted the shape you want.

Figure 7-25: Building the back of the headdress was an exercise in sculpting with slopes. I didn't follow any hard-and-fast rule; I just kept adding and removing slopes, changing the type of slope I was using, and worked at it until I got the natural look I wanted.

Building the Foundation Last

There will be times when you'll want to start building a model from the bottom up, like when you're creating buildings.

For my Sphinx model, I chose to do the opposite: I built the head first to make sure my replica looked the part, and then I built a body to match the head. With the head complete, it was easiest to work on the shoulders next, then the back, and finally the legs. When building down from the neck, I found it easier to make the body match the scale to which I had built the head. Since I wasn't too concerned with building a perfect representation of the real-life Sphinx, I didn't need to work out the exact scale, like we did for the train station in Chapter 3.

As I built the lower body and legs (see Figure 7-26), I returned to the pictures of the Sphinx I found on the Internet. Images of real-life objects, buildings, vehicles, and so on can be enormously beneficial when you're building LEGO models. If you have a chance to see the real thing that you wish to build, take photographs. Capture the subject in a wide shot and get close-ups of details and features that you want to replicate. This research technique is used by Master Builders who work for the LEGO Group. Why not use it to make your work more realistic and natural?

Figure 7-26 shows the completed Sphinx model. Notice that I decided to leave some areas of the model uneven; not every edge is perfectly square. This was my attempt to evoke the erosion of the actual Sphinx.

Figure 7-26: The body of my Sphinx is basically a box shape with staggered sides. It's the head and face that really bring the sculpture to life.

Review: Sculptures Are in the Eye of the Builder

When sculpting real-life objects, remember to look for edges that can be rounded by either staggering bricks (as in the sphere) or by using slopes. Also keep in mind that things like faces, statues, or mountains may not be completely symmetrical; one side or another may be shaped slightly differently than the others. Reproduce some of that organic quality to add depth to your creations. As you've seen, I built the Sphinx using trial and error, focusing on its overall *look* and *feel* rather than strictly following a blueprint. On the other hand, the sphere required careful planning to produce a precise shape. You'll probably find that you'll use a bit of both techniques to build sculptures, depending on your subject. In the end, the way that you sculpt and your results will reflect your vision of each model. It's up to you to decide whether your model is a successful build.

8

MOSAICS: PATTERNS AND PICTURES IN BRICKS

The term *mosaic* describes artwork consisting of patterns or pictures created with tiles, bricks, glass, or even stone, like the example shown in Figure 8-1. As you'll learn in this chapter, LEGO pieces are a perfect medium for creating mosaics.

LEGO elements offer you two ways to create mosaics. The first, *studs-out*, is formed by attaching smaller bricks or plates (often 1×1s or 1×2s) to a baseplate with their studs exposed, or "out," like the mosaic shown in Figure 8-2.

Studs-out mosaics tend to look blocky, but they're fairly easy to plan and build. I'll show you a couple of simple ways to turn an image into a mosaic in "Creating Photo Mosaics" on page 117.

Figure 8-1: A Roman-style mosaic made of stone pieces. You can find similar patterns on the Internet to use as inspiration for mosaics you can make out of LEGO elements. (Photo by Photos8.org)

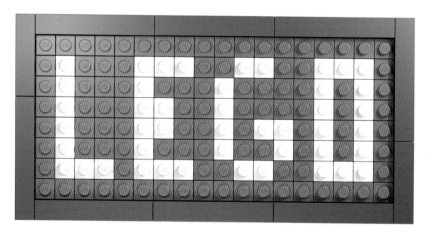

Figure 8-2: The elements making up the main image are studs-out, whereas the border is made up of standard tiles.

Then there's the *studs-up* approach, shown in Figure 8-3. Here the bricks and plates are viewed from the side with their studs pointed toward the top of the picture.

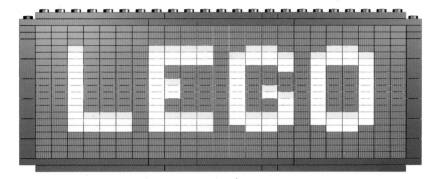

Figure 8-3: You can use studs-up mosaics to create interesting, artistic stand-alone pieces or to add lettering or images to a larger model.

A more advanced version of this technique involves turning some of the plates (or tiles) 90 degrees to create more subtle shapes. We'll look at the basic technique and then create a more complicated pattern in "Mosaics on Edge" on page 124.

You can use the mosaic technique to create interesting and artistic panels for display, just like a painting or photograph. But you can also incorporate a mosaic section into a larger model, using it to spell out a company name on the side of a cargo truck or a locomotive, for example. Or, you could use the technique to simulate a painted mural on the side of a building.

What You Need to Make a Studs-Out Mosaic

First, you'll need to choose a baseplate. This will be the foundation of your studs-out mosaic. Figure 8-4 shows the two most common waffle-bottom LEGO baseplates. The blue one is 32×32 studs, and the grey one is 48×48 studs. The rest of this section will focus on creating mosaics on the 32×32 version.

You'll also need lots of 1×1 elements. If you can get enough 1×1 standard plates, you can create a very thin picture; otherwise, you'll probably build studs-out with 1×1 standard bricks. Although the mosaic will be thicker, the resulting image will be the same when viewed from the front. (You may also want to use other standard bricks, or even slope elements, to create a frame around your image.)

Before you begin creating your mosaics, see the design grids in Appendix B and print at least one copy of Design Grid #1 from *http://nostarch.com/legobuilder2/*. This grid looks a lot like traditional graph paper, except that each square is the size of a standard 1×1 LEGO element as seen from above. To plot the location of different colored bricks, you'll simply shade in the squares.

Figure 8-4: The 2×4 brick gives you a sense of the size of the 48×48 baseplate.

Geometric Patterns

As a first attempt at mosaic building, we'll create a geometric pattern. You can use the design grid to plan this mosaic. Try a repeating pattern at first: Outline a small set of squares (say 6×6, 8×8, or 10×10) like the ones in Figure 8-5, and then use this small area to create a patterned tile.

The next step is to use your sketch as a pattern to create the actual mosaic. Use a 32×32 stud baseplate if you have one, or use smaller waffleplates and simply join them together. Figures 8-6 and 8-7 show how building a mosaic is simply a matter of attaching your 1×1 elements to a baseplate.

Figure 8-5: Planning a mosaic tile doesn't need to be complicated. You can plan your design as a pattern alone, without thinking about color. Or you can start blending colors together to form your pattern right from the start.

rd plates while the one shown

e the same pattern. From

1 bricks for your mosaic since

than 1×1 plates.

ts to the baseplate, your first

mplete work of art (yet!); it's

nal mosaic.

re 8-8, and you'll see that I've

lored LEGO pieces.

peat the 6×6 pattern from

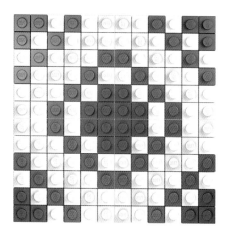

Figure 8-8: A small grouping of 1×1 pieces creates a tile that you can repeat to make more complex patterns.

Figure 8-9: Four tiles grouped together to make a larger mosaic. Repeat this pattern to make even bigger images.

The mosaic in Figure 8-9 is made up of four copies of the 6×6 tile in Figure 8-8. I've rotated a couple of the tiles to make the black corners meet in the middle. This helps create a more pleasing pattern, one that can be repeated many times.

In Figure 8-10, I've created four more copies of the 6×6 pattern and placed them next to the first four.

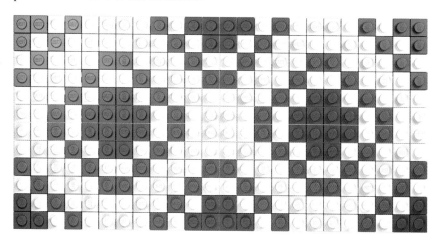

Figure 8-10: Eight copies of my original 6×6 tile create a repeating pattern.

Maybe this could be the ballroom floor for a minifig-scale hotel. Or, you could simply repeat the pattern until it fills a large waffleplate to create a pleasing image of nothing but patterns. Try designing your own tile pattern. Then, see what it looks like when you put multiple copies side by side.

Creating Photo Mosaics

There are a couple of interesting ways to create this type of mosaic. The first, print and trace, is a fairly low-tech approach that has you print a photo and trace over it. It allows a bit of room to add your own artistic flair. The second involves using a computer to produce a highly pixelated copy of your image. You can use either method to create realistic-looking photo mosaics.

Print and Trace

In order to use the print-and-trace method, you'll need a photo of what you want to turn into a mosaic. If the photo is digital, make sure it's loaded onto your computer. If it's a printed photograph, first scan it so that you can manipulate it digitally. You'll also need to print your picture, but before you do, crop the image so that the picture is more or less square on all sides. Then, resize the image so that its length and width are as close to 6.5 inches (16.5 cm) as you can get (assuming you are making a 32×32-stud mosaic).

You'll also need a copy of Design Grid #2 from Appendix B, which you can find at *http://nostarch.com/legobuilder2/.* This should be printed on paper that is as thin as possible.

To create the pattern for your mosaic, place your photo under the copy of the printed design grid. (Staple or clip the two sheets together so that they don't slide apart.) Now shade in the squares on the grid to match the light and dark patterns you see through the paper. In Figure 8-11, I've used this technique to trace an image of a fish that I found on the Internet.

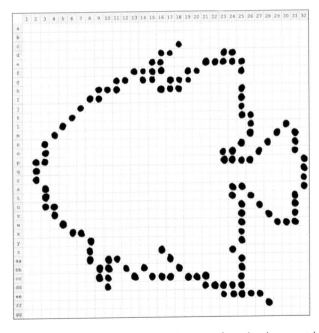

*Figure 8-11: An angelfish begins to emerge from the design grid.
Plan this way to get a sense of what your final mosaic will look like.*

Although the studs-out technique tends to look a bit blocky, it works reasonably well for subjects with strong shapes, outlines, or patterns. When selecting a picture to use, make sure that the important part of the image fills as much space as possible. A close-up of a friend's face will work better than a picture of a car driving on a bridge far away.

Notice in Figure 8-11 that the illustration of the fish mostly fills the 32×32 grid. This reduces the amount of background and presents a stronger subject, making it easier to identify, despite the low resolution of this small mosaic. Remember, when creating a studs-out mosaic, you won't end up with smooth, flowing lines. The challenge is to see just how natural you can make your design despite creating it with square pieces.

The numbers and letters along the top and side of the design grid are there to make it easier to match a location on your paper design to where that element will go on your actual baseplate. For example, in the fish outline shown in Figure 8-11, the tip of the fin starts at C18. That tells you that on the actual baseplate you should count down three rows: A, B, and C, and then count across to the 18th column. That's the spot on the baseplate where the fin starts and where you should put the element that you sketched on the design grid. From there, you can keep using the grid references, or you can use the first element you place as a guide to where each of the subsequent pieces should be placed.

In Figure 8-12, I've begun to add some of the details within the outline of the fish. I've used different shades of pencil and even different types of shading to suggest differences in color. (Of course, you could always use colored pencils to make your sketches.)

Use the legend printed at the bottom of the design grid (Figure 8-13) as a reminder of which symbol represents which color. Simply draw a symbol (or shading pattern) in a box and then write the name of the color it represents next to it.

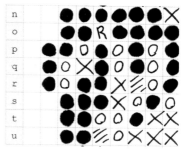

Figure 8-12: A close-up of just the face and mouth of the angelfish. Coloring within the lines is optional.

Legend

⬤ Black ⊠ White B Blue
▨ Grey ⊡ Orange R Red

Figure 8-13: It takes only a minute to jot down the legend for your design. This will help make the actual building much more enjoyable.

It really doesn't matter how neat your design looks on paper because the design grid version is just a rough sketch of what your final LEGO

mosaic will look like. The important thing is that you be able to tell which color you intended to go in each square. No one will see the paper version, so be as messy as you like.

It can be a challenge to see through the printed Design Grid to know which boxes to shade. If you're having trouble, try holding the original image up to a window; then place the Grid on top of it. The light shining through should help you see where you want to sketch. If the sun's not shining, grab a translucent plastic storage container— like the one you might use to store your LEGO bricks—and turn it upside down. Put the grid over your original image and lay them both on top of the container. There should be enough light filtering up from below to help you see what the original image looks like.

Figure 8-14 shows my finished angelfish design. Although it's far from photorealistic, it looks like a fish!

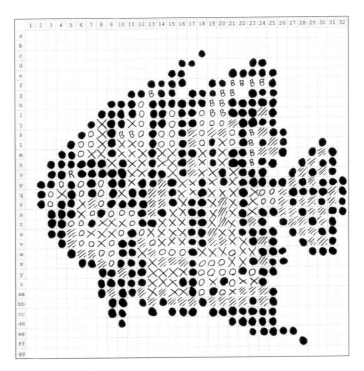

Figure 8-14: Although a bit rough around the edges, the blueprint for my fish mosaic still gives me a good starting point.

As you start turning your paper design into actual LEGO elements, make changes as needed. The pattern you've drawn is an excellent starting point, but you don't need to follow it exactly. Sometimes seeing the actual pieces on the baseplate will suggest places to make changes; make as many as you need to until the picture feels right.

If you're having trouble seeing what the mosaic looks like before it's complete, try one of two things:

1. **Stand up your work and step away from it.** Most mosaics are best viewed from a distance, which helps the lines and rough edges blur together to form a smoother image.
2. **Squint.** Squinting for a few seconds will make things blur together so that you can get a better sense of how the overall design is progressing.

Pixelating an Image Using a Computer

The second way to create the blueprint for your mosaic is to use software to apply a mosaic effect directly to a digital image. Figure 8-15 shows a picture of one of my cats. The original image of Izzy was taken with a digital camera; the modified version has a mosaic effect applied to it.

To create the mosaic effect I used GIMP (*http://www.gimp.org/*) to add a *mosaic filter*. This special effect turns an ordinary image into a series of square blocks of color—in this case dark grey, white, and hints of orange. You can also create photo mosaics using other software such as Photoshop.

To get the mosaic effect I wanted, I played around with the size of the blocks that GIMP uses for the effect. When I was done, the image on the right had exactly 32 squares across and down—just like the LEGO waffleplate.

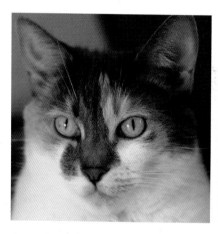

Figure 8-15: The real Izzy meets the pixelated Izzy: a side-by-side comparison of an original photo and the same photo with a mosaic filter.

Once you've created the mosaic effect, print out the modified image for use as your blueprint. You can use this like a map to show you which squares should be which colors. If you use a color image and a color printer, you can create a mosaic with many different colors.

Because the mosaic image doesn't have the row and column labels of the design grid, you need a way to track where you are on the baseplate

versus the printout. One way is to divide your image and baseplate into quarters, like I've done in Figure 8-16. Figure 8-17 shows the Izzy mosaic at the beginning of construction.

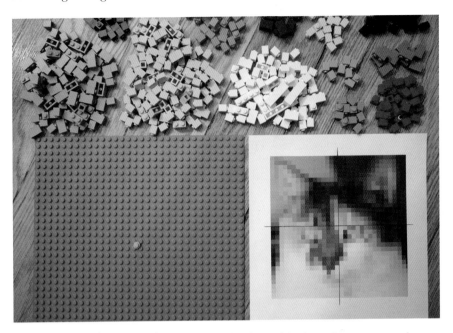

Figure 8-16: The grey 1×1 cylinder plate in the center of the baseplate represents the point on the printout where the four quarter sections meet.

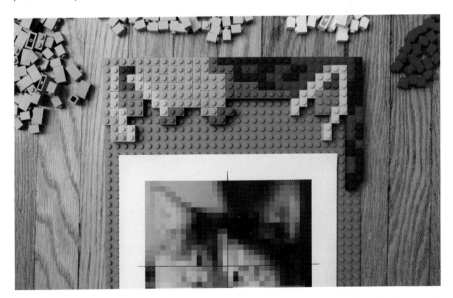

Figure 8-17: Starting at the top, you can see I've begun to fill in some of the background behind her head. I've also started to outline her ears, comparing against the printout of the pixelated image as I go.

Use each quarter of the printout to represent each quarter of the base-plate. In other words, if there is a dark red square in the top-right corner of the image, make sure the top-right corner of the baseplate gets a dark red element. Then see what color goes next to that piece and build the mosaic accordingly.

Once you've attached all the bricks to the baseplate, the result is a real-life mosaic that looks more or less like the plan I started out with and, as you can see in Figure 8-18, like my original subject.

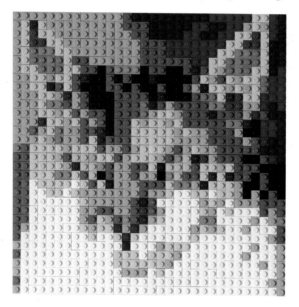

Figure 8-18: Izzy the cat becomes Izzy the LEGO mosaic. Remember to step back a few feet and let your eyes see the bricks as one image and not as individual elements.

If your mosaic doesn't look the way you want it to, don't give up. Try standing it upright and stepping back. Look at the entire image and try to see which parts don't look right, then replace a few bricks at a time until the problem areas disappear.

Designing a Studs-Up Mosaic

Studs-up mosaics offer some subtleties that studs-out mosaics don't. Because you're using plates as seen from their sides, rather than the square tops of bricks, you can create more subtle changes in color and shape. In Figure 8-19, we compare Figure 8-2 (a studs-out mosaic; left) to Figure 8-3 (a studs-up mosaic; right). As you can see, the word *LEGO* is a little more natural look-ing in the studs-up version. The ability to incorporate simple shading or highlighting techniques (such as the yellow highlights above the letters in the studs-up version) gives you more control as a builder.

Figure 8-19: A comparison of the two basic mosaic techniques. The studs-up version (right) offers some advantages when it comes to lettering.

Design Grids for Studs-Up Mosaics

Before designing your studs-up mosaic, have a look at Design Grids #3 and #4 in Appendix B, and then go to *http://nostarch.com/legobuilder2/* and print out copies of each. Both of these grids show LEGO elements from the side, as shown in Figure 8-20.

These *plate view* versions of the design grids allow you to plan your work as seen from the side in order to help you establish shapes and angles. They're the perfect grid to use when designing a studs-up mosaic. When you use these grids to create your design, you can sketch more subtle patterns, like the example shown in Figure 8-21, than you can with a studs-out approach. In fact, when used in a larger mosaic and viewed from a short distance, this letter will look almost hand drawn. Compare it with the chunky lettering of the studs-out technique shown on the left in Figure 8-19 to see the difference.

Figure 8-20: The plate view grids approach design work as though you were looking at a model from the side.

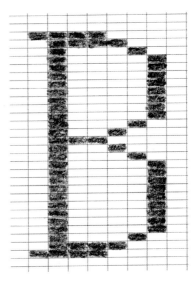

Figure 8-21: Gently curving loops make this letter B an excellent subject for a studs-up mosaic.

Mosaics on Edge

It helps to turn a mosaic on edge from time to time, especially when you're trying to create letters or complete words. For example, look at the small mosaic in Figure 8-22.

Figure 8-22: Alien writing? It could be, but keep reading to find out what it really is.

When you first look at Figure 8-22, it's hard to even tell what letter, if any, it's supposed to be. But flip it around, orient the studs to the right, and look at it again. You should recognize the symbol now (see Figure 8-23). It's a dollar sign. But now there's a problem. What do you do with a small mosaic like this when its studs are turned the wrong way?

Rather than build an entire model turned on its side like this, you can easily incorporate this submodel into a larger work. For example, say you want to build a bank or a casino to add to your LEGO town. You could use the dollar sign mosaic to help indicate the nature of the building you're constructing. In fact, with just a bit of planning, you could make the dollar sign part of the wall of the building, as you see in Figure 8-24.

As you can see, I've built a portion of the wall surrounding the dollar sign mosaic to give you an idea of what the final model might look like. But what makes it stay in like that? The answer is a bit of geometric trickery that is surprisingly easy to accomplish.

What you don't see in Figure 8-24 are the two 1×1 Technic bricks that are helping to hold the mosaic section in place on either side. To give you a better idea of what's really going on, Figure 8-25 shows that the right side of the mosaic is supported by a 1×1 plate (in yellow) that fits perfectly into one of the two Technic bricks. The plate is oriented horizontally, like the rest of the mosaic submodel, whereas the Technic brick is oriented with its stud up, like the rest of the main wall.

Figure 8-23: Turning a letter or symbol the right way makes it easier to read. But how do you add it to a model where the other bricks are pointing in different directions?

Figure 8-24: Up close, you can see the different orientations of the bricks and plates. From a short distance away, though, the model looks more uniform and realistic.

The left side of the mosaic (Figure 8-25) is supported by a Technic half pin (shown in yellow) that connects to the bottom side of the plate to its right, which is turned 90 degrees like the rest of the mosaic-related pieces. When viewed from even a short distance away, the mosaic section looks like it's just part of the wall. The delicate lines that form the dollar sign become natural looking and easy to read.

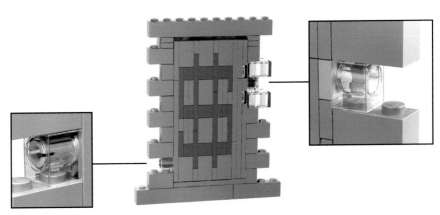

Figure 8-25: Mixing Technic bricks with regular LEGO parts offers some amazing construction possibilities.

Review: Mosaics of All Sizes and Shapes

Remember, there is no one correct size or shape for a mosaic. The techniques I've discussed in this chapter can be applied to complete pictures (like Izzy the cat) or to a much smaller arrangement of pieces that you use to embellish a model (like the dollar sign).

If you add a mosaic section to a larger model, the work will display itself. If you decide to try your hand at an image, be sure to show it off once you're done, like in Figure 8-26. Let people know what interests you, and show them how you've captured that in LEGO pieces.

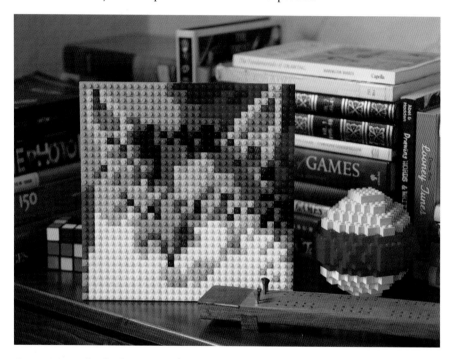

Figure 8-26: A finished mosaic can be displayed along with books, games, and other things that interest you.

There is no one rule to guide you in determining how large a mosaic should be or which of the two basic techniques you should use. Let the requirements for each project guide your decisions. If you need to spell out a company name on the side of a building, then build your mosaic letters to an appropriate size. If, on the other hand, you're creating a portrait of a favorite relative, be sure to make the mosaic large enough to capture his or her entire personality.

9

PUTTING IT ALL TOGETHER: WHERE IDEAS MEET BRICKS

We've covered a lot of topics up to this point. Throughout this book, you've looked at basic building techniques, like overlapping and stacking; different types of LEGO elements and how best to use them; and design ideas, like scale and color. Now it's time to put your skills to use. This chapter focuses on you, the builder, working toward designing the models you want to make. So print out some design grids, dump some bricks out onto your building table, and get to work!

NOTE *You can find the design grids at* http://nostarch.com/legobuilder2/, *with complete instructions for using them in Appendix B.*

How to Think Like a Model Designer

You become a designer as soon as you step away from existing sets and pre-written building instructions. Whether you're working from real-life inspiration or creating something completely original from your imagination, you're *designing*. And as a designer working in LEGO elements, you have almost no boundaries.

Some people are a little bit overwhelmed by this sense of complete control. Although your head may be full of ideas, it may seem daunting to figure out how to turn those ideas into actual models. You may end up with a sketch pad that looks like Figure 9-1.

Figure 9-1: Freedom to create anything you can imagine can leave some people wondering what to build.

Limit Your Scope

Sometimes knowing what to leave out of your project makes as much difference as what you put in. The term *scope* refers to the range of your model. It's the answer to "What is the goal of my design?" and "How will I accomplish it?"

It's easy enough to sit down at your build table and announce, "I'm going to build the Empire State Building!" You decide that this model will be 20 feet tall, include hundreds of windows, and be made entirely from light grey bricks. It's certainly possible to build such a model, but do you have the necessary pieces to build it now? Probably not. Its scope is just too ambitious.

So let's start simpler.

Say you decide to build a copy of the Empire State Building. You look at your bricks and discover that you have plenty of dark grey, light grey, and white bricks. Why not use these colors to build your model? You don't have very many transparent bricks or windows, so you can't realistically re-create every window. You decide to use black bricks to simulate window openings. Finally, you decide that a 2- or 3-foot-tall structure is probably more reasonable than a 20-foot-tall one given the number of bricks in your collection.

You've determined a realistic scope for your project, one that's much more achievable than your first idea. Setting reachable goals can help you succeed and ultimately help you be more satisfied with the time and effort you put into building.

Part of limiting your scope involves knowing what to leave out. In the Empire State Building example, one thing you left out was height. You reduced it to something realistic because the idea for the first model was too big for the average builder. You also substituted a part for a specific detail on the real building that would have been difficult to re-create otherwise: black bricks for windows.

In addition, you decided to mix colors so you could build a reasonably tall model with the bricks that you already have. In fact, most builders find that they usually need to use more than one color for their builds, regardless of the actual color of the object being modeled. But as with size, don't let your color limitations limit your creativity. Look at what you have available and adjust your scope accordingly. For the Empire State Building, the use of greys, white, and black might actually make the model look more interesting than if you had built it entirely in a single color. Turn your limitations into features!

Defining the scope of your projects will also help you decide the level of detail to include. When building the Empire State Building, you'll need to drop certain details in order to build to the reduced height, cutting elements like intricate details above windows and perhaps simulating where windows would be, rather than building each window. The same might hold true for doors and other street-level details.

Learning to build within boundaries is an excellent way to improve your skills, hone your artistic eye, and maximize the enjoyment you get from your existing collection of LEGO bricks.

Pick Your Subject

When choosing the subject of your models, pick things that interest or challenge you on different levels. For example, try building tall, thin models (like the Empire State Building) to practice your column building techniques, or try to create realistic-looking buildings at different scales to practice working out the scale dimensions. But no matter what subject you pick, make sure it's something that you like. You'll spend a lot of time thinking about and examining your subject from many angles as you figure out how to best re-create it in LEGO pieces.

To illustrate as many design and building principles as possible, in the sections that follow we'll create our own model of a NASA space shuttle, a subject that combines a good mix of shape, color, and construction challenges. I picked the shuttle because I'm a big fan of space exploration. Don't worry if you're not a spaceflight aficionado, as you can still apply the lessons from this exercise to a subject that does interest you.

Figure 9-2 is a photo of the space shuttle *Atlantis*, which we'll use as inspiration to guide our design.

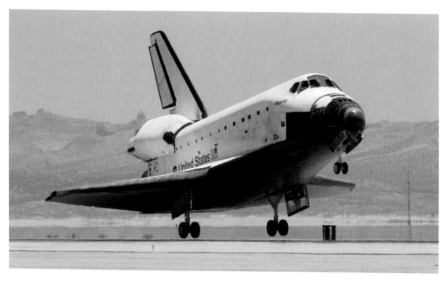

Figure 9-2: The space shuttle Atlantis (photo credit: NASA/courtesy of nasaimages.org)

Although we're going to work to a fairly small scale, your LEGO version of a space shuttle will still be very recognizable and will include a number of distinctive features inspired by the real thing. Figure 9-3 shows what we're going to wind up with by the end of this chapter.

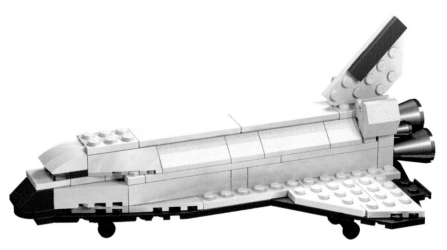

Figure 9-3: This is the goal of the design exercise.

To add some originality, let's call our model the *Triton*. That was the name of a ship that once sailed in the British Royal Navy and the name of Neptune's largest moon, so I think it makes the perfect name for a fictional space shuttle.

Work from the Bottom Up

Where do we start? Well, let's look at the shuttle. What section should we build first? We could start with the tail, but how would we know to make it the right size? We could build the cargo bay doors, but could we easily attach them to the rest of the shuttle?

Rather than just jumping in, look at what you're trying to duplicate. The shuttle has many distinctive features, but one stands out: its unique wing design (as you can see in the drawing I've made in Figure 9-4 using Design Grid #1).

Because the wings are effectively the bottom of the shuttle, they're an excellent place to start modeling. With that question behind us, we can decide how to attach and accurately scale other parts of the ship to match the wings (kind of like modeling the ground floor of a building first so you know how wide and tall the remaining floors should be).

Design Grid #1 – 1:1 Scale
[Studs Up/Top Down Orientation]

Figure 9-4: Copying the outline of your model from a photo or drawing can help you achieve realistic results.

I created the outline in Figure 9-4 like this:

1. I searched the Internet for a diagram that showed the shape of the shuttle wings from below.
2. I printed this image onto a sheet of plain paper.
3. I printed out a copy of Design Grid #1. This grid takes a *top-down* look at a model.
4. Finally, I put the printed image under the design grid and traced the outline of the wings. This gave me a very accurate reproduction of their shape, which helped me find LEGO pieces to match that outline.

Of course, the shuttle's wings aren't basic rectangles. To re-create them you'll need tapered parts. Wing plates and diamond-cut plates (see Table A-3 on page 167 for sizes and shapes) will provide the shapes you need.

Creating the wings using the design grid is almost like putting together a jigsaw puzzle, except that instead of being given the pieces to assemble, you have to find suitable pieces in your collection and fit them to match the outline you've drawn on the grid. Notice in Figure 9-5 that I've used wing plates to form the outer shape and standard plates in the space between. You can set real pieces on top of your penciled-in design to test them out because the squares on the design grid are exactly one stud by one stud in size.

Together, these elements give you the foundation for your vehicle. Of course, the size and quantity of these plates might vary if you are designing this model based on your own collection of parts. For example, you might substitute standard plates for wing plates if you don't have those parts. But the goal is the same, regardless of whether your shuttle is 10 studs long or 100 studs long: to make the model look like the real thing.

Let Reality Guide Your Design Decisions

The method of finding one feature of an object upon which to base your model can apply to nearly every creation you take from real life. Just follow these steps:

1. **Use a distinctive feature of the item being modeled.** In the case of the *Triton*, we use the unique wings. When building a model of a train engine, you might select the crew cab. For a spaceship, you might start with the engines.
2. **Choose the elements best suited to represent that feature.** For the *Triton*, we chose wing plates to match the real shape of the wings that we drew on the design grids. Pay more attention to angles than size.
3. **Build your model by incorporating elements that work together.** As you finish the *Triton*, you'll see that the choices we make for each section, along with the bricks we build with, are driven by the foundational elements of the model. In other words, the wings provide a reference for the rest of the model.

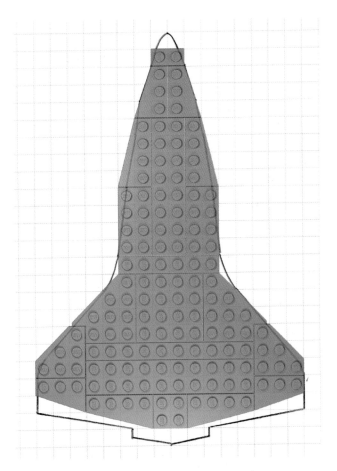

Figure 9-5: The LEGO elements are superimposed on a copy of the design grid with the outline of the wings drawn in.

Structural Decisions: Let the Real Thing Tell You How to Build

That's it for the basic wing design, but now we need to make a structural decision. How will we hold these pieces together? The easiest solution is to use the actual shuttle as our guide.

The portion of the wings we've built so far is a lot like the protective tiles that cover the underside of the shuttle. When you look at the real shuttle, you see that the upper part of the wings is almost the same size and shape as the underside, but it's made from a different material than the tiles underneath.

To duplicate the look of the real wings, we can add a second layer of plates in a different color. As you can see in Figure 9-6, the second layer doesn't exactly match the shape of the first, but that's all part of the design. By working to re-create the parts on the actual shuttle, we end up figuring out how to hold the first layer of plates together.

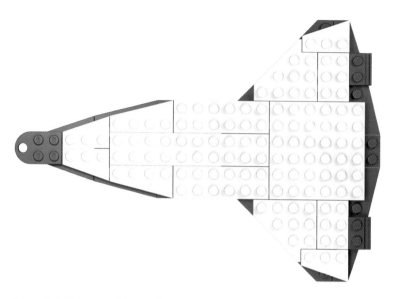

Figure 9-6: The second layer of plates (white) doesn't quite match the first, but that's a good thing.

If the second layer of plates were configured exactly like the first layer, nothing would hold them together. By selecting plates of different sizes and shapes, we make sure that the individual parts are arranged to take the best advantage of the overlap technique.

Look at Your Model from the Side

So far, we've been using only Design Grid #1, which looks down on a model from above. This grid is good for estimating the length and width of a model as well as its overall shape, but it doesn't allow you to see its height. To have a look at our model's height, we'll use Design Grid #4 to show the *Triton* from the side.

Each small rectangle on this grid represents a 1×1 plate as seen from the side. You can use this perspective to decide how many layers of bricks or plates you need to achieve your goal height. For the *Triton* design, we'll use the *landscape*-oriented Design Grid #4. This sheet is longer than it is tall, so it's a good fit for the shuttle.

As you can see in Figure 9-7, you can use the side-view grid to plan the model's height (roughly three bricks high) and determine the location of key structures like the tail and engines.

As you draw your plan, don't worry about making your sketch fit the lines on the design grids exactly. You'll end up making compromises between what you draw and what you actually build. Compromise isn't a bad thing; in fact, it's often the source of the most inspired ideas. Sometimes not having the perfect piece leads you to use another piece (or pieces) that actually ends up being a better solution.

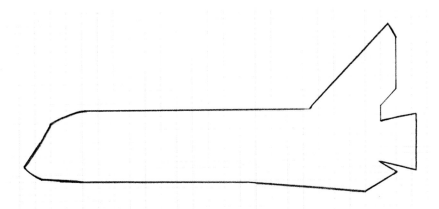

Figure 9-7: Sketches don't have to be perfect to be useful.

Pick a Scale

Choosing a scale for any original model is one of the key decisions you'll make. We've talked about scale a number of times already. For our model of the space shuttle, we've let the design of the wings and how it matches available wing plates set the scale. In other cases, you might pick a scale in advance and build everything to that size, like the train station we built in Chapter 3.

Because this is an original model, you get to choose the scale. Of course, if you're trying to match the size of another model, you'll need to work to that scale; otherwise, choose the scale that you think is best for your project.

Color Concerns

Like scale, the choice of colors is up to you. And don't underestimate the importance of color. Color can change the way that people react to a model. For instance, a sculpture of a dog made out of blue bricks might make people think of a cartoon character rather than a real pet.

Combinations of colors can also have a dramatic effect on how people react to your work. For example, a helicopter built from primarily white bricks with red accent pieces will probably make most people think of an air ambulance. But build the same design with black or dark grey bricks and the result looks like a military or police vehicle. Similarly, color combinations can evoke particular themes or settings. Bright colors like red, yellow, and blue might suggest an amusement park ride, whereas a building made out of mostly grey bricks might feel more like a warehouse or a factory than a comfortable home. As you design your model, consider the colors you're using to see if they represent the theme or the feeling you're trying to convey.

Picking colors for the *Triton* isn't that tricky; you can let reality guide you. The real shuttle is mostly white, dark grey, and black—the standard NASA color scheme. By sticking to these colors you add realism to your model despite its small size. And, as you can see in Figure 9-8, the black and white bricks create a dramatic contrast that brings out some of the main features of the ship.

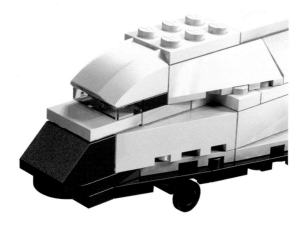

Figure 9-8: The contrasting black-and-white color scheme adds realism to your mini shuttle.

Elements of Design

No matter what you're planning to build, there are certain elements to keep in mind. We'll focus on four major attributes: shape, color, proportion, and repetition.

Shape

What shape will your model be? There is a reason why cars aren't shaped like trees. Think about the form you're trying to create. Plain, flat walls can be boring, so don't forget to include curves, angles, indents, and other interesting surfaces in your models to make them look more interesting.

In building the *Triton*, we're trying to re-create the shape of the original shuttle. Shape is one of the most important attributes when working from real life. In Figure 9-9, you can see that I've selected specific plates for the wings and slopes for the top of the body that most accurately represent the real thing.

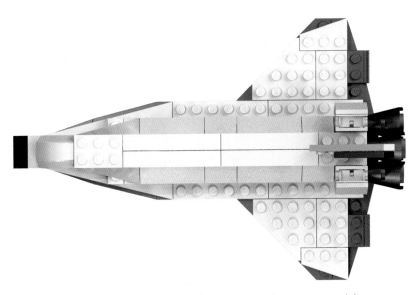

Figure 9-9: The shape of the shuttle is distinct, so match it in your model.

Color

Will you be working with only a couple of colors or a whole range? Your choice of color can affect the overall impression the model makes, especially when combined with the shapes you use.

We let reality guide us when building the *Triton* and we chose the NASA color scheme of black, white, and shades of grey (Figure 9-10). But you could build the *Triton* in different color schemes. Perhaps a black and yellow version could be a construction shuttle, destined for a space station? Or a red and white version could be a rescue shuttle, standing by in case of emergency?

Figure 9-10: Making smart choices with colors, like using black and white plates for the wings or black cones for the engines, can help bring out some details on an otherwise monochromatic model.

Proportion

Are the model's substructures all the same scale? For example, if you build the doors and windows on your model to the same scale, it will look more realistic. The real shuttle is a complex flying machine. To make the *Triton* emulate it, you need to retain the correct balance between the length of the body and the width of the wings. You have to make sure that the tail (Figure 9-11) is tall enough but not too tall and not too thick. You need to design the wings to be strong enough to serve as the base of the model but thin enough to look like they could fly.

Figure 9-11: A single plate mounted vertically between the studs below creates a tail that's tall and thin.

Repetition

Rows and rows of 2×4 bricks can be boring, but a few rows of arches can be beautiful. Sometimes repeating the same shape can add dimension to your model. Just be sure to select an *interesting* shape before you add too many to your creation.

The *Triton* uses repetition by employing 1×6 tiles (Figure 9-12) along the top of the cargo bay doors, giving at least the *impression* that they might open. In fact, the doors themselves, made from 45-degree slopes, are another example of where repetition can help add authenticity.

Figure 9-12: On this small model, we repeat only a few tiles and slopes to make the cargo bay doors. On a larger-scale version of the shuttle, you would probably use much more repetition.

Building the Triton Step by Step

It's finally time to build the *Triton*. In the pages that follow, you'll find building instructions and notes for each step. Figure 9-13 lists the pieces that you'll need to make this model, but don't forget that substitution is a regular part of building original models. If you don't have every piece shown in the BOM, try to find substitutions—and be creative!

Official instructions for most LEGO models don't include many words. Typically, the company relies on images to show you how to put together the set you've bought. Because we're looking at the design process in this chapter, I've included detailed notes on each step. I want to explain why we've made certain design choices and how those choices affect the outcome of the final model.

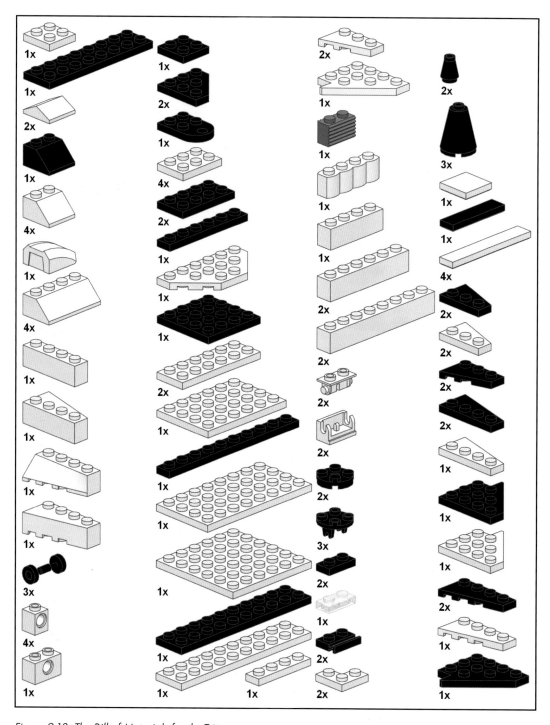

Figure 9-13: The Bill of Materials for the Triton

Step 1

Figure 9-14 shows the bottom layer of the wing structure, similar to Figure 9-5.

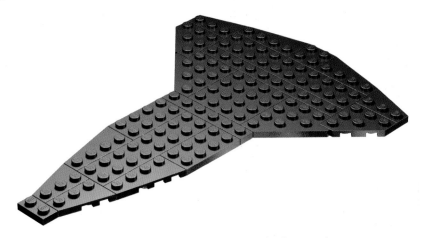

Figure 9-14: A combination of plates creates the unique shuttle wing shape.

The wings serve as an excellent base upon which to build the rest of the craft.

Step 2

The second layer of plates (Figure 9-15) follows the outline of the lower layer closely but not exactly. This slight mismatch is a design decision. The real shuttle's wings have some of the protective heat-absorbing material lining their front edges. By exposing some of the lower layer, we create the illusion of that material on the model. (This is a variation on the staggering technique.)

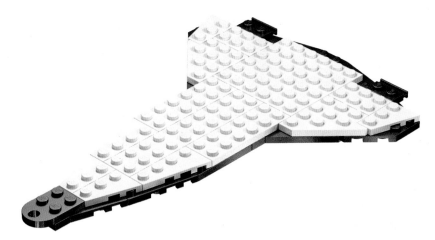

Figure 9-15: The pieces of the second layer also individually overlap the elements in the first layer, which helps hold them all together.

Step 3

The body of the shuttle model is simple because at this scale there isn't much room for detail. As you can see in Figure 9-16, we're concentrating on creating the basic outline for the cargo bay.

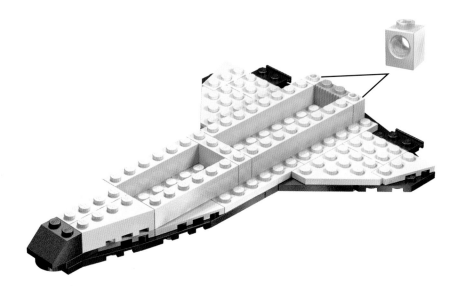

Figure 9-16: The image at the top-right corner gives you a building hint. One 1×1 Technic brick goes on each side of the 1×2 grille brick.

You'll always need to make similar decisions about detail when you create your own models. Try to design realistically, but don't overwhelm a small model with more details than it can handle. Ultimately, ask yourself, "Does this model look the way I want it to?" As long as the answer is yes, you've got a successful design.

Step 4

Because this model isn't meant to be functional, we don't need to create a hollow cargo bay. Instead, we'll use 4×N plates (Figure 9-17) to join the side walls.

This makes for a sturdier ship that holds up better to being whooshed around the room. A larger-scale model of the shuttle could have included such things as retractable landing gear or movable wing flaps, but it would have been difficult to try to make those features work on this small scale. It's up to you to decide how many details to include based on the size of your project.

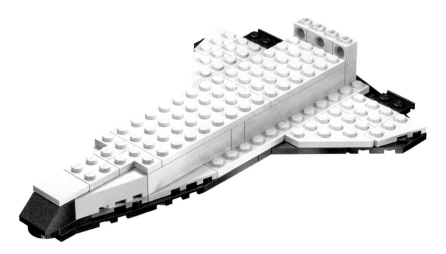

Figure 9-17: More Technic bricks are placed near the back of the body. This time it should be obvious which pieces to use.

Step 5

The *Triton* model is fairly small, so it comes together quickly. In Figure 9-18, you see that by Step 5 we're already adding the 45-degree slopes that form the cargo bay doors. (Remember, the doors aren't functional—they are only for show.)

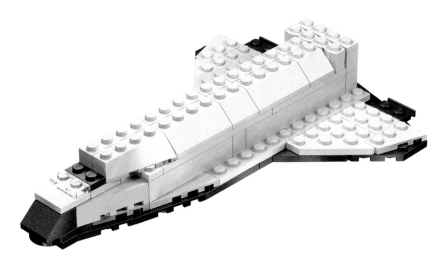

Figure 9-18: The cargo bay doors are already in place, as well as a transparent 1×2 plate intended to represent the cockpit windows.

Step 6

You can sometimes add several unrelated portions of a model in the same building instruction step, as you can see in Figure 9-19.

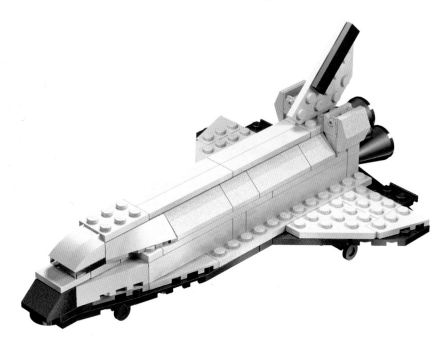

Figure 9-19: As long as nothing is blocked from view by the new elements, you can add any number of pieces in a single building instruction step without causing confusion.

Here, we added the tail (mounted on a 2×3 plate), the cowlings near the engines (the 2×2 33-degree peaks hanging off the 1×2 hinge bricks), and the curved slope that becomes the top of the crew cabin.

Use a black 1×4 tile on the tail to represent some of the protective tiles on the real shuttle. Don't worry about re-creating the specific movable parts of the tail (at the rear). If you add too much detail, you may take away from the look of the rest of the model. Don't add more detail in one area if you are keeping other areas sparse.

The tail is held in place by the studs on the 2×3 plate below it. Because the thickness of the plate is nearly identical to the distance between the studs, it can be wedged in.

Step 7

Sometimes you'll need to turn your model one way or another to more clearly see a building step. For example, in Figure 9-20, we turned the *Triton* so that the tail section was facing toward us. This allows us to see where the 1×1 and 2×2×2 cones should go to create the engines.

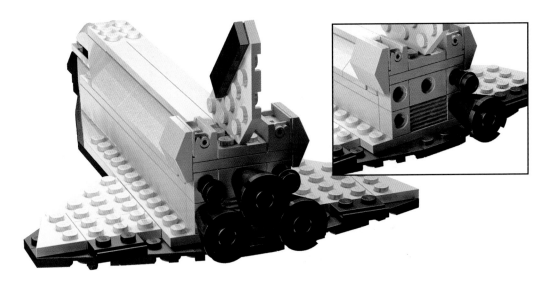

Figure 9-20: Now you see why I used Technic bricks to build the end of the body. The inset shows the rear of the shuttle without all the cones in place.

Although the engines might not be exactly the right size for this scale, they are very close. Also, they match the pattern in which the engines are mounted on the real shuttle fairly accurately, which makes your micro model look more like the real thing. Remember, we're capturing the look, not the minutest detail.

Step 8

In Step 8, reposition the ship as shown in Figure 9-21. This time, we're looking at it from underneath so that we can see where to attach the landing gear.

When you're adding pieces to the underside of another element, count the tubes to see where to make the attachment. When you're adding pieces on top of others, use the studs as guides instead.

Figure 9-21: Using only a picture and no words, I can accurately describe where to attach the landing gear on the lower wing.

The two sets of wheels closer to the back of the *Triton* are mounted slightly differently from the front landing gear. Each rear wheel has a 2×2 cylinder plate sandwiched between the wheel and the shuttle's underside. This causes the nose of the craft to sit slightly lower when it's finished, as you can see in Figure 9-22. This effect duplicates the angle at which the real shuttle points when it is taxiing after a landing.

Step 9

Figure 9-22 reveals that Step 9 isn't really a step at all, but a view of what the completed model should look like.

Figure 9-22: The shuttle Triton parked in the classic nose-down position.

You might want to use this last step to determine where to add decals (printed from your computer) or small detail pieces. In Figure 9-22, I added a runway made of tiles beneath the model to enhance the realism.

Something Wrong? Redesigning Doesn't Mean You've Failed

Don't be concerned if something in your model isn't quite right. Remember, you're building with LEGO bricks. You can take everything apart and put it back together! Disassemble the section you feel is lacking and rebuild it with different pieces, combinations of pieces, or alternative colors.

For the *Triton*, I built a prototype first, and then I rebuilt the nose two or three times before I hit on the combination of plates, tiles, and slopes that I felt best represented the shape I wanted. I also adjusted the pattern of plates I used to make the wings several times until I felt they looked right but were also strong enough to support the pieces I was going to add on top. The engines, on the other hand, just seemed to work right off the bat.

Not every section of a model will come together perfectly on your first attempt. Some turn out exactly as you intend, while others will require changing parts or techniques again and again until things begin to look better.

You're Done. What Now?

Now you've seen how to design and build an original model from scratch. You've looked at various ways to capture details from real-life objects and how to make wise design decisions when translating an object into LEGO pieces. But when you're done, what's next?

The first thing you'll probably want to do once you finish a model is to display it where other people can see it. If you're displaying it on a shelf somewhere, you may want to build something to set your model on (like the runway in Figure 9-22), or you may even make it part of a complete diorama.

You can also display your model online. Take pictures of it and display them on the Internet for your friends and others to enjoy on sites like *http://www.brickshelf.com/* or *http://www.mocpages.com/*.

Review: You're the Model Designer

You don't have to be hired by the LEGO Group to be a model designer. The moment you decide to build something that's never been built before, you are the designer. And that's really what this book is about.

As a model designer, you will need to consider all the aspects of LEGO building—part selection, color choices, scope, and scale—to make good decisions about your models. But working through those decisions really adds to this hobby.

Whatever you build, enjoy!

10

BEYOND JUST BRICKS: OTHER WAYS TO ENJOY THE LEGO HOBBY

Some hobbies are limited in just how much you can do with them. For instance, if you're a coin collector, you can collect coins, look at them, catalog them, and sell or trade them, but not too much more. The LEGO system, on the other hand, allows for activities beyond merely building with bricks.

In this chapter, we'll look at two activities that go beyond building with LEGO pieces and put your creative and analytical skills to the test.

Creating Your Own Building Instructions

One way to expand your LEGO building hobby is to share your building instructions. When you create a model, why not share the build information with others so that they can build your model too? Sharing is an integral part of joining the worldwide LEGO community.

Given all the techniques you've learned in this book, you'll soon be building original models that have never existed before. Once you end up building a space shuttle, a bulldozer, or a sculpture of a dragon, you may want to document your building process in order to share your model with the world or just to ensure that you can rebuild the model. Having the steps of your model recorded makes it easy to pull out the right bricks and build that same project again any time you like.

Step-by-Step Pictures

One easy way to create plans for your models is to photograph your building process step by step with a digital camera. Take as many pictures as you need to fully explain how to build the model, and then share your photos.

First, take a shot of the parts used to build the model, as shown in Figure 10-1.

Figure 10-1: Set out the parts for the model and photograph them before beginning construction. Here, I show the pieces needed to build a 4X 1×2 plate.

A photo like Figure 10-1 will give other builders a clear picture of the parts they'll need to build your model.

Next, capture each step, right after you add the parts it calls for to the model. Figures 10-2 and 10-3 show sequential steps for building a 1×2 plate in 4X scale.

You can then import these pictures into a word processor or layout program to create a single set of instructions, or you can just post them online for people to view one at a time.

Figure 10-2: Each photograph should show a single step in the construction of the model. Here are steps 1 and 2 of the 1×2 plate in 4X scale.

Figure 10-3: Each subsequent picture should show the model from the same angle but with more parts added. Here are steps 3 and 4.

Computer-Generated Instructions

Throughout this book, you've seen many examples of building instructions. Most of these images were created using computer-aided design (CAD) software, like the programs used to design cars and airplanes. These amazing tools provide an endless supply of LEGO bricks in every color you need. You can design and build an entire model using this software, as shown in Figure 10-4.

These programs also let you track each building step as you go, so you can create step-by-step instructions for other builders to follow, like the example shown in Figure 10-5.

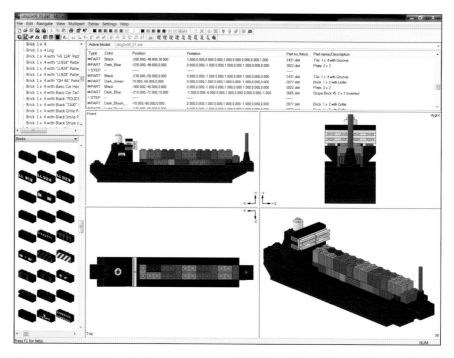

Figure 10-4: MLCad can help you create virtual LEGO models with an endless supply of elements.

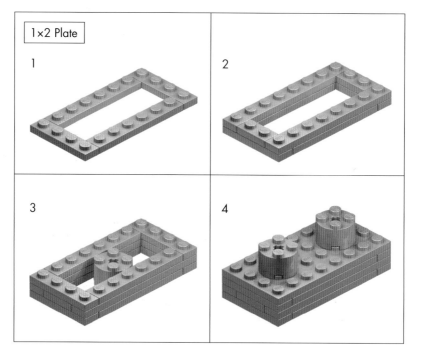

Figure 10-5: These building instructions were created using software. Notice how similar these images appear to Figures 10-2 and 10-3.

Fun LEGO Games

The word *fun* is often associated with the LEGO hobby. To take the fun even further, you can combine your LEGO elements with games you already know (by re-creating them in LEGO pieces), or you can create games that are completely original.

LEGO Checkers or Chess

Many traditional games are played on a checkerboard with eight squares along each side, for a total of 64 squares. One easy project to tackle is to make your own checker (or chess) board from LEGO pieces. Conveniently, LEGO makes a waffled baseplate that is 32×32 studs—perfect for making checkerboards. If you do some quick math, you'll find that you can break up the board into eight rows and eight columns, just by adding tiles in the right pattern.

As you can see in Figure 10-6, it takes only four 2×2 tiles to create each square on the game board. And with very little effort, you've got your own custom game board, ready to play!

Figure 10-6: Four 2×2 tiles create each colored square on the game board.

NOTE *If you don't have as many tiles as you need to cover a 32×32 baseplate, use two different colors of standard plates. Your board won't look as smooth, but it should be just as useful for playing games.*

Once you've made your board, you can use it to play games like checkers or chess. To play a game of checkers all you'll really need are simple playing pieces, like 2×2 bricks in two different colors. But if you want to play chess, consider creating your own custom set of chess pieces.

Figure 10-7 shows a simple pawn. It uses mostly common parts, so building 16 of them shouldn't tax your collection too much. Figure 10-8 shows what a rook and bishop could look like.

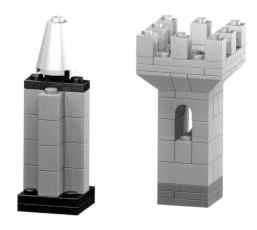

Figure 10-7: A basic pawn made from common LEGO pieces.

Figure 10-8: The bishop and rook are both built on 3×3 bases.

Connect-Across

Here's a game that I originally designed to be played on wooden tiles using glass beads as markers. It's called Connect-Across, and it works just as well with LEGO bricks.

First, make 30 tiles like the ones in Figure 10-9. (Their style and color isn't important, as long as they're the same size.)

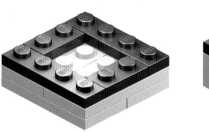
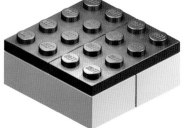

Figure 10-9: These are two examples of how to create the game tiles. You'll need 30 identical tiles.

You'll also need two 15-piece sets of playing pieces, for a total of 30 pieces. Pick one of the styles shown in Figure 10-10 or design your own. The main thing is that the two sets should look different from each other.

For example, for the first set, you could use 15 upside-down wheels (with or without the rubber tires), like the one shown on the far left of Figure 10-10. Then, for the second set, you could make 15 copies of the marker shown on the far right.

Figure 10-10: Several different styles for markers that can be used to play the game

Connect-Across combines the basic goal of tic-tac-toe with the strategy of checkers. You and your opponent both build and fill the board as the game progresses while trying to get four of your pieces aligned in a row. Any tiles that you add to the board must touch another tile on the side or corner.

Setting Up to Play Connect-Across

To begin your game, first decide who will use which set of markers, and then have the players set their markers near themselves on the table. Now set aside four of the square tiles, and then divide the remaining ones.

Flip a coin to see who goes first. The player who goes second arranges the four tiles set aside earlier in the center of the table (as shown in Figure 10-11). The tiles can be arranged in any pattern, as long as each tile touches another on the side or corner.

Figure 10-11: One example of an opening pattern.

NOTE *You might use a large 48×48 waffled baseplate as your board to keep things from shifting around too much, but you can play on any level surface.*

The Basic Rules

There are really only three basic rules for playing Connect-Across. When it's your turn, you can do one of the following:

1. Place one of your markers on any open tile on the board.
2. Place a new tile on the table, making sure that it touches the side or corner of another tile on the board.

3. Move one of your markers on the board a single space (to an adjacent and empty tile), or capture another piece, just like in checkers. To capture a piece, move your marker over an opponent's piece and land on an empty square. Remove the piece you've jumped over from the board. Return the captured piece to your opponent, to be used again during subsequent turns.

Playing the Game

To start playing, the first player places one marker on any of the four empty squares or places a tile on the table to increase the size of the game board, as shown in Figure 10-12.

Figure 10-12: The upside-down wheel makes a simple marker, and it fits perfectly in the center of a tile.

The second player can place a marker or a tile, and game play continues, in turns. The board will grow as you move, with rows and columns branching out in different directions. For example, in Figure 10-13 you can see that the player using the red markers has a good chance of making four in a row diagonally, through the middle of the board.

Figure 10-13: Getting four in a row may not be as easy as you think!

Winning the Game

Players add tiles or markers and make single or capture moves until one player lines up four markers in a row vertically, horizontally, or diagonally, and wins. Notice in Figure 10-14 that the player using the red markers has created a diagonal row.

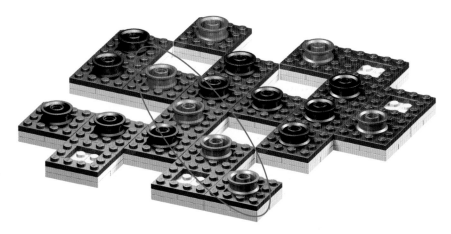

Figure 10-14: The oval shows the winning move.

Review: Enjoying Every Aspect of LEGO

How you choose to enjoy LEGO as a hobby is up to you. As you've seen in this chapter, there are ways to add interest to your LEGO elements that don't simply involve building models. As with the building techniques you've explored in this book, there is no one right or wrong way to enhance your participation in this hobby. That's why things like playing LEGO-based games or creating instructions can be just as rewarding as building the models themselves.

BRICKOPEDIA

The LEGO system is made up of thousands of elements. Some are different sizes of the same type of piece (like 2×3 and 2×4 bricks), while others are exactly the same size with different decorations or patterns printed on them.

I'd need an entire book in order to catalog every piece in the system. Instead, this Brickopedia contains a selection of more than 275 elements, from basic bricks, slopes, and plates, to specialized elements, arches, and even decorative elements. The pieces included represent the most common and most reusable elements in the LEGO system, and they are the most likely to be found in your own LEGO collection. In the case of bricks, plates, slopes, and arches, I've included nearly every basic element that falls into those categories. In some of the other categories (such as specialized elements and decorative pieces), I've included a narrower selection of pieces, focusing on those that offer the most creative possibilities and interaction with other basic parts.

As you'll see, I've categorized the Brickopedia from the perspective of building with LEGO pieces. As a result, I suggest that you do not use it to plan purchases of LEGO pieces because its categories and terminology may not match the ones used by stores or websites. Some of the categories and descriptions are unique to this text. I hope that you'll find the Brickopedia useful in your attempts to categorize, organize, and, of course, build with the LEGO system of parts.

How the Brickopedia Works

The Brickopedia contains a separate entry for each element. Each entry contains several pieces of information, as shown in Figure A-1.

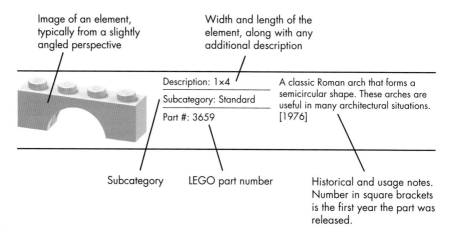

Figure A-1: A sample Brickopedia entry

This information notes why you might have certain pieces in your collection, suggests how to use them, or in some cases, just offers an interesting anecdote about the part.

The category and subcategory names convey the nature of the pieces. Whenever possible, I've cataloged similar parts together, like standard and inverted slopes of the same size, to show their relationship. I've also divided the LEGO elements into several broad categories. Each category contains subcategories that further refine the way pieces are classified (see Table A-1). Tables A-2 through A-10 catalog each major category from basic bricks to decorative elements.

Table A-1: LEGO Element Categories and Subcategories

Category	Subcategory	Description
Bricks	Standard	Rectangular sides, same height as a 1×1 brick.
	Adapted	Irregular sides/shape or taller than a standard 1×1.
Plates	Standard	Square or rectangular shape, same height as a 1×1 plate.
	Adapted	Irregular sides/shape. "Quarter cut" or "diamond cut" describes pieces that can be combined to form a circle or a diamond shape.
	Bows	One edge has symmetrical angles cut away, whereas the opposite edge is straight or indented in the center.
	Wings	Available in left and right varieties, shaped like airplane wings.
Slopes	Standard	The angled face is usually on the top part of the element.
	Inverted	The angled face is usually on the underside of the element.
	Corners	Any slope that can be used to form a corner where two rows of the same type of slope meet at 90 degrees.
	Peaks	Two or more angled faces meet at the top of the element. When in place, there are no exposed studs.
	Compound	Two or more (flat or curved) angled faces.
	Curved	Angled faces that have a curve.
Specialized Elements	Junctions	Elements with studs on their sides or with a portion perpendicular to another part. These pieces allow you to join two or more pieces to make a bend in or change the shape of a model.
	Odd Faces	Elements with one or more irregularly shaped, contoured, or textured faces.
	Hinges and Turntables	Hinges are bricks or plates that meet at a flexible joint. Turntables allow attached elements to rotate. Both hinges and turntables can add movement to a model.
	Pin-Enabled	Bricks or plates with a Technic-style pin attached on the sides, top, or bottom, or elements capable of accepting a pin.
	Wheels/Tires	Pieces that add motion to vehicles.

(continued)

Table A-1: LEGO Element Categories and Subcategories (continued)

Category	Subcategory	Description
Arches	Standard	A single piece that creates a complete arch.
	Half	A piece that forms only half of the complete arch. Studs are on top as with the standard variety.
	Half Inverted	A piece that forms only half of the complete arch. Tubes are on the bottom, and no studs are showing. The arch is on top of the element.
Tiles and Panels	Standard	Standard tiles are any flat elements that are the same height as a plate but have no exposed studs. Standard panels are thin elements that can create a division smaller than a full-width brick.
	Inverted	Inverted tiles have smooth undersides with no exposed tubes, but they do have studs on top, unlike standard tiles.
Cylinders and Cones	Standard	Standard cylinders are cylindrical elements that resemble a coffee can or a drum. Standard cones are elements shaped like upside-down ice cream cones.
	Adapted	An element that is only partially cylindrical or conical. Pairs or groups of this kind of element can be combined to form a complete cylinder or cone.
Baseplates	Standard	Baseplates that are one full brick in height and 8×16 studs or larger.
	Waffle	Any thin baseplate with a waffled underside that does not accept studs.
Decorative Elements	Fences, Rails, and Rungs	Latticework or ladder-like elements that can be used as fences, grilles, hand rails, and so on.
	Bars, Clips, and Handles	Bars are the diameter of a minifig hand; clips are bricks or plates that can hold them in place. Handle elements have a bar-sized portion attached to an otherwise standard piece.
	Foliage	Any element that looks like flowers, trees, shrubs, or other greenery.
	Ornamental	Any piece that is purely decorative but isn't some type of foliage. A flag is perhaps the best example of this type of element.
	Doors/ Windows	Pieces that can be used as doors or windows.

Table A-2: The Bricks Category

Part	Specifications	Notes
	Description: 1×1 Subcategory: Standard Part #: 3005	This part is the basis of the LEGO system. Measurements and categorization of other parts are based on its 1×1 size. It's the third most common part. Just don't step on it barefoot in the dark! [1958]
	Description: 1×2 Subcategory: Standard Part #: 3004	The most common part in the system; used in over 3,000 official sets. Just about everything that you build (mosaics, sculptures, minifig-scale buildings, and so on) will use some of these. [1958]
	Description: 1×3 Subcategory: Standard Part #: 3622	A bit odd because of its uneven number of studs, but don't overlook 3-stud-long parts like this one. Not every model has an even number of studs. [1969]
	Description: 1×4 Subcategory: Standard Part #: 3010	Like its half-sized cousin, the 1×2, this part is common and often very useful. On the list of the most common parts, this one shows up at number seven. You probably have lots of these. [1967]
	Description: 1×6 Subcategory: Standard Part #: 3009	A short stretcher-style brick that's less common than the 1×4. It's extremely useful for creating large sections of walls for minifig-scale dwellings or for making the walls of macroscale models. [1958]
	Description: 1×8 Subcategory: Standard Part #: 3008	A longer stretcher-style brick that's less common than the 1×4. Like the 1×6, it is very useful for quickly extending the walls of minifig buildings. [1958]
	Description: 1×10 Subcategory: Standard Part #: 6111	This piece is a relatively new addition to the standard 1×N bricks. It's not as common as the 1×8. Longer walls become short work with a long brick like this. [1993]

(continued)

Part	Specifications	Notes
	Description: 1×12	The second longest 1×N brick because (as of this writing) there are no 1×14 bricks. The 1×12 is rare in smaller sets. It provides a huge overlap for smaller bricks, resulting in a stronger model. [1993]
	Subcategory: Standard	
	Part #: 6112	
	Description: 1×16	This piece isn't usually found in smaller sets, but if you can get some, you'll probably find them useful as your projects grow more complicated. [1988]
	Subcategory: Standard	
	Part #: 2465	
	Description: 2×2	The "stubby" is another brick that is sometimes overlooked. Several 2×2s can be tied together with a few larger bricks. It's the second most common part in the LEGO system. [1958]
	Subcategory: Standard	
	Part #: 3003	
	Description: 2×3	As with the 1×3, this brick is really useful, especially when you need pieces of unequal length. Two of these equal a 2×6 (obvious, but easy to forget). [1958]
	Subcategory: Standard	
	Part #: 3002	
	Description: 2×4	The common 2×4 is often the first LEGO brick people envision. Introduced in 1958, it's a core building element. You can never own too many of these. [1958]
	Subcategory: Standard	
	Part #: 3001	
	Description: 2×6	A midsized beam often found in assorted tubs and buckets. Despite its common length, it's interesting to note its late arrival. You might have expected it to have been around from the beginning. [1990]
	Subcategory: Standard	
	Part #: 2456	
	Description: 2×8	This beam-like brick was first seen in the late 1950s when the stud and tube connection mechanism was first patented. [1958]
	Subcategory: Standard	
	Part #: 3007	

Table A-2: The Bricks Category (continued)

Part	Specifications	Notes
	Description: 2×10 Subcategory: Standard Part #: 3006	One of the original elements that helped define the modern LEGO system. Useful for bracing large models or for finishing a wall above windows or doors. [1958]
	Description: 4×6 Subcategory: Standard Part #: 2356	First seen in the mid-1990s but more common in sets released after 2000. One of only a handful of standard bricks that are four studs wide. [1995]
	Description: 4×10 Subcategory: Standard Part #: 6212	Introduced the same year as the 4×6 brick. Usually found in assorted tubs and buckets. [1995]
	Description: 4×12 Subcategory: Standard Part #: 4202	Seen occasionally during the early 1980s but not again until the mid-1990s. A relatively uncommon brick. [1981]
	Description: 4×18 Subcategory: Standard Part #: 30400	A long and uncommon brick. Appeared in a few sets in the early 2000s but hasn't been seen much since. [2000]
	Description: 2×2 elbow Subcategory: Adapted Part #: 2357	A so-called elbow piece. Handy for shoring up the corner of a wall where columns of stacked pieces come together. Although it has the same shape as the 4×4 elbow, it wasn't seen until the late 1980s. [1987]
	Description: 4×4 elbow Subcategory: Adapted Part #: 702	This piece is included as a comparison to the newer, smaller 2×2 elbow. This version has not been seen in regular sets for over 40 years. [1958]
	Description: 3×3 diamond cut Subcategory: Adapted Part #: 30505	I call this diamond cut because if you arrange four of these with their right angles at the center, they form a rough diamond shape. [2001]

(continued)

Table A-2: The Bricks Category (continued)

Part	Specifications	Notes
	Description: 3×3 zig zag Subcategory: Adapted Part #: 2462	Depending on which way this piece faces, it can provide texture because of its indented side. The reverse side gives a realistic bevel to a square corner where two walls meet. [1988]
	Description: 2×3 left beveled Subcategory: Adapted Part #: 6565	It's sometimes useful to look at two elements as a pair of similar pieces, especially when you're talking about these two beveled elements. Introduced in the mid-1990s, they can be used on cars, planes, spaceships, and so on to help contour the body and make your models look more realistic. Also available in larger sizes as parts #41767 and #41768. [1994]
	Description: 2×3 right beveled Subcategory: Adapted Part #: 6564	
	Description: 2×4 left beveled Subcategory: Adapted Part #: 41768	Although the 2×3 versions of these pieces were found in sets around 1994, the longer 2×4 versions shown here didn't arrive until 2002. The longer and shorter types work well together to create subtle shapes and angles. [2002]
	Description: 2×4 right beveled Subcategory: Adapted Part #: 41767	

Table A-3: The Plates Category

Part	Specifications	Notes
	Description: 1×1 Subcategory: Standard Part #: 3024	The LEGO Group once referred to plates as "slim bricks," because they're much shorter than regular bricks. The entire plate is not much bigger than the stud on top of it. It's one of the smallest elements. [1963]
	Description: 1×2 Subcategory: Standard Part #: 3023	Ranked number five on the list of the most common parts, it's also one of the most useful parts. [1963]
	Description: 1×3 Subcategory: Standard Part #: 3623	This piece is as useful as the 1×3 standard brick. Pieces with odd numbers of studs are relatively uncommon. [1977]
	Description: 1×4 Subcategory: Standard Part #: 3710	Number nine on the list of most common parts. You can never have enough small bricks or plates. This very common part was not one of the original elements released in 1958. [1975]
	Description: 1×6 Subcategory: Standard Part #: 3666	This may have arrived as early as 1969 but was seen in only one set. It became common around 1977. [1977]
	Description: 1×8 Subcategory: Standard Part #: 3460	Although available earlier than the 1×6, this piece was first seen in the early 1970s, over a decade after the launch of the modern system. I remember it being used as the blades of a helicopter set I had as a kid. [1972]
	Description: 1×10 Subcategory: Standard Part #: 4477	Among the standard plates, this is a less common piece. [1983]
	Description: 1×12 Subcategory: Standard Part #: 60478	If it were any longer, a 1×N plate might be too flexible. This relatively new piece has appeared in a number of larger sets. [2008]
	Description: 2×2 Subcategory: Standard Part #: 3022	The plate version of the 2×2 stubby brick. One of several plates to first appear in the early 1960s. [1963]

(continued)

Table A-3: The Plates Category (continued)

Part	Specifications	Notes
	Description: 2×3 Subcategory: Standard Part #: 3021	This piece rounds out the list of basic elements with an odd number of studs on one side. You'll find it most useful as you build models that require pieces that aren't an even number of studs long. [1963]
	Description: 2×4 Subcategory: Standard Part #: 3020	This plate version of the venerable 2×4 brick has appeared in over 2,500 different sets. [1963]
	Description: 2×6 Subcategory: Standard Part #: 3795	Like its 2×6 brick counterpart, this plate is used to bridge the gap between elements four studs long (and shorter) and eight studs long (and longer). It can end up in models of all kinds. [1969]
	Description: 2×8 Subcategory: Standard Part #: 3034	In the late 1950s and early 1960s, this plate was available in one of the early parts packs. [1958]
	Description: 2×10 Subcategory: Standard Part #: 3832	What about making a roof with a gentle slope by staggering plates? You can, and when you do, this piece will come in handy for covering lots of area at once. [1977]
	Description: 2×12 Subcategory: Standard Part #: 2445	Like #3832, this piece is great for building plate roofs, among other things. And like the 1×12 standard brick, it's the second longest element in its category. (There is no 2×14 plate.) [1987]
	Description: 2×16 Subcategory: Standard Part #: 4282	This piece is probably about as long as a piece can be. Anything longer than 2×16 might be too prone to bending and breaking. [1984]
	Description: 4×4 Subcategory: Standard Part #: 3031	Although introduced in 1969, this part was not seen widely until 1973, when it began appearing often in official sets. [1969]

Table A-3: The Plates Category (continued)

Part	Specifications	Notes
	Description: 4×6 Subcategory: Standard Part #: 3032	Introduced in 1970, this piece was featured in several sets. [1970]
	Description: 4×8 Subcategory: Standard Part #: 3035	The first year of the modern system featured only two large plates: This one and the 6×8. [1958]
	Description: 4×10 Subcategory: Standard Part #: 3030	Nice for building small minifig vehicles. Just attach wheels underneath and build a passenger cab on top. [1969]
	Description: 4×12 Subcategory: Standard Part #: 3029	Use this plate to build things like a long minifig vehicle or a short section of an aircraft wing. It also comes in handy for filling in sections of floors for buildings. [1967]
	Description: 6×6 Subcategory: Standard Part #: 3958	For many years, the 6×6 was the largest of the perfectly square plates. [1978]
	Description: 6×8 Subcategory: Standard Part #: 3036	One of the two large plates featured in sets released in the first full year of the modern system. [1958]
	Description: 6×10 Subcategory: Standard Part #: 3033	The late 1960s and early 1970s brought several welcome additions to the 6×N plate family. This part and the next four parts were released within five years of each other. [1971]
	Description: 6×12 Subcategory: Standard Part #: 3028	One of the 6×N plates released between 1967 and 1975. [1967]
	Description: 6×14 Subcategory: Standard Part #: 3456	Odd that neither a 1×14 brick nor a 2×14 plate exists and yet here is a 6×14 plate. The LEGO system is flexible enough to allow for these little oddities while maintaining its functional side. [1972]

(continued)

Table A-3: The Plates Category (continued)

Part	Specifications	Notes
	Description: 6×16 Subcategory: Standard Part #: 3027	Good for building train cars, fire trucks, or even a piece of a roof made from plates attached to hinges. [1967]
	Description: 6×24 Subcategory: Standard Part #: 3026	Transport trucks, train cars, and even airplane wings benefit from this long, wide plate. [1967]
	Description: 8×8 Subcategory: Standard Part #: 41539	The largest of the perfectly square plates. [2001]
	Description: 2×2 elbow Subcategory: Adapted Part #: 2420	Can't figure out how to tie together two 1×N walls at a corner, or how to connect two stacked sections? This piece may be just what you need. [1987]
	Description: 4×4 elbow Subcategory: Adapted Part #: 2639	Although this piece is only two studs longer on each side than the 2×2 elbow, it has nine more studs, which give it more surface area and allow it to connect larger sections that meet at a vertical seam. [1991]
	Description: 2×3 hitch Subcategory: Adapted Part #: 3176	Use this part as a trailer hitch or to connect Technic pins. Its curve matches a 2×2 cylinder or cylinder plate. [1967]
	Description: 3×3 quarter cut Subcategory: Adapted Part #: 30357	Useful for rounding corners of wings, fenders, or even walls. [1999]
	Description: 4×4 quarter cut Subcategory: Adapted Part #: 30565	The only one of the three quarter-cut plates that forms a circle when you place four of them with their flat sides together. [2001]
	Description: 6×6 quarter cut Subcategory: Adapted Part #: 6003	Use this piece to create shapely balconies for minifig apartments or other structures that need a large, rounded corner. [1992]

Table A-3: The Plates Category (continued)

Part	Specifications	Notes
	Description: 3×3 diamond cut Subcategory: Adapted Part #: 2450	Four of these placed with their longest sides together form a rough diamond shape. [1988]
	Description: 4×4 diamond cut Subcategory: Adapted Part #: 30503	This diamond-cut piece can help to define the complex shapes of wings. [2001]
	Description: 6×6 diamond cut Subcategory: Adapted Part #: 6106	Unlike the other elements in this sub-category, this one has two studs at each of the smallest pointed ends, not one. [1995]
	Description: 8×8 diamond cut Subcategory: Adapted Part #: 30504	Big pieces can be beautiful. You might use this one to create the wings of a space shuttle. [2001]
	Description: 2×4 Subcategory: Bows Part #: 51739	Use this piece near the nose of an aircraft model or at the front of a boat. It is a "bow" plate after all. [2005]
	Description: 3×4 Subcategory: Bows Part #: 4859	This part predates the 2×3 wing plates (#43722 and #43723), but it's essentially the same shape as a pair of them combined. You might use it in the noses of airplanes, helicopters, and so on. [1985]
	Description: 4×4 Subcategory: Bows Part #: 43719	As with #4859, this piece is roughly the same shape as a pair of similarly sized wing plates. Its 2×2 cutout leaves space for a minifig pilot's seat or another substructure. [2003]
	Description: 3×6 Subcategory: Bows Part #: 2419	This bow plate could be the stern of a small ship or winglets on a small landing craft launched from a larger spaceship. [1987]
	Description: 4×6 Subcategory: Bows Part #: 32059	You might use this bow plate for a ship's stern or a small deck area jutting out from its side. [1998]

(continued)

Table A-3: The Plates Category (continued)

Part	Specifications	Notes
	Description: 6×7 Subcategory: Bows Part #: 2625	This bow plate really looks like the bow of a small boat. [1991]
	Description: 4×9 Subcategory: Bows Part #: 2413	Is this a bow plate or a wing plate? Given that it has no left/right variants, I've classified it as bow, though it's certainly an odd duck with its unusual shape and nine-stud length. [1987]
	Description: 2×3 left Subcategory: Wings Part #: 43723	I consider wing plates to be any plate elements whose sides are all different lengths. Too, wing plates must come in pairs that, when arranged with their two second-to-shortest sides together, form the shape of a pair of airplane wings. [2002]
	Description: 2×3 right Subcategory: Wings Part #: 43722	
	Description: 2×4 left Subcategory: Wings Part #: 41770	When combined, these two pieces cover just slightly more area than the #43719 bow plate. The drawback to using them as a substitute is that they must be held together tightly by other elements. In contrast, #43719 can be used to hold other elements together. [2001]
	Description: 2×4 right Subcategory: Wings Part #: 41769	
	Description: 4×4 left Subcategory: Wings Part #: 3936	I like these stubby little wings. Use them to create great wing shapes. [1979]
	Description: 4×4 right Subcategory: Wings Part #: 3935	

Table A-3: The Plates Category (continued)

Part	Specifications	Notes
	Description: 3×6 left	Another variation on the wing plate. [2006]
	Subcategory: Wings	
	Part #: 54384	
	Description: 3×6 right	
	Subcategory: Wings	
	Part #: 54383	
	Description: 3×8 left	A pair of wing plates seen in several space- and movie-themed LEGO sets. [2005]
	Subcategory: Wings	
	Part #: 50305	
	Description: 3×8 right	
	Subcategory: Wings	
	Part #: 50304	
	Description: 4×8 left	This pair of wing plates was found in some of the early classic Space sets. They each have the same basic size and shape near the notch as the 4×4s shown above, but they extend out twice as far. [1978]
	Subcategory: Wings	
	Part #: 3933	
	Description: 4×8 right	
	Subcategory: Wings	
	Part #: 3934	
	Description: 3×12 left	These wing plates were introduced five years after the 6×12 wing plates. [2004]
	Subcategory: Wings	
	Part #: 47397	
	Description: 3×12 right	
	Subcategory: Wings	
	Part #: 47398	
	Description: 6×12 left	Classic Space sets gave us the original wing plates (#3933 and #3934). Twenty years later, sets based on *Star Wars* gave rise to what are sure to become classic plates in their own right. The 6×12s shown here are long enough to be the only piece you need to form the entire wing for many minifig-scale ships. [1999]
	Subcategory: Wings	
	Part #: 30355	
	Description: 6×12 right	
	Subcategory: Wings	
	Part #: 30356	

Table A-4: The Slopes Category

Part	Specifications	Notes
	Description: 4×1 18 degree Subcategory: Standard Part #: 60477	This low rise slope offers an alternative angle for roofs for your minifig buildings. [2008]
	Description: 4×2 18 degree Subcategory: Standard Part #: 30363	One of the newer elements in the slope family also has one of the lowest angles. It matches perfectly with the 4×1 version shown above. Imagine entire roofs made from these slightly angled slopes. [1999]
	Description: 4×4 18 degree Subcategory: Outer Corners Part #: 43708	This multifaceted slope was used in just a handful of official sets in the mid-2000s. It's rare, but matched with the other 18-degree slopes, it could be used to create a gorgeous pagoda-style roof. [2004]
	Description: 1×1 31 degree Subcategory: Standard Part #: 54200	Lovingly known as the "cheese slope," this is the only element in this category to cover only one stud. It's useful for subtle shaping in sculptures, or for adding delicate details to the smallest minifig vehicles. This piece has been used in nearly 500 sets. [2004]
	Description: 1×2 31 degree Subcategory: Standard Part #: 85984	Want extra cheese on your model? How about a 1×2 slope that perfectly matches the angle of #54200? [2009]
	Description: 2×2 33 degree Subcategory: Peaks Part #: 3300	The early 1970s saw a whole new series of sloped pieces raked at 33 degrees. This peak element typically caps off a sloped roof. [1971]
	Description: 2×4 33 degree Subcategory: Peaks Part #: 3299	The longer of the two 33-degree peaks. (Although the 33-degree slopes are available in odd-numbered widths of one and three studs, the peaks come only in even-numbered lengths.) [1971]

Table A-4: The Slopes Category (continued)

Part	Specifications	Notes
	Description: 3×1 33 degree Subcategory: Standard Part #: 4286	It was only in the early 1980s that 33-degree roofs with odd lengths became possible. This element and #4161 greatly enhanced the classic 4-stud-wide roof brick (#3297), allowing you to finally build roofs of odd lengths. [1982]
	Description: 3×1 33 degree Subcategory: Inverted Part #: 4287	Many standard slopes have matching inverted varieties. This slope is a near mirror image of #4286. [1982]
	Description: 3×2 33 degree Subcategory: Standard Part #: 3298	Among the first of the 33-degree slopes released in the early 1970s, this slope is commonly referred to as a *roof brick*. [1971]
	Description: 3×2 33 degree Subcategory: Inverted Part #: 3747	The undersides of boats, pontoons, airplanes, and more all benefit from inverted slopes like this one. Although the 3×1 slope was released in both standard and inverted styles in the same year, the 3×2 standard had to wait eight years for its inverted match. [1979]
	Description: 3×3 33 degree Subcategory: Standard Part #: 4161	Use this to build roofs at a 33-degree slant with odd numbers of studs. [1980]
	Description: 3×3 33 degree Subcategory: Outer Corners Part #: 3675	One of the more graceful slopes. Low-angle, pagoda-style roofs just wouldn't be complete without this piece. [1980]

(continued)

Table A-4: The Slopes Category (continued)

Part	Specifications	Notes
	Description: 3×4 33 degree Subcategory: Standard Part #: 3297	The classic roof brick. [1971]
	Description: 2×1 45 degree Subcategory: Peaks Part #: 3044	Use this slope to cap off fences, castle walls, or the backs of dinosaurs, or make it part of the peak of a standard 45-degree roof. [1976]
	Description: 1×2 45 degree Subcategory: End Peaks Part #: 3048	A perfect companion to #3044 above. Use this to finish the end of a row of peak elements. [1965]
	Description: 1×2 45 degree Subcategory: End Peaks Part #: 3049	Use this when one peak meets another peak or a portion of sloped roof. The side facing front butts up against a piece like #3043 or against other 45-degree slopes. [1969]
	Description: 2×1 45 degree Subcategory: Standard Part #: 3040	Introduced three years *after* its inverted counterpart. Now a common element. [1979]
	Description: 2×1 45 degree Subcategory: Inverted Part #: 3665	Use this piece to create subtle inverted detail under the nose of a small airplane or the hip of a miniland figure, or use it to shape a small sculpture. [1976]
	Description: 6×1 45 degree Subcategory: Inverted Part #: 52501	Similar to the 2×2 version (#4871). The perfect start to a minifig-scale boat. [2005]
	Description: 2×2 45 degree Subcategory: Peaks Part #: 3043	Use this standard 45-degree peak with #3048 to create a contoured roof. [1965]

Part	Specifications	Notes
	Description: 2×2 45 degree Subcategory: Standard Part #: 3039	One of the earliest slopes. Roofs in the late 1950s and early 1960s depended on staggered bricks to form their slope. [1965]
	Description: 2×2 45 degree Subcategory: Inverted Part #: 3660	The inverted match to #3039. Notice that part of the top is open and some of the studs are hollow, like tubes sticking out of a small open box. [1975]
	Description: 4×2 45 degree Subcategory: Inverted Part #: 4871	Imagine a few of these as the bottom of a minifig boat or the underbelly of a helicopter. [1985]
	Description: 2×2 45 degree Subcategory: Outer Corners Part #: 3045	This graceful slope could be considered a compound slope. It's probably best described as an outer corner because that's the portion of a roof it will most often become. [1965]
	Description: 2×2 45 degree Subcategory: Inner Corners Part #: 3046	When two sections of roof meet, join them with a piece like this. There is currently no similar element in any of the other angles. [1965]
	Description: 2×2 45 degree Subcategory: Inverted Outer Corners Part #: 3676	There are many uses for this piece, such as a turret near the top of a castle tower. [1984]
	Description: 2×3 45 degree Subcategory: Standard Part #: 3038	You can never have too many elements with odd numbers of studs. [1965]

(continued)

Table A-4: The Slopes Category (continued)

Part	Specifications	Notes
	Description: 2×3 45 degree Subcategory: Peaks Part #: 3042	An uncommon peak element that's three studs long. [1965]
	Description: 2×4 45 degree Subcategory: Standard Part #: 3037	When building a roof, you'll need longer slopes like this one to cover the bulk of the surface. [1965]
	Description: 2×8 45 degree Subcategory: Standard Part #: 4445	This piece comes in really handy when you need a longer slope to stretch across a gap in your roof or something to use as a dormer window. One of the longest slopes available. [1983]
	Description: 6×1×5 55 degree Subcategory: Standard Part #: 30249	It's easy to imagine this elegant piece as the tail of a small plane. As of this writing, this is the only 55-degree slope available. [1999]
	Description: 2×1×2 65 degree Subcategory: Standard Part #: 60481	A perfect complement to the 2×2×2 version, you could use this as the tail of a microscale airplane, or as part of a castle wall. [2008]

Table A-4: The Slopes Category (continued)

Part	Specifications	Notes
	Description: 2×2×2 65 degree Subcategory: Standard Part #: 3678	Though originally released without a center tube inside, a newer version of this element released in 2003 did include this important feature. This piece is one of only two pieces raked at 65 degrees. [1978]
	Description: 2×2×2 75 degree Subcategory: Peaks Part #: 3688	Not necessarily a dunce cap for square-headed people; you'll find this steeply peaked element useful for everything from castle towers to Santa hats. Although the other 75-degree slopes are three bricks high, this is only two. [1986]
	Description: 2×1×3 75 degree Subcategory: Standard Part #: 4460	Another piece commonly found in castle walls, and the perfect angle for the rear end of a classic fire truck. [1984]
	Description: 2×1×3 75 degree Subcategory: Inverted Part #: 2449	Currently the only 75-degree inverted element. The entire face opposite the sloped side is hollow so that it accepts studs at a 90-degree angle. [1988]

(continued)

Table A-4: The Slopes Category (continued)

Part	Specifications	Notes
	Description: 2×2×3 75 degree Subcategory: Standard Part #: 3684	Perfect for the lower walls of any castle or building that requires a sturdy foundation. [1977]
	Description: 2×2×3 75 degree Subcategory: Outer Corners Part #: 3685	A perfect match for #3684 and #4460. This piece gives you the angles you need to create a corner. You can even use 75-degree slopes to create a very steep roof, perhaps for a ski chalet. [1978]
	Description: 3×1 Subcategory: Curved Part #: 50950	This part began to appear in sets in the mid-2000s. With no studs on top, it's extremely useful for rounding out the front of a minifig vehicle. [2005]
	Description: 4×1 Subcategory: Curved Part #: 61678	A sleek, curved slope that can add complex curves and modern lines to your models. Like the 3×1 version, it has no exposed studs. [2008]
	Description: 1×3×2 Subcategory: Curved Part #: 33243	A unique new piece that has yet to find its way into many sets. It perfectly matches the curve of the 1×3×2 half-arch piece (#6005) in the Arches category. [2003]

Part	Specifications	Notes
	Description: 3×2 bullnose Subcategory: Curved Part #: 6215	An element with no equal in shape. Perfect for giving a more subtle rounded edge to buildings or vehicles. [1995]
	Description: 2×4 left 45 to 90 degree Subcategory: Curved Part #: 43721	These two elements are some of the most interesting ones released in many years. They are unique in that they can act as intermediaries between standard bricks and 45-degree slopes since one end of each is a perfect 90 degrees. Along its four-stud length, that 90 degrees becomes 45 degrees; the sloped end is one full stud wider at the base. [2002]
	Description: 2×4 right 45 to 90 degree Subcategory: Curved Part #: 43720	
	Description: 2×6 left Subcategory: Compound Part #: 41748	Make spaceships, airplanes, and other flying machines more streamlined with this pair of pieces. Their compound shape—with its curving slope from tip to studs and a matching curved side—provides a sleek and realistic shape for traveling machines. [2002]
	Description: 2×6 right Subcategory: Compound Part #: 41747	
	Description: 2×6 left Subcategory: Compound Inverted Part #: 41765	This pair of elements helps add contours to boats of all sizes, whether as parts of the bow or pontoons. Use these together, side by side, or separated by #500 (the 6×1 curved inverted slope) to create a wider profile. [2002]
	Description: 2×6 right Subcategory: Compound Inverted Part #: 41764	

(continued)

Table A-4: The Slopes Category (continued)

Part	Specifications	Notes
	Description: 6×1 Subcategory: Curved Part #: 42022	When you want something more delicate than a flat-sided slope, try these pieces to create a more rounded and smoother angle. [2002]
	Description: 6×1 Subcategory: Curved Inverted Part #: 500	
	Description: 6×2 Subcategory: Curved Part #: 44126	Because it exactly matches the slope of #42022, this part is great for nose cones, wings, and other models that require a gentle arc. [2003]
	Description: 4×4 original style Subcategory: Compound Part #: 4858	Older and boxier than #6069. [1985]
	Description: 4×4 new style Subcategory: Compound Part #: 6069	Although not an exact replacement for #4858, this piece certainly creates a sportier projection. [1992]
	Description: 4×4 Subcategory: Compound Inverted Part #: 4855	Although released at the same time as the #4858 compound slope, this inverted element is a much closer match to the more modern-looking #6069. [1985]

Table A-5: The Specialized Elements Category

Part	Specifications	Notes
	Description: 2×2 macaroni Subcategory: Odd Faces Part #: 3063	This is one of the most beloved pieces ever produced, but it's often difficult or expensive to acquire in large quantities. [1958]
	Description: 4×4 macaroni Subcategory: Odd Faces Part #: 48092	An excellent companion to the original 2×2 macaroni brick. [2004]
	Description: 1×1 with indented stud on one side Subcategory: Junctions Part #: 4070	The famed headlight brick shown from both front and back. You can attach it to other pieces in various ways. The indented stud on the side can hold transparent 1×1 cylinder plates to create faux headlights, or you could use a row of these to attach a 1×N element horizontally. The opening in the back can accept a single stud of any kind. [1979]
	Description: 1×1 with stud on one side Subcategory: Junctions Part #: 87087	This piece, long awaited by many builders, takes the usefulness of the headlight brick to another level by moving the side stud flush with the face of the brick. Having these studs on only one side allows this piece to become part of any wall. [2009]
	Description: 1×1 with studs on two sides Subcategory: Junctions Part #: 47905	Introduced five years before #87087, this piece offers studs on opposite sides to which you can attach other pieces. [2004]
	Description: 1×1 with studs on all sides Subcategory: Junctions Part #: 4733	This element is sometimes called the hydrant brick. Although its design is amazing, it has one drawback: Often the studs you aren't using just get in the way. [1985]
	Description: 1×2 with two studs on both sides Subcategory: Junctions Part #: 52107	This 1×2 brick has six exposed studs upon which to attach other elements. [2005]

(continued)

Table A-5: The Specialized Elements Category (continued)

Part	Specifications	Notes
	Description: 1×4 with studs on one side Subcategory: Junctions Part #: 30414	Although maybe not the most elegant part, this piece is one of the most functional. It's small enough to build into almost any structure, while offering four horizontal studs onto which you can securely attach other pieces. [2000]
	Description: 2×4×2 with studs on two sides Subcategory: Junctions Part #: 2434	This solid piece can form the core of junction substructures. [1990]
	Description: 2×4×2 with tubes on two sides Subcategory: Junctions Part #: 6061	The industrial look of this 2×4×2 with tubes on two sides earns it the nickname "engine block." [1992]
	Description: 1×2 single-stud offset plate Subcategory: Junctions Part #: 3794	This short element allows you to recess parts of a model one-half stud deep, allowing you to add greater subtlety to the shape and feel of your work. [1977]
	Description: 2×2 single-stud offset plate Subcategory: Junctions Part #: 87580	A really useful piece when building with the offset technique. [2009]
	Description: 1×4 plate with two studs Subcategory: Junctions Part #: 92593	Is this a plate missing two studs or a tile with two extra studs? The studs are in the standard place, but the smooth portion in the middle is unique. [2011]
	Description: 1×1 to 1×1 bracket Subcategory: Junctions Part #: 554	When you need to change directions in a very small space, use this. The hole on top is exactly one stud in diameter, and the area around it is exactly the height of a stud. [2002]

Table A-5: The Specialized Elements Category (continued)

Part	Specifications	Notes
	Description: 1×2 to 2×2 bracket Subcategory: Junctions Part #: 44728	You can easily insert these pieces into a vertical wall, leaving the four-studded side exposed and available for attaching other parts. [2002]
	Description: 2×2 to 2×2 bracket Subcategory: Junctions Part #: 3956	One of the earliest parts to offer studs perpendicular to its base. This gem showed up in some of the classic Space-themed sets of the late 1970s. [1978]
	Description: 1×2 to 1×4 bracket Subcategory: Junctions Part #: 2436	Similar to #44728, except that the four horizontal studs are in one row rather than in two rows of two. You'll find this useful for attaching an element directly to a vertical wall. [1987]
	Description: 1×2 log Subcategory: Odd Faces Part #: 30136	Odd Face is the name given to this subcategory because the "face" or front surface of these bricks is something other than standard studs or a smooth wall. The log brick is, of course, useful in brown, but grey versions are interesting too. [1996]
	Description: 1×4 log Subcategory: Odd Faces Part #: 30137	This is the longer version of #30136. As this book goes to press, there isn't a 1×1 log brick, but you can sometimes substitute a 1×1 cylinder to get a similar effect. [1996]
	Description: 1×2 grille Subcategory: Odd Faces Part #: 2877	A unique piece in that the oddness of its face is different from front to back. Use these in groups or rows with similar faces exposed, or mix the faces for a great effect. Because both sides are grille-like, you'll sometimes see these used as grates on the sides of machinery, as roll-up doors on fire trucks, or even as corrugated steel panels. [1986]

(continued)

Table A-5: The Specialized Elements Category (continued)

Part	Specifications	Notes
	Description: 2×1 grille slope Subcategory: Odd Faces Part #: 61409	This is a slope, but not in the traditional sense. It's useful for creating realistic-looking vents and grates on machines and vehicles. [2008]
	Description: 1×2 and 1×2 plate Subcategory: Hinges Part #: 2429/2430	Although technically two pieces, this pair is almost always used together (like for the arms on miniland figures in Chapter 4). [1987/1987]
	Description: 1×2 and 1×2 brick Subcategory: Hinges Part #: 3830/3831	Use this pair of parts to create a wall section that swings away from the rest of a building or to create fixed angled sections. [1977/1977]
	Description: 1×2 brick Subcategory: Hinges Part #: 3937/3938	Use these pieces to allow a spaceship cockpit to move, or angle the studs forward and build it into a stationary wall. Once the studs are exposed, you can use them to attach other elements. [1978/1978]
	Description: 2×2 brick Subcategory: Hinges Part #: 3937/6134	The bottom portion of this element is the same as the 1×2 hinge brick above. The larger top portion allows you to attach even larger roofs, hoods, or doors that swing. [1978/1991]
	Description: 2×5 plate Subcategory: Hinges Part #: 3149	This classic piece is sometimes used to attach things like fire truck ladders, but it could just as well be used as the hinge for wings on a bird. [1967]
	Description: 2×2 plate Subcategory: Turntables Part #: 3680	This piece is a scaled-down version of the larger 4×4 turntable (shown below) but is only one plate high and can hide in many inconspicuous areas of a model. [1977]
	Description: 4×4 brick Subcategory: Turntables Part #: 3403	This turntable is the "modern" version of a similar element produced in 1963. Earlier versions lacked the square baseplate seen here; they were cylindrical all the way to the bottom. [1977]

Table A-5: The Specialized Elements Category (continued)

Part	Specifications	Notes
	Description: 1×2 channel rail plate Subcategory: Odd Faces Part #: 32028	Use this piece to build a substructure that can slide into the 1×4 channel face element (#2653). It's also available in a 1×8 version. [1997]
	Description: 1×2 channel face Subcategory: Odd Faces Part #: 4216	This part is sometimes seen as a stacked decorative element. [1981]
	Description: 1×4 channel face Subcategory: Odd Faces Part #: 2653	This piece can be both decorative and useful for accepting substructures mounted on the #32028 channel rail plates. [1991]
	Description: 1×2 pin face with one pin Subcategory: Pin-Enabled Part #: 2458	Say you've built a substructure on rail plates and are using the 1×4 channel brick to mount it. Use this brick to lock it in place with 1×2 Technic bricks. [1988]
	Description: 1×2 pin face with two pins Subcategory: Pin-Enabled Part #: 30526	The pin configuration on this piece matches any two holes on any other Technic brick. Note that its pins are centered under the studs, unlike #2548 above. [2000]
	Description: 2×2 pin face Subcategory: Pin-Enabled Part #: 4730	Try this piece when you need a pin as a secure part of a solid wall. Build it into a 2×N wall to add a sturdy pin onto which you can attach almost anything. [1985]
	Description: 2×2 pin top Subcategory: Pin-Enabled Part #: 4729	You may not need this piece often, but when you do, you'll be glad it exists. The same goes for the plate version of this part (#2460). [1995]

(continued)

Table A-5: The Specialized Elements Category (continued)

Part	Specifications	Notes
	Description: 2×2 pin-top plate Subcategory: Pin-Enabled Part #: 2460	Use this part to mount the rotors for a small helicopter and so much more. You can turn this element on its side and connect its pin to a Technic brick that's been built into the side of a model. You can then attach other pieces to the bottom of this plate. [1988]
	Description: 2×2 pin-drop plate Subcategory: Pin-Enabled Part #: 2476	Like the #2460, the #2476 plate also offers some interesting possibilities. For example, two of these plates will fit perfectly side by side when their pins are inserted into a 1×4 Technic beam. [1988]
	Description: 2×2 single-drop-hole plate Subcategory: Pin-Enabled Part #: 2444	These pieces allow Technic pins or axles to attach below bricks or plates. The #2444 element has only one hole on one side. The #2817 has two holes. [1987/1989]
	Description: 2×2 double-drop-hole plate Subcategory: Pin-Enabled Part #: 2817	
	Description: 2×2 plate with small wheels/tires Subcategory: Wheels/Tires Part #: 4600/4624/3641	Even compact models may require motion. This wheel/tire set is mounted on a tiny 2×2 plate with slender pins sticking out of each side. [1985/1986/1985]
	Description: 2×2 wide plate with slick tires Subcategory: Wheels/Tires Part #: 6157/6014/30028	If you're creating a microscale street machine, why not include some mean-looking slicks? The plate in this figure sets the wheels out wider than the parts above, which can give your street rod more of a racing look. [1994/1991/1996]
	Description: 2×4 wide plate with wheels/tires Subcategory: Wheels/Tires Part #: 30157/55981/30648	If you need wider wheels for a wider vehicle than the 2×2 options above allow, use this piece, which can exchange tires with its brick-sized counterpart (next). [1998/2006/2001]

Table A-5: The Specialized Elements Category (continued)

Part	Specifications	Notes
	Description: 2×4 brick with medium wheels/tires Subcategory: Wheels/Tires Part #: 6249/6248/3483	The wheels here (with the four studs showing) are sometimes referred to as *Freestyle*, after the sets they came from. They spin freely on pins jutting out from the sides of the 2×4 brick. [1995/1988/1985]
	Description: Medium wheels with Technic axle holes Subcategory: Wheels/Tires Part #: 3482/3483	These wheels with Technic axle holes can be used in many ways. Pop some Technic bricks on this axle, and you can mount these wheels on any size car. [1984/1985]
	Description: Brick separator Subcategory: n/a Part #: 6007	Although they've been replaced with a streamlined version, there are still lots of the original brick separators around. [1990]
	Description: Brick separator Subcategory: n/a Part #: 630	The reengineered brick separator is slimmer than the original. Its thin front edge allows you to remove tiles and offset plates. The feature on top allows you to remove axles from Technic bricks or parts like the 2×2 cylinder (#3941). [2011]

Table A-6: The Arches Category

Part	Specifications	Notes
	Description: Subcategory: Standard Part #: 4490	This piece is perfectly suited for building arched windows into thick castle walls. It's probably the smallest possible arch piece that can be both practical and elegant. [1976]
	Description: 1×4 Subcategory: Standard Part #: 3659	A classic Roman arch that forms a semicircular shape. These arches are useful in many architectural situations. [1976]

(continued)

Table A-6: The Arches Category (continued)

Part	Specifications	Notes
	Description: 1×4×2 Subcategory: Standard Part #: 6182	Given its shape, it's no surprise that this element shows up in a number of medieval-themed sets. [1994]
	Description: 1×6 Subcategory: Standard Part #: 3455	The radius of this arch is much greater than that of the 1×6×2 shown next (#3307). [1972]
	Description: 1×6×2 Subcategory: Standard Part #: 3307	Like the 1×4 arch (#3659), this piece represents a classic Roman shape. A series of these can create a pleasing arcade for any building. [1971]
	Description: 1×8×2 Subcategory: Standard Part #: 3308	Like the 1×6 arch, this piece has a slightly greater radius for the arch shape. [1971]
	Description: 2×8×3 Subcategory: Standard Part #: 4742	This part has appeared in a number of assorted buckets, mostly aimed at younger builders. [1985]
	Description: 1×12×3 Subcategory: Standard Part #: 6108	Now that's an arch! Impressive in size, this piece adds a grand opening to train tunnels, fire stations, and other structures. [1993]
	Description: 1×2 Subcategory: Half Part #: 6091	Tuck this compact piece under #6005 (below) to create interesting shapes in matching or complementary colors. [1992]

Part	Specifications	Notes
	Description: 1×3×2 Subcategory: Half Part #: 6005	Part #6091 fits nicely under this arch. By itself, this piece can also be a flying buttress–type arch. [1995]
	Description: 1×3×2 Subcategory: Half Inverted Part #: 88292	This graceful little inverted arch is like the faux inverted arches (made from inverted 1×2 slopes) we saw in the train station model in Chapter 3. [2010]
	Description: 1×5×4 Subcategory: Half Part #: 2339	Used alone, this flying buttress arch starts at a point away from a wall or structure and meets with the top of its half arch. When used in pairs, these pieces become a 1×10×4 arch. [1986]
	Description: 1×5×4 Subcategory: Half Inverted Part #: 30099	This half arch is another case where more than a decade separates the release of a standard part (like #2339) and the release of its inverted counterpart. [1997]
	Description: 1×6×2 Subcategory: Standard Part #: 6183	No, it's not the handle from a LEGO lunchbox, though it could be. It's an arch with gently curved corners that can be used as a wonderful decorative piece. [1994]

(continued)

Table A-6: The Arches Category (continued)

Part	Specifications	Notes
	Description: 1×6×3 Subcategory: Half Part #: 6060	Probably the piece best suited to being a flying buttress, it really extends outward from the top until it reaches the bottom of the half arch. Simply elegant. [1992]

Table A-7: The Tiles and Panels Category

Part	Specifications	Notes
	Description: 1×1 tile Subcategory: Standard Part #: 3070B	Although a similar part was released in 1971, this modern version includes a tiny groove around the base, which makes it easier to remove. [1978]
	Description: 1×2 tile Subcategory: Standard Part #: 3069A	Like the 1×1, this is the second version of this part. The first, without the groove around the bottom, was first seen in 1968. [1977]
	Description: 1×3 tile Subcategory: Standard Part #: 63864	2010 saw the introduction of two new tiles to the LEGO system. This 1×3 version was joined by a 2×4 version shown below (#87079). [2010]
	Description: 1×4 tile Subcategory: Standard Part #: 2431	Run these in series down the middle of a few rows of black tiles to create the lines of a divided road. [1987]
	Description: 1×6 tile Subcategory: Standard Part #: 6636	A tile like this could become the top edge of the sides of a microscale ship, like the one in Chapter 6. [1995]
	Description: 1×8 tile Subcategory: Standard Part #: 4162	To make small helicopters look more real, try using these pieces as rotors. [1980]
	Description: 2×2 tile Subcategory: Standard Part #: 3068B	Sidewalks are just one of many uses for standard 2×2 tiles. Mix them with 1×N tiles of different colors to create streets or parking lots. [1976]

Table A-7: The Tiles and Panels Category (continued)

Part	Specifications	Notes
	Description: 2×4 tile Subcategory: Standard Part #: 87079	When you need to smooth out a lot of surface area, use these elements that cover eight studs apiece. [2010]
	Description: 2×2 cylinder Subcategory: Standard Part #: 4150	It's a manhole cover and more! Like many other tiles, this part also has a small groove at its bottom edge, which makes it easier to remove. [1983]
	Description: 2×2 cylinder Subcategory: Inverted Part #: 2654	This isn't exactly a true inverted plate—it has a curved underside. It's sometimes called a *boat plate*, since you can attach these pieces under boats to allow them to skim over carpet or other surfaces. [1991]
	Description: 1×1×1 panel Subcategory: Standard Part #: 6231	This piece is great for creating hollowed-out areas along the face of a solid wall. It works well with #4865 shown next. [1995]
	Description: 1×2×1 panel Subcategory: Standard Part #: 4865	This element could be a tiny little couch, the steps on the sides of vehicles, or tiny accents on a large open space. [1985]
	Description: 1×4×1 panel Subcategory: Standard Part #: 30413	A longer version of #4865 above. [2000]
	Description: 1×2×2 panel Subcategory: Standard Part #: 4864	Try using these panels on an outside wall to leave room inside the model for moving parts or other substructures. [1997]

(continued)

Part	Specifications	Notes
	Description: 1×2×3 panel Subcategory: Standard Part #: 2362	Panels are useful no matter which direction they're facing. When turned like this piece, they can add an indent to an otherwise dull wall, but when turned 180 degrees, they look solid. [1998]
	Description: 3×2×6 panel Subcategory: Standard Part #: 2466	Not all panels are flat. Some, like this one, are made up of several thin, flat sides meeting at interesting angles. [1988]
	Description: 1×4×3 panel Subcategory: Standard Part #: 4215A	Many parts are available in transparent colors. This panel is available in several opaque colors, but the clear version (same part number) allows you to use it as a window for a large office building or a minifig structure where you need a lot of light. [1994]

Table A-8: The Cylinders and Cones Category

Part	Specifications	Notes
	Description: 1×1 cylinder plate Subcategory: Standard Part #: 4073	This is about the smallest element in the entire system. It's barely bigger in the middle than the stud on top and it's hardly bigger at the bottom than a regular tube. Match up transparent red ones with headlight bricks and you've got brake lights for a minifig car. [1980]
	Description: 2×2 cylinder plate Subcategory: Standard Part #: 4032	The keyhole-shaped opening in this piece matches a similar feature found on 2×2 cylinders. [1980]
	Description: 4×4 cylinder plate Subcategory: Standard Part #: 60474	You can imagine plates like this turned outward as the airlock doors on a space station or turned on edge as the wheels on a chariot. [2008]
	Description: 1×1 cone Subcategory: Standard Part #: 4589	You might use this piece as the nose cone of a small rocket. The tip is just the right size to fit into the bottom of an identical piece or into the under-side of nearly any regular brick or plate. [1985]
	Description: 1×1 cylinder Subcategory: Standard Part #: 3062B	This part is the updated version of one originally released with the earliest parts in 1958, except that the stud is hollow (the original was solid). [1977]
	Description: 2×2×2 cone Subcategory: Standard Part #: 3942	This part got a facelift after its original release. This newer version has a hol-low stud. [1984]
	Description: 2×2 cylinder Subcategory: Standard Part #: 3941	This piece looks like a tiny coffee can with studs on top. The hole running vertically through it matches the size of a standard Technic axle. [1978]

(continued)

Table A-8: The Cylinders and Cones Category (continued)

Part	Specifications	Notes
	Description: 3×3×2 cone Subcategory: Standard Part #: 6233	These pieces are sometimes used as engines on a rocket or a space shuttle. [1995]
	Description: 4×4×2 cone Subcategory: Standard Part #: 3943	This lampshade-like piece can be used as the engine of a spaceship or as a transitional piece that joins 4×4 to 2×2 cylinder pieces. [1982]
	Description: 4×4 cylinder Subcategory: Standard Part #: 6222	The holes on the sides of this piece easily accept a Technic pin or axle or the studs from any standard piece. The only problem is that when you stack a bunch of them, they look a bit like a column of Swiss cheese. [1995]
	Description: 4×4 quarter-cut cylinder Subcategory: Adapted Part #: 2577	Two of these pieces together could be used to create a semicircular *Romeo and Juliet*–style balcony. Four used together could create a round launchpad for a small rocket. [1990]

Table A-9: The Baseplates Category

Part	Specifications	Notes
	Description: 8×16 Subcategory: Standard Part #: 4204	This baseplate is a newer version of a similar element (#700). This updated part has extra bracing beneath it that helps make it very rigid and strong. [1985]
	Description: 8×16 Subcategory: Waffle Part #: 3865	This baseplate is perfect for smaller buildings like gas stations or bus stops in your minifig town. [1971]

Table A-9: The Baseplates Category (continued)

Part	Specifications	Notes
	Description: 10×20 Subcategory: Standard Part #: 700	As a kid I nearly wore out my green 10×20 brick plates. They were the bases for countless houses, factories, and shops, which all met with some disaster that inevitably resulted in my LEGO fire apparatus coming to the rescue. [1965]
	Description: 16×16 Subcategory: Waffle Part #: 3867	Large baseplates like this one are also found in sizes such as 32×32 and 48×48. The latter is perhaps one of the largest LEGO elements ever produced. These form the bases for all manner of buildings and scenes. [1978]

Table A-10: The Decorative Elements Category

Part	Specifications	Notes
	Description: 1×4 lattice Subcategory: Fences, Rails, and Rungs Part #: 3633	This part could become a small garden fence or the decorative guardrail on a microscale ship. [1976]
	Description: 1×4×2 lattice Subcategory: Fences, Rails, and Rungs Part #: 3185	This element looks great when built into a wall, as the grate over an air conditioning system, or just as a vent of some kind. [1967]
	Description: 1×2 ladder plate Subcategory: Fences, Rails, and Rungs Part #: 4175	This tiny ladderlike piece is easy to incorporate into most models since you really only need to find room for the 1×2 plate. The rungs of the element can rest against the side or end of a model to form a ladder or grille. [1980]

(continued)

Table A-10: The Decorative Elements Category (continued)

Part	Specifications	Notes
	Description: 1×2 grille plate Subcategory: Fences, Rails, and Rungs Part #: 2412B	This piece was re-released in the mid-1990s with a tiny groove around the bottom edge. This groove is handy, as it makes it easier to remove the grille plate from any surface to which it's been attached. Try mounting it on another piece in a contrasting color—the openings in the grille allow the color of the element below to show through. [1987/1995]
	Description: 1×6 handrail Subcategory: Fences, Rails, and Rungs Part #: 6583	This handsome element is often used on train models but can just as easily be the handrail on a small bridge or a ship's guardrail. [1996]
	Description: 1×8×2 Subcategory: Fences, Rails, and Rungs Part #: 2486	This piece looks like the fencing you might find in parking lots or the railings along the upper decks of a fancy passenger liner. Of course, it could just be a plain old bicycle rack for a minifig park. [1988]
	Description: 4-brick-high basic bar Subcategory: Bars Part #: 30374	Light saber? Baseball bat? Hand rail? Yup, it's all that and more. The diameter of this bar is exactly the size of a minifig hand, and it's the right size for any of the following clip elements. [1999]
	Description: 4-brick-high basic antenna Subcategory: Bars Part #: 3957	How about a self-attaching bar? The round-tipped antenna has a socket at the end that attaches easily to any studded element. The antenna is also the same width (along the main section) as the basic bar shown in the previous entry. [1977]
	Description: 1×1 clip plate vertical Subcategory: Clips Part #: 4085C	Some parts just keep evolving; this part is on its third incarnation. It's often used to attach handled parts and bars to models. [1979/1987/1993]

Table A-10: The Decorative Elements Category (continued)

Part	Specifications	Notes
	Description: 1×1 clip plate horizontal Subcategory: Clips Part #: 6019	Clip plates don't just have to clip to ordinary bars like #30374. They can also be attached to handled parts such as #2540 or #30236. [1990]
	Description: 1×2 clip plate with two clips Subcategory: Clips Part #: 60470	Twice as wide as #6019 above, this part gives you more gripping power on a sturdier 1×2 base. [2008]
	Description: 1×2 clip plate horizontal Subcategory: Clips Part #: 63868	The greater length of this element (compared to #6019 above) makes a stronger connection for a moving panel or swing-away doors. [2009]
	Description: 1×1 with studs Subcategory: Clips Part #: 4081B	This is the modern version of an earlier piece. The rounded part on the side has two stud-sized areas that allow any number of elements to connect to it. The hole through those studs is exactly bar sized. [1980/1988]
	Description: 1×1 with clip top Subcategory: Clips Part #: 2555	Need a handrail for a minifig boat or just something decorative along the top of a wall? Grab a pair of these and put them at the ends of the #30374 bar element and you're all set. [1989]
	Description: 1×2 with clip top and single stud Subcategory: Clips Part #: 92280	The combination of a clip on top and a single exposed stud makes this an interesting and unique piece. [2011]
	Description: 1×1 brick with handle Subcategory: Handles Part #: 2921	Some pieces in this category have clips; others, like this one, have a handle attached instead. [1992]
	Description: 1×2 plate with handle Subcategory: Handles Part #: 2540	This piece can be decorative or functional depending on what you attach to the handle. It takes up only the space of a 1×2 plate, which can make it more useful than the brick version (#30236). [1989]

(continued)

Table A-10: The Decorative Elements Category (continued)

Part	Specifications	Notes
	Description: 1×2 brick with handle	This piece has the same size handle as the #2540 plate. Use rows of this brick to decorate the tops of buildings or even some vehicles. [1999]
	Subcategory: Handles	
	Part #: 30236	
	Description: 1×2 plate with braced handle	This part is often called the "1×2 tile with handle." [1987]
	Subcategory: Handles	
	Part #: 2432	
	Description: 1×2 plate with handle	This piece is like a horizontal version of the 1×2 plate with handle shown above (#2432). Use it for hinging small doors and panels to add functionality to small models. [2004]
	Subcategory: Handles	
	Part #: 48336	
	Description: 1×2 plate with handle	This part includes a 1-stud-wide handle on its narrow end. [2008]
	Subcategory: Handles	
	Part #: 60478	
	Description: 1×2 plate with handles	Originally introduced in the late 1970s, this piece was redesigned a few years later (to have a more robust connection between the plate and the handles) and continues to be used in sets today. [1981]
	Subcategory: Handles	
	Part #: 3839B	
	Description: Bush	Decorative gardens, rustic western settings, and mountainous train layouts all benefit from this spiky little bush element. [1992]
	Subcategory: Foliage	
	Part #: 6064	

Table A-10: The Decorative Elements Category (continued)

Part	Specifications	Notes
	Description: Fruit tree Subcategory: Foliage Part #: 3470	When you need an apple orchard or some well-groomed bushes for the sides of a posh minifig mansion, the fruit tree is the answer. [1977]
	Description: Pine tree (small) Subcategory: Foliage Part #: 2435	This little pine tree has been seen only in standard green since its introduction more than a quarter century ago. [1976]
	Description: Pine tree (large) Subcategory: Foliage Part #: 3471	This large pine tree has been manufactured only in green during the last 40 years. Mixing large and small versions together in a scene adds realism and interest. [1973]

(continued)

Table A-10: The Decorative Elements Category (continued)

Part	Specifications	Notes
	Description: 3×5 stem Subcategory: Foliage Part #: 2423	Use several of these pieces to create the look of an ivy-covered wall for a library or an older home. [1987]
	Description: Sea grass Subcategory: Foliage Part #: 30093	Sure, this element can be used as sea grass, but how about making it a cactus or a yet-to-be-discovered creepy munga bush on a planet first explored by a minifig ship of your own design? [1997]
	Description: Basic flag Subcategory: Ornamental Part #: 4495	Castles, carnival rides, and parade floats need colorful flags that look like they're blowing in the wind. This simple but effective ornamental element is usually placed atop #3957, the four-brick-tall antenna. [1984]
	Description: Lion head carving Subcategory: Ornamental Part #: 30274	Decorative pieces reached a new level of sophistication and elegance with this lion head. Perfect for classy downtown buildings where minifigs gather to do business. [2000]

Table A-10: The Decorative Elements Category (continued)

Part	Specifications	Notes
	Description: 1×2×2 window Subcategory: Windows Part #: 7026	A staple from the beginning, these pieces can be used in groups to create large office windows or alone to add character to even the smallest minifig dwelling. [1958]
	Description: 1×4×3 train window Subcategory: Windows Part #: 6556/4034	This is the newer version of the train window shown with the original version of the glass insert. This part combo also works well as windows for buses or even spaceships. [1993/1980]
	Description: 1×2×2 window Subcategory: Windows Part #: 2377	Often called airplane windows, these pieces can also be used in models of trains, fire trucks, ships, helicopters, and so on. They're useful with or without the glass inserts. [1987]
	Description: 1×4×2 windows Subcategory: Windows Part #: 4863	Two airplane windows, joined together. As with #2377, this element can find its way into a variety of vehicles. Think of it as a panel with cutouts. [1985]
	Description: 1×2×2⅔ window Subcategory: Windows Part #: 30044/30046	Do the occupants of your castle need light? This beautiful pair of elements will certainly help. Use a 1×4 standard arch over the top of this window to make it look like part of the wall. [1996/1996]

(continued)

Part	Specifications	Notes
	Description: 1×4×3 Subcategory: Windows Part #: 3853	The old reliable 1×4×3 basic window is shown with inserts that look like panes of glass. You can replace the solid panes with ones that are latticed or turn the part around. Add shutters to give it a homier look. [1977]
	Description: 1×4×5 four-pane door Subcategory: Doors Part #: 3861	Minifig-scale buildings aren't much good if your characters can't get in and out of them. This often-used part is strangely available only in this version, which opens from the left. [1977]
	Description: 1×4×5 glass door Subcategory: Doors Part #: 73436	This more modern-looking door is available in both left and right varieties. It's perfect for office buildings, schools, banks, or other urban minifig structures. [1982]

B

DESIGN GRIDS: BUILDING BETTER BY PLANNING AHEAD

Sometimes just a little planning can save a lot of head-aches. The design grids discussed in this appendix are intended to save you some of the frustration that comes from not mapping out the direction you want your work to take. The grids are graph paper created with dimensions that match those of LEGO elements. You may find them useful for experimenting with different part combinations before actually getting your bricks out on the table.

You can use the design grids to plan a small part of a large model or the layout of an entire mosaic. Ultimately, their use is up to you, but here are some suggestions for how to use them effectively.

Downloading the Grids

By downloading and printing your own copies of the design grids, you ensure that they're sized correctly and that you can make as many copies as you need. You can download the design grids (as PDF files) from *http://nostarch.com/legobuilder2/*.

About the Grids

Each design grid has a different purpose. Design Grids #1 and #2 are most useful when you're sketching out mosaic images or planning a model that will be viewed from the top looking down. Design Grids #3 and #4 allow you to imagine a LEGO model as seen from the side.

Design Grid #1

Design Grid #1 allows you to look straight down on the studs of a model. As you can see in Figure B-1, each square is exactly the size of a real 1×1 brick.

Design Grid #1 – 1:1 Scale
[Studs Up/Top Down Orientation]

Figure B-1: The squares on Design Grid #1 are all the same size as the top surface of a 1×1 brick.

Design Grid #2

Design Grid #2 is unique in that it's the only one that doesn't have lines drawn to exactly the size of real LEGO elements. Instead, it's made up of a 32×32 field of squares sized to fit on a single page. You might use it to plan a mosaic that fits onto LEGO's common 32×32 waffled baseplate.

As you can see in Figure B-2, this grid also makes it easy for you to pinpoint any location on the baseplate by placing letters and numbers next to the squares of the grid. For example, in Figure B-3, I've marked an X in some of the squares on the grid. I can identify these locations by the letter and number combination that meets at that square.

Figure B-2: Like the reference markers on a map, the numbers and letters help you determine where bricks need to go.

You may find these coordinates useful when transferring your mosaic design from paper to actual elements. For example, in Figure B-3, the *Xs* on the design grid show where pieces should go. On the right, you see the actual LEGO pieces in the same locations on the baseplate. The red 1×1 plate is at A1, the blue plate is at B2, and the yellow plate is at C3.

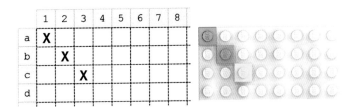

Figure B-3: This side-by-side comparison shows how marks on the design grid translate into the positions of real pieces on a baseplate.

Design Grid #3

Design Grid #3 allows you to plan a model as though you are looking at it from the side. A portion of the grid is shown in Figure B-4. You can see that the boxes (or *cells*) on this grid are much shorter than the ones in Design Grid #2. In fact, each box is the height and width of a standard 1×1 plate as seen from the side. This configuration is referred to as *plate view*.

Design Grid #3 – 1:1 Scale
[Plate View – Portrait Orientation]

Figure B-4: A portion of Design Grid #3 shows the layout of the cells.

As with real plates, three of these boxes equal one standard 1×1 brick in height. The page is set up the way a standard book is, with the short sides of the page at the top and bottom. This is known as *portrait orientation* (see Figure B-5).

Figure B-5: The entire grid as it appears when you print it

Design Grid #4

Design Grid #4 has the same size squares as Design Grid #3, but the entire page is oriented with the long sides at the top and bottom. This is known as *landscape orientation*. The image of the grid shown in Figure B-6 is reduced in size so that you can see the orientation of the squares as they appear on a full page.

Figure B-6: This grid is useful for planning models that are wider than they are tall.

Using the Grids Effectively

As noted earlier, the grids fall into two categories. Design Grid #1 is useful for creating things like the floor plan for an office building, an airplane's wings, or the layout of walls surrounding a castle. Design Grid #2 is most effective for planning small, studs-out mosaics. Design Grids #3 and #4 allow you to plan the height of a model and include the side view of such things as slopes and plates. You can also use them to plan studs-up mosaics or help you design custom-sized arches made from inverted slopes.

Your choice of grid will depend on which part of the model you are trying to design. If a large model won't fit on a single grid, use the grid to work out only a portion of the model, or tape several sheets together until you have enough room to complete your design.

You should use two, three, or all four of the grids when designing a model. For example, if you're sitting down to design your own version of the train station model from Chapter 3, you might use Design Grid #1 to plan the walls, including the ticket counter and the front door; Design Grid #3 to experiment with combinations of parts or ideas for substituting parts; and Design Grid #4 to sketch the front of the train station including the windows and the bench.

Because the grids are sized to the exact dimensions of LEGO elements, you can use them to sketch out your model on the grid, not worrying about which pieces go where, or to draw specific pieces onto the cells to see how they look.

Colorize Your Ideas

You can also use the grids to test out color combinations. To do this, draw the outlines of the pieces with which you want to experiment, and then color them with colored pencils, crayons, or fine markers. You can even test the look of color combinations for parts you may not own.

Description and Date for Future Reference

Spaces at the bottom of each grid offer a place to fill in the description of the model and the date the design sketch was made. Figure B-7 shows an example.

Description Shuttle Wing Outline Date Oct 11/14

Figure B-7: Descriptions don't have to be fancy. Jot down just enough information to remind yourself of the purpose of this particular design.

Keep your designs on file so that as you design new projects, you can look back to see what did and did not work.

Drawing on Design Grid #1

Remember, Design Grid #1 presents a view of your model as if you're floating high above your design. You can see only the tops of any object from this view. For example, if you were to draw the Empire State Building microscale model (from Chapter 6) onto a copy of Design Grid #1, you would end up with something like the drawing shown in Figure B-8.

Figure B-8: A microscale Empire State Building as seen from above

You can use this grid to determine the various heights of layers within the same model. For example, in Figure B-8, I've used shading to represent different levels of the building—light and dark grey, diagonal lines, and blank areas. The shading reminds me to pay attention to the changing geometry as I construct the building and allows me to represent three dimensions on a two-dimensional diagram.

You can also use Design Grid #1 to plan the outline of a model or part of a model (as with the shuttle wings in Chapter 9), or to see the distances between walls within a building (as with the train station example from Chapter 3) or between two small buildings.

If you're going to use Design Grid #1 for outlining, draw a line around the outside of the shape, and then use the grid to fill in the needed bricks. Figure B-9 shows part of the shuttle wing from Chapter 9.

In the case of buildings, you can use the grids to place the walls, doors, and windows. Figure B-10 shows a portion of the train station walls from Chapter 3.

Figure B-9: Using the design grids, you can piece together a model design by placing real elements on your paper sketch.

Figure B-10: Make notes to remind yourself of different features or substructures.

And you can use Design Grid #1 to help plan studs-out mosaics. Studs-out mosaics aren't as subtle as the studs-up variety, but they can still be fun to plan and build. (See Figure B-11.)

If you're having trouble seeing your original image through the design grid, try using a light source coming from behind, as I did in Figure B-12. This made it much easier to transfer the figure I wanted to my paper plan.

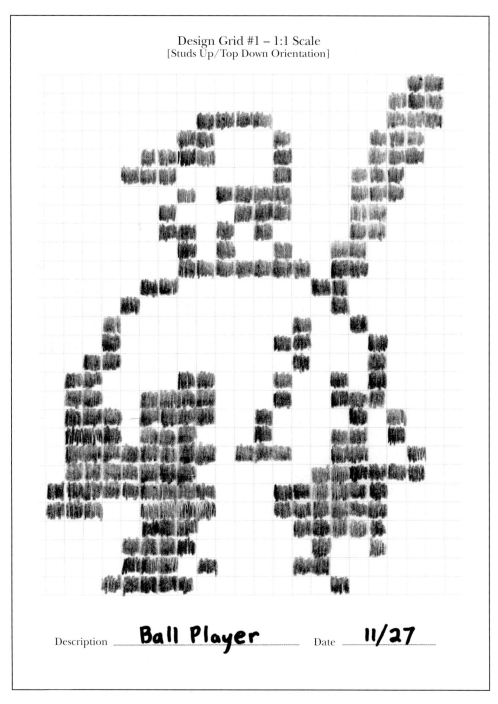

Design Grid #1 – 1:1 Scale
[Studs Up/Top Down Orientation]

Description ___**Ball Player**___ Date ___**11/27**___

Figure B-11: Simple characters and themes are good subjects for studs-out mosaics.

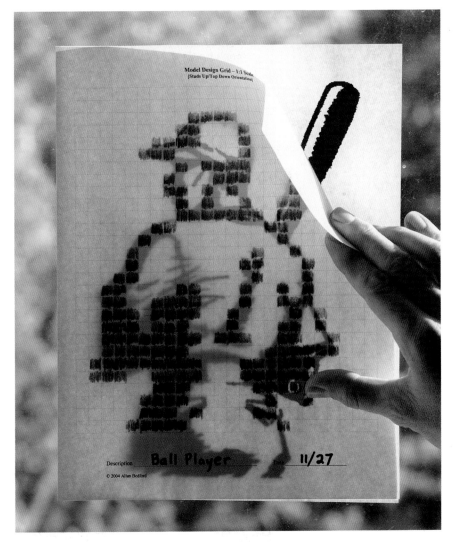

Figure B-12: If possible, try to use lightweight paper when printing out Design Grid #1 to allow your image to show through from below.

Drawing on Design Grid #2

Got an image you want to turn into a 32×32 mosaic without having to use software? Rather than pixelating your image (as I did in "Creating Photo Mosaics" on page 117), you can print and trace an image, just like the method shown in Figure B-12. To plan a mosaic this way, print out a copy of Design Grid #2 and a copy of your image. Make sure to print your image within the length and width of the grid (6.5 inches × 6.5 inches, or 16.5 cm × 16.5 cm). Then place the grid on top of your image and trace the shapes and lines you see coming through.

Drawing on Design Grid #3

Design Grid #3 has you look at your model from the side. If you were to simply draw a single 1×1 plate, it would look like Figure B-13. A standard 1×1 brick would look like Figure B-14.

Figure B-13: As simple as it gets. This illustration shows you what a 1×1 plate should look like.

Figure B-14: Three 1×1 plates stacked together always equal the height of a standard 1×1 brick.

As you can see, each time you want to draw the equivalent of a full-height 1×1 brick, you simply draw a line around three of the cells. You draw longer bricks, such as a 1×N bricks, by extending the top and bottom lines horizontally until you have captured the length you need.

You don't need to limit yourself to just standard bricks and plates; you can draw other pieces just as easily. Figure B-15 shows what a 1×4 arch brick would look like when drawn on this grid.

Figure B-15: Parts with complex shapes, such as this arch, can also be easily drawn on the design grids.

You can indicate slopes on this grid by drawing diagonal lines along with lines for the bottom and side of the element (see Figure B-16).

Figure B-16: Follow the geometry of a real element, and your drawings will always be accurate.

For example, in Figure B-16 you can see a 2×1 45-degree slope and a 3×1 33-degree slope. Notice that the diagonal lines cut across the lines of the grid itself. If you're ever confused about which lines to connect to make the sloped side of a piece, just grab an actual slope from your collection and study where the slanted edge meets the rest of the brick. (Don't forget to leave a flat line at the top to represent where the stud is located.)

Drawing on Design Grid #4

Once you understand how to use Design Grid #3, you know how to use Design Grid #4. The only real difference between the two is the way they're oriented: Design Grid #3 is used in portrait orientation, whereas Design Grid #4 is in landscape. You'll find Design Grid #3 useful when your model is taller than it is wide, and Design Grid #4 works well when the model is wider than it is tall.

Figure B-17 shows how to test a particular combination of parts to view their final shape without taking any pieces out of storage. As you can see, the drawing isn't perfect, but it can help you make some key construction decisions.

Figure B-17: Inverted slopes are just as easy to draw as their standard counterparts. Here I've sketched out a substitute arch, like the example in Chapter 3 (Figure 3-25 on page 53).

Review: From Grids to Bricks

You will always need to tweak your model as you translate it from a sketch into real bricks, but by doing so, you should end up with a stronger design. The drawings you create on the grids provide a guide; you don't have to follow them brick for brick. The best thing to do is to create your design sketch and then simply start building. As you work, step back and examine the actual assembly to see which bricks or plates you want to change. The result, whether it's a small group of pieces or a complete mosaic portrait, will be a work of art that you can call your own.

INDEX

Numbers

1×1 brick, as standard for
 measurement, 2
1×1 brick model (jumbo version), 75
1×2 plate model (jumbo version),
 78–79
1×N, 3
2×2 45-degree slope model (jumbo
 version), 78, 79–80
2×4 brick model (jumbo version),
 75–76
4X scale, 75–76, 79–80, 81, 82
5:6 ratio, 11–12
6X scale, 82–83
10X scale, 73–74, 82–83
12X scale, 82–83

A

alternative solutions. *See*
 substitution
angelfish, mosaic design, 117–119
approximation
 defined, 83
 examples of, 84, 86
arch
 elements, 189–192
 parts of, 52
 substituting for, 52

B

baseplate
 defined, 9–10
 elements, 196–197
 selecting size for mosaics,
 113–114
beam
 composite type, 27
 correct assembly, 28
 defined, 27
 examples of usage, 26, 28, 71

incorrect assembly, 28
simple type, 27
Bill of Materials (BOM)
 defined, 38
 for microscale house model, 92
 for space shuttle model, 140
 for sphere model, 97
 for train station model, 39
bond patterns, 18. *See also*
 overlapping; stacking;
 staggering
bracing
 defined, 25
 demonstrated, 26, 69–71
brick
 defined, 2
 elements, 163–166
 uses, 4–5
brick separator
 defined, 32
 elements, 189
 examples of usage, 32–33
 how to obtain, 32
 using bricks instead of, 33
Brickopedia
 categories and subcategories,
 161–162
 defined, 159–160
 listings
 arches, 189–192
 baseplates, 196–197
 bricks, 163–166
 cylinders and cones, 195–196
 decorative elements,
 197–204
 plates, 167–173
 slopes, 174–182
 specialized elements,
 183–189
 tiles and panels, 192–194
 sample entry, 160
brickplate. *See* baseplate
building principles, 34, 82, 128–129

substitution
> arches, 52
> brick separator, 33
> colors. *See* colors
> defined, 51–52
> examples of, 38, 79
> in miniland figures, 64–65
> roofs, 53–56
> walls, 52, 70
> when designing, 129, 132
> windows, 53

substructure. *See* submodel

symbols, for legend, 118

system, defined, 1

T

taking apart elements. *See* brick
> separator

ten-times scale, 73–74, 82–83

test build, 78

tile
> defined, 8
> elements, 192–193

top-down design grid, 206–207

train station model
> Bill of Materials, 39
> instructions, 38–51
> other uses for, 37
> roof submodel, 48–51
> substitute arches, 52
> substitute roofs, 53–55
> substitute walls, 52
> substitute windows, 53

Triton. See space shuttle model

tube, defined, 4

turntables, 186

twelve-times scale, 82–83

W

waffleplate. *See* baseplate

walls
> creating, 20, 22–23
> curved, 24–25
> overlap technique, 20–21, 22–23
> substituting in, 52

wheels
> elements, 188–189
> microscale, 90–91

windows
> elements, 203–204
> microscale, 89, 91
> substitute for train station
> > model, 53

COLOPHON

The Unofficial LEGO Builder's Guide, 2nd Edition is set in New Baskerville, Futura, and Dogma.

The book was printed and bound by Tara TPS in Paju-si, Kyunggi-do, South Korea. The paper is 100gsm Neo Moorim.

A NOTE FROM THE ILLUSTRATOR

Most of the images in this book were computer generated using freely available software written by the LEGO user community. The core software, LDraw, was originally developed in 1995 by James Jessiman with a DOS interface. The LDraw file format is still used today to maintain a library of thousands of LEGO parts modeled by users. I used the LDraw editor MLCad (created by Michael Lachmann) to assemble the virtual parts for the images in this book. The models were then imported into a viewer called LDView (created by Travis Cobbs), which I used to find just the right orientation and perspective for each picture. LDView then converted and exported the LDraw files into a form that could be read by POV-Ray (Persistence of Vision Raytracer), an open source 3-D rendering package. This tool was used to adjust lighting, colors, and reflections to make the photorealistic images you see in the book. Among the advanced features used were radiosity and HDR (High Dynamic Range) lighting. On average, each image rendered for about 20 minutes on a modern computer. More complex models are possible, and more sophisticated images can be created by using such advanced features as fog, focal blur, motion blur, and complex backgrounds. These can take hours or even days to render.

All of the software mentioned above can be downloaded from *http://www.ldraw.org/*. Many more examples of rendered LEGO images can be found in my Brickshelf folder at *http://www.brickshelf.com/cgi-bin/gallery.cgi?f=353519*.

ABOUT THE AUTHOR

Allan Bedford is a lifelong LEGO fan and builder whose most ambitious model is a 5,000-piece replica of Toronto's famed CN Tower. An avid photographer, Bedford spends his time chronicling the streets and people of his adopted hometown, Toronto.

ABOUT THE ILLUSTRATOR

Eric "Blakbird" Albrecht is an aerospace engineer living in the northwest United States. He maintains the globally known Technicopedia (*http://www.technicopedia.com/*) and is also an avid user of LEGO CAD tools. He has generated over 1,000 photorealistic renders of official models and MOCs (My Own Creations) and created dozens of sets of instructions for some of the best Technic MOCs from around the world, averaging 1,500 parts each.

UPDATES

Visit *http://nostarch.com/legobuilder2/* for updates, errata, and other information.